A YEAR
in the
COUNTRY

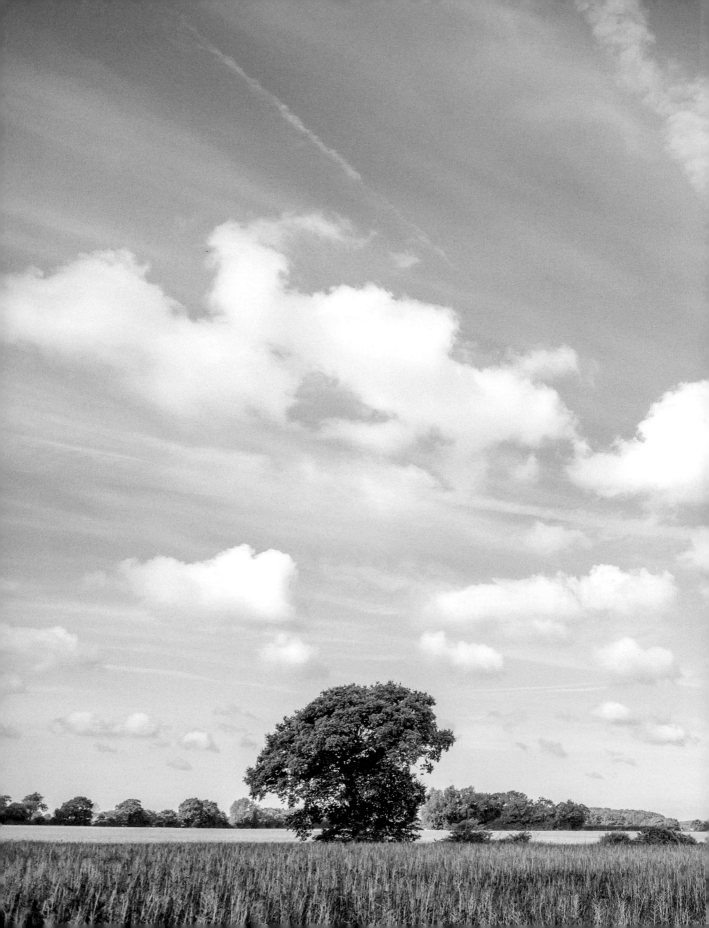

A YEAR
in the
COUNTRY

COUNTRY LIVING

HarperCollins*Publishers*

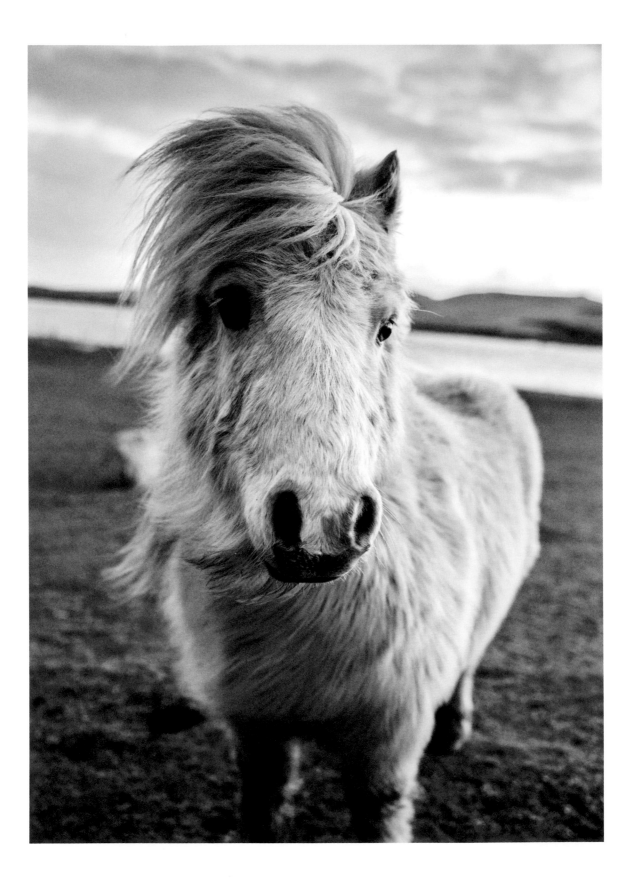

CONTENTS

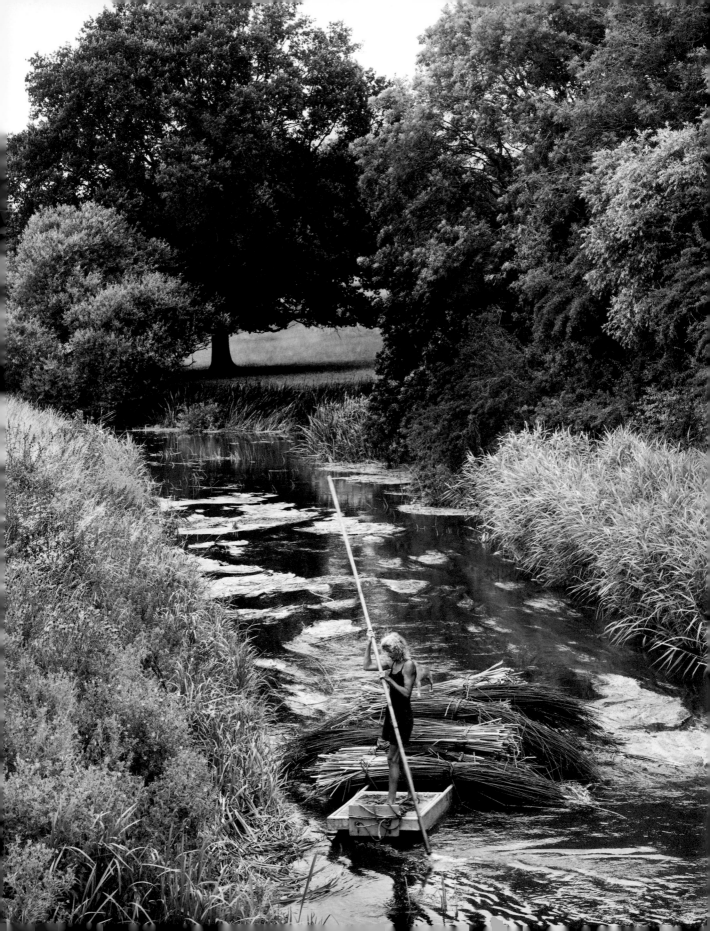

FOREWORD

Back in 2020, when we decided to compile a short series of iconic images to mark *Country Living* magazine's 35th birthday, we could never have envisaged that, less than a year later, we'd be publishing those amazing shots – and lots more besides – in this beautiful book. But really, we shouldn't have been that surprised. Over the three and a half decades that this magazine has been championing all things country, we've amassed a wealth of compelling and evocative images that shine a spotlight on the beauty and charm of life in the countryside.

Working hand in hand with our amazing family of loyal, dedicated photographers – brilliant visual narrators such as Andrew Montgomery, Alun Callender, Nato Welton and many more – we've caught on camera what we believe is a true celebration of the ever-changing seasons across the whole of the British Isles. Within these pages, you'll find candid portraits of farmers, fisherman, craftspeople and artisans going about their daily work, majestic land and seascapes, and nature in all its glory, from newborn lambs in the field to rescued ponies grazing in a woodland idyll.

Each and every photograph in this book means something special to us at Country Living. Showcasing farming, heritage crafts, community spirit, rural issues, provenance and sustainability, these images unite us in our love of country life and the inspiring beauty of the natural world that surrounds us. We hope you enjoy leafing through this book as much as we enjoyed creating it.

The Country Living Team

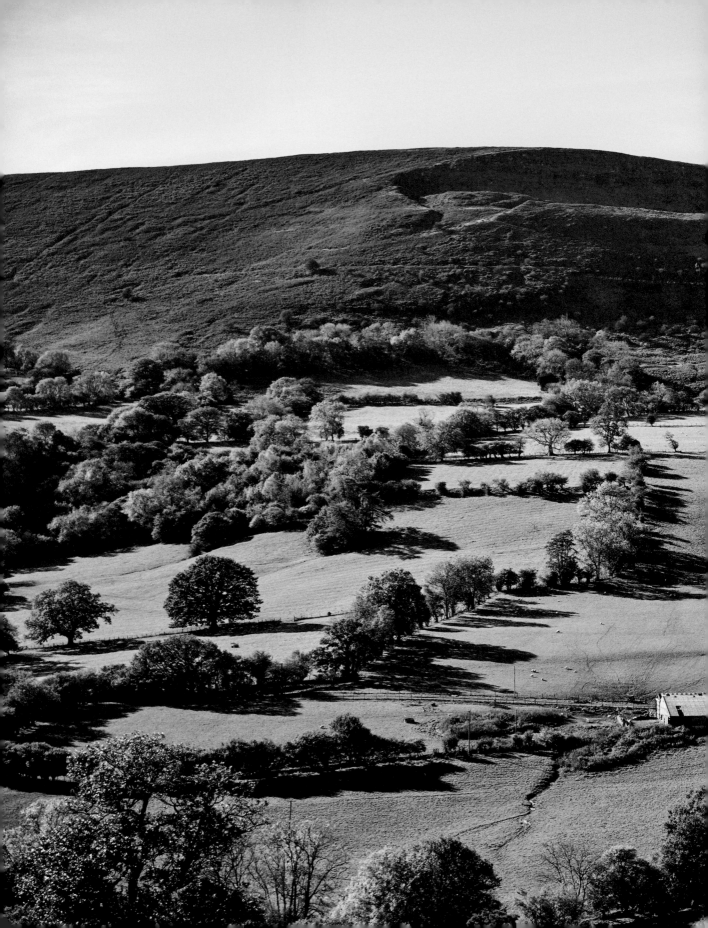

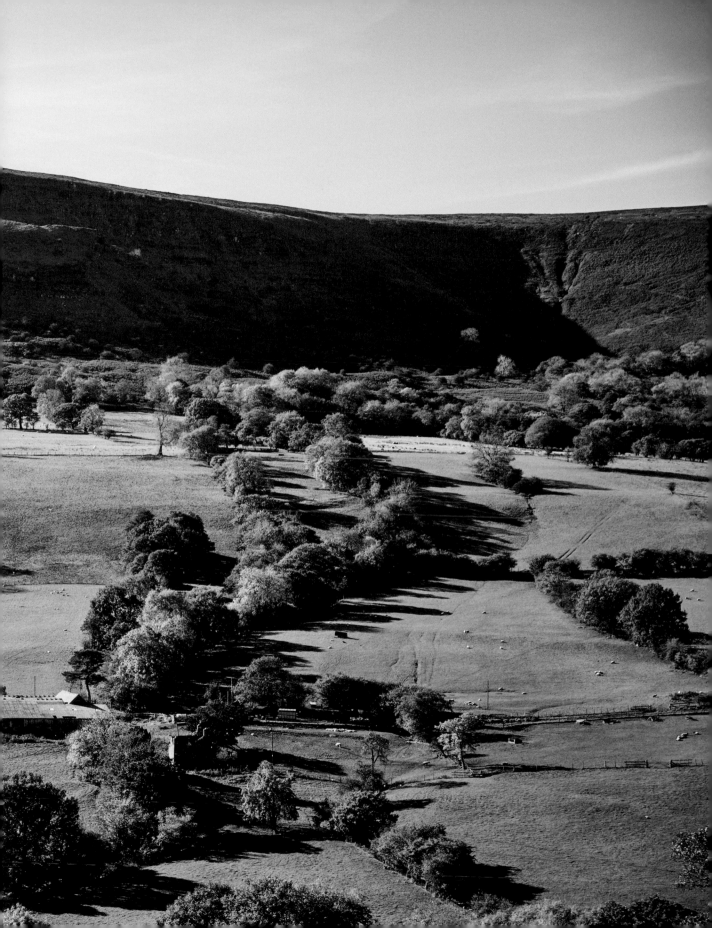

SPRING

SPRING AWAKENINGS

Like a chrysalis, over the three months of spring, the country is woken from its dormancy and gently coaxed into life. Winter has loosened her icy grip and nature, free from her grasp, re-emerges.

March begins tentatively: wild primroses and bluebells peep through the woodland floor, tempting hungry bees from their hibernation. High up in the treetops, rooks have been busy for days, rebuilding their nests with stolen twigs.

By April, more birds have returned, pouring home from warmer climes in search of a place to raise their young. Swallows, after a heroic flight from southern Africa, seek out familiar spaces in barns and old buildings. Once they've settled in, they'll raise a family for a few months in the rafters and then head back. Over the space of just a few weeks, the trees shake out their blossomy branches – blackthorn first, then wild cherry and hawthorn in quick succession. Hedgehogs, thin from their winter hibernation, begin their arduous night-time hikes from garden to garden, snuffling out earthworms and other juicy treats.

Come May, spring is overflowing – verges foam with cow parsley and golden, lanky buttercups. Pale, sunny days slide into cold nights; gardeners, impatient to start the growing season, curse the late frosts but keep on sowing. Summer, they know, is only a handful of seeds away.

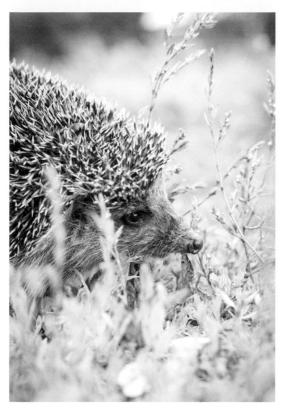
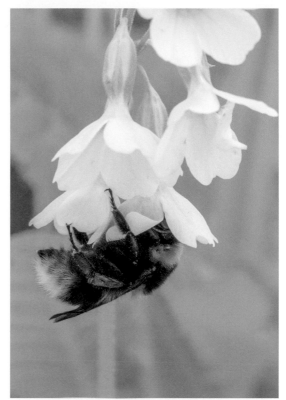
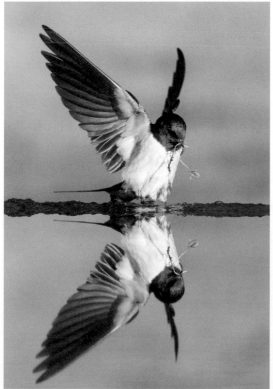
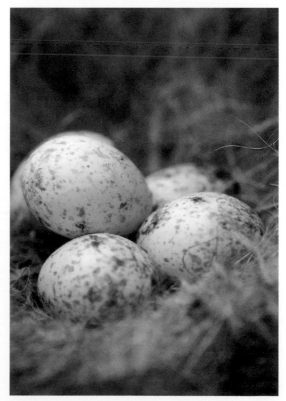

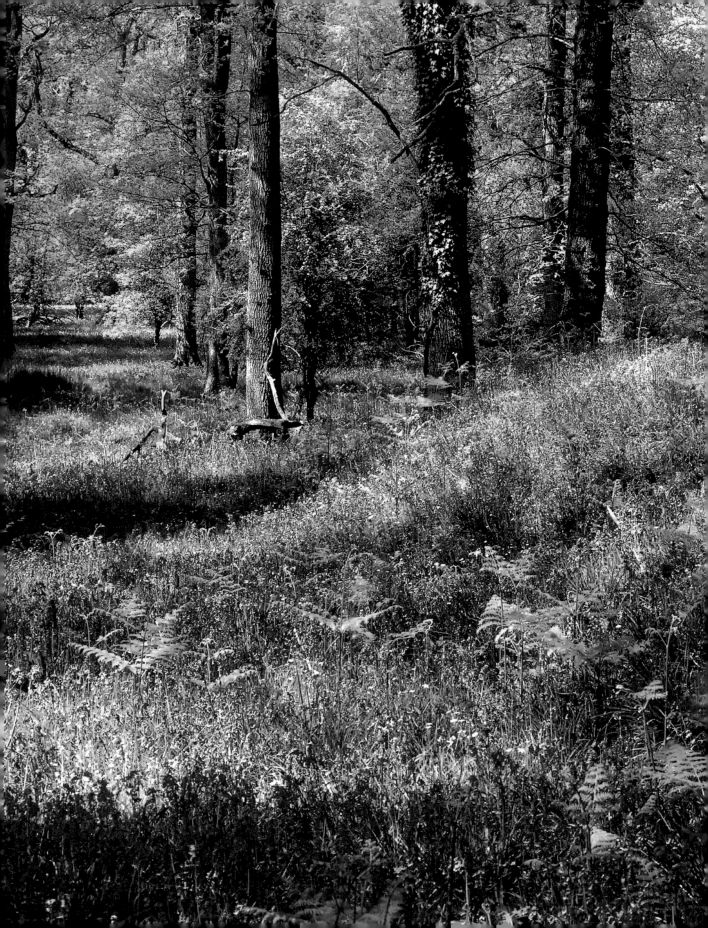

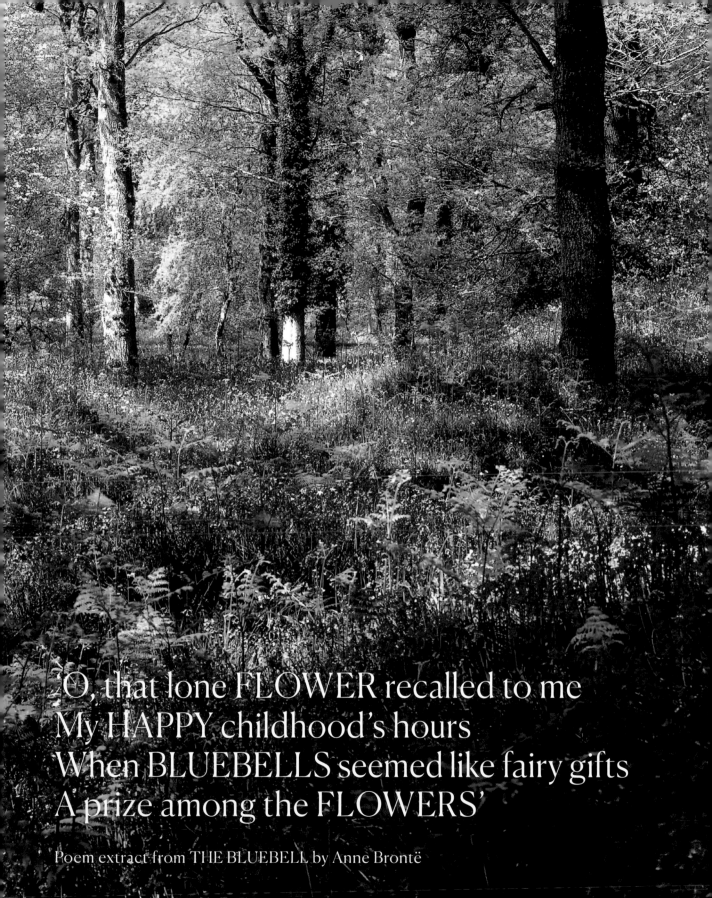

'O, that lone FLOWER recalled to me
My HAPPY childhood's hours
When BLUEBELLS seemed like fairy gifts
A prize among the FLOWERS'

Poem extract from THE BLUEBELL by Anne Brontë

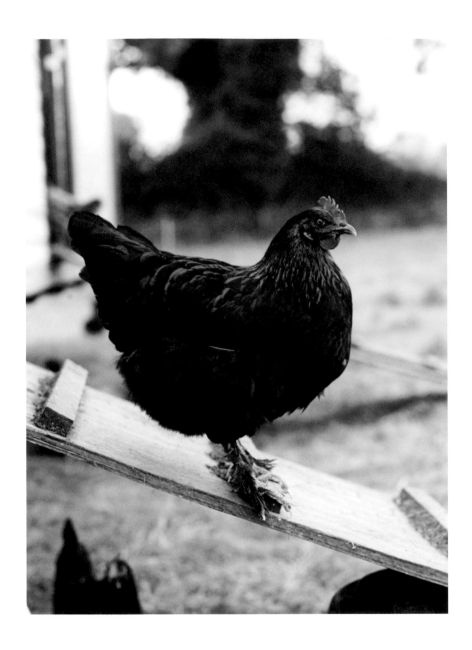

GOOD EGGS photographed by Andrew Montgomery, 2018

At Blackacre Farm in Sparkford Vale, Somerset, farmers Dan and Briony Wood produce premium free-range eggs and also distribute duck, geese and quail eggs for small local farms, promoting animal welfare and enabling sustainable farming methods in the process. Hens that lay eggs for them are kept in traditional 'flat-deck' systems – single-storey hen houses – with all-day access to the outdoors. 'All our hens have bright red rings around their eyes, a sign that they are healthy and get plenty of natural light,' says Briony.

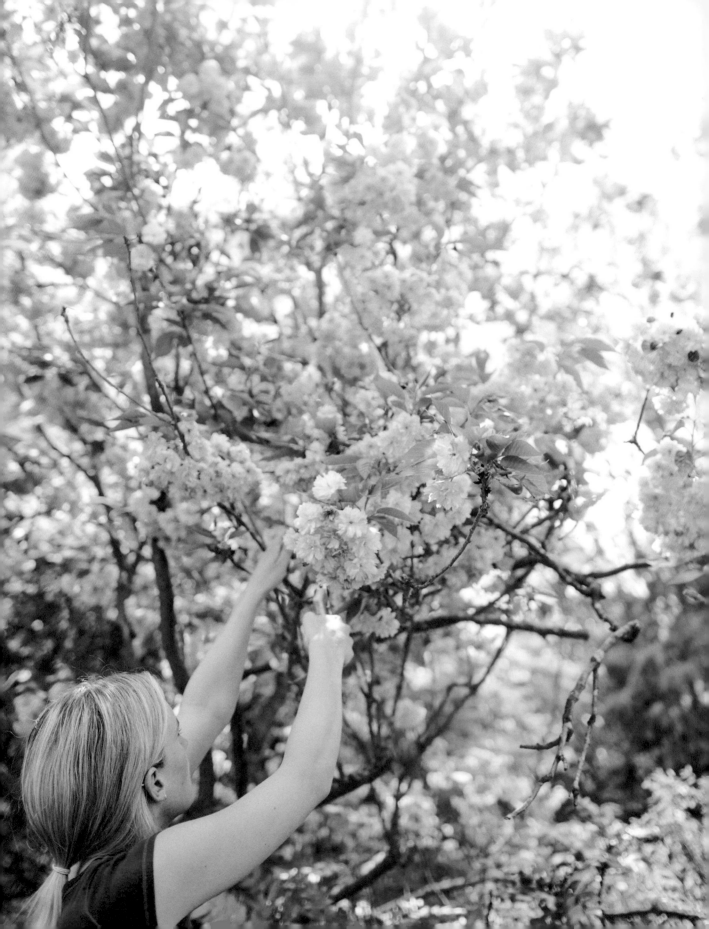

Few sights in the BRITISH countryside are as uplifting and EVOCATIVE as boughs heavy with spring blossom. TREES bursting with pale-pink puffballs of CHERRY blossom can last until early May when BREEZES finally turn the petals into soft drifts of natural confetti.

A PROMISE OF SPRING photographed by Brent Darby, 2019

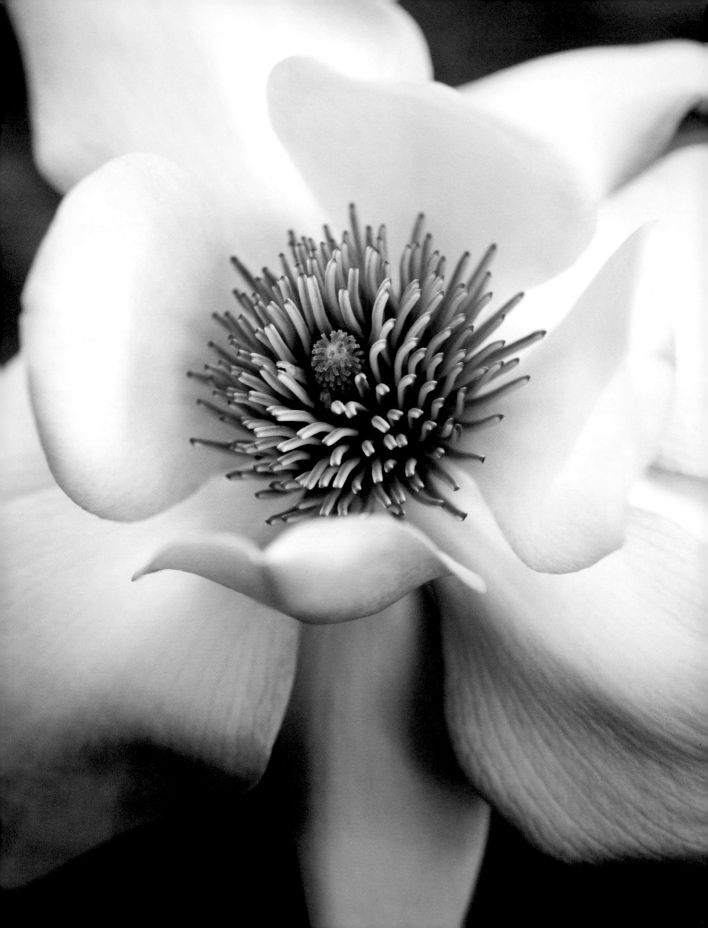

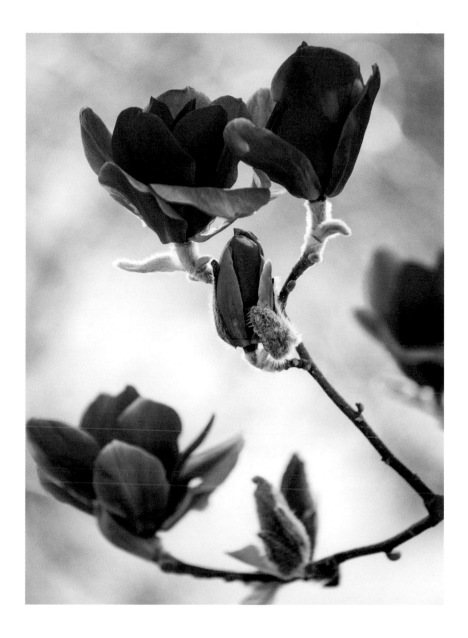

THE MAGNIFICENT MAGNOLIA photographed by Richard Bloom, 2020

A magnolia in full bloom is one of the glories of spring, whether it's a mature tree festooned with large, cup-shaped flowers or a compact shrub smothered in starry blossom. The profusion of flowers all but hides the leafless branches, in colours that range from purest white through creams and yellows to every shade of pink, rich reds and purples. There is nothing subtle about this performance. At a time when the rest of the garden is stirring into life, the magnolia is putting on a stunning display that guarantees it centre stage.

UNDER THE BLOSSOM BOUGH photographed by Brent Darby, 2018

'Getting this shot was a lesson in patience,' says photographer Brent. 'I'd set it up early in the day but it was looking a little colourless and drab, so we decided to leave it and come back to it later. As the sun climbed higher, the backlighting suddenly made the whole scene glow beautifully. It just goes to show that biding your time can bring the most rewarding results (although it can also bring rain!).'

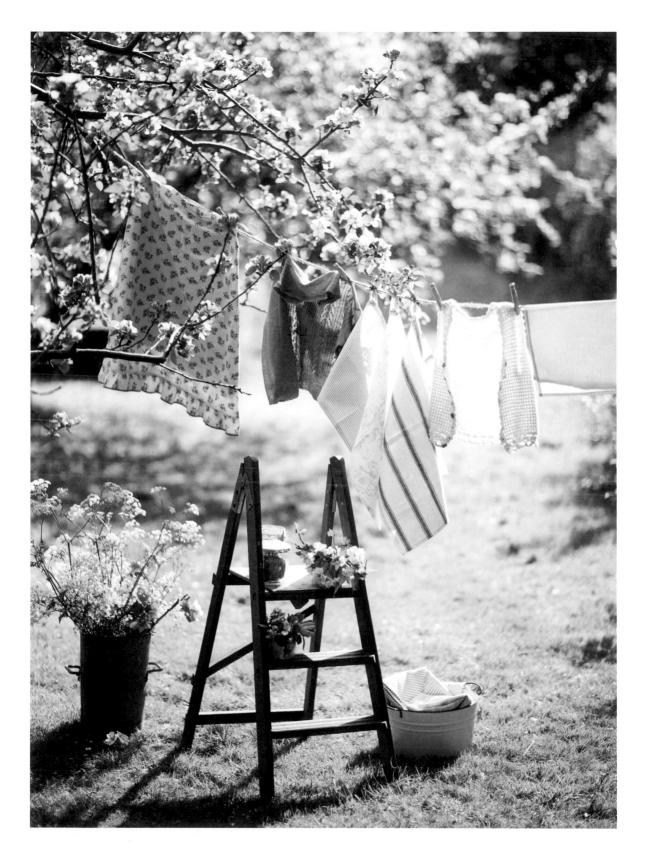

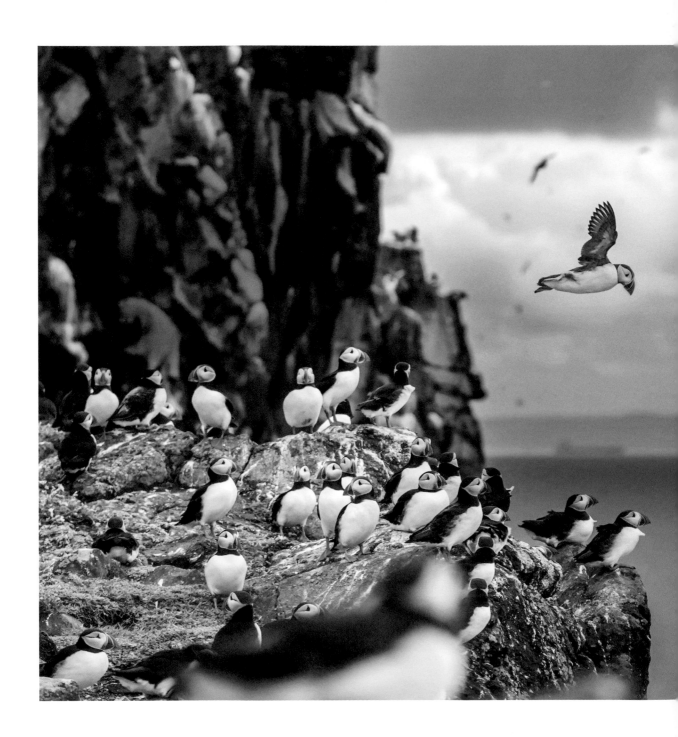

Spotters' guide...
PUFFIN

April onwards is the best time to catch the teeming puffin colony on the Isle of May National Nature Reserve. It's a noisy spectacle, with up to 90,000 of these bright-billed seabirds returning from the open sea, where they have been since August, to breed among the clifftops of this rocky outcrop anchored on Scotland's Firth of Forth. Puffins lay only a single egg, incubated by both parents who also share feeding duties until the chick is ready to fledge.

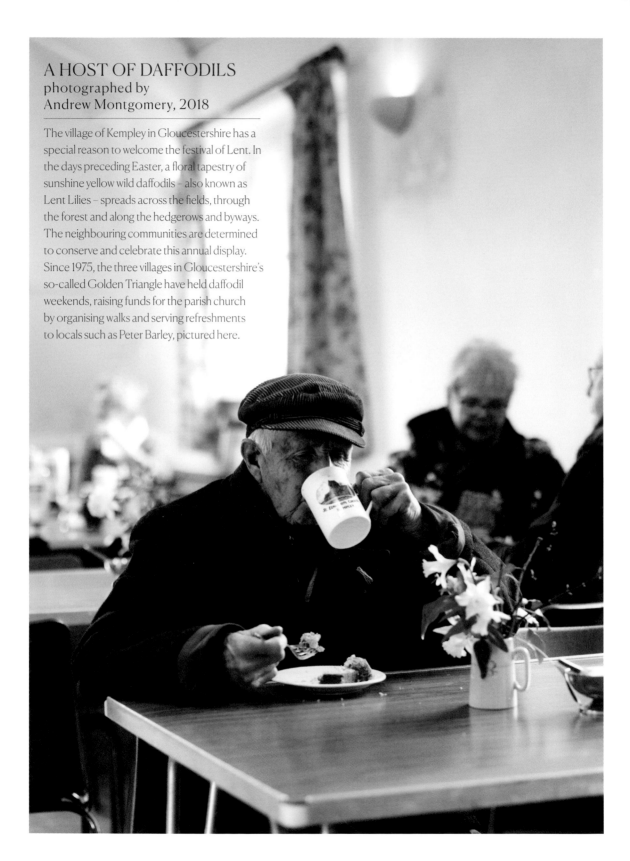

A HOST OF DAFFODILS
photographed by
Andrew Montgomery, 2018

The village of Kempley in Gloucestershire has a special reason to welcome the festival of Lent. In the days preceding Easter, a floral tapestry of sunshine yellow wild daffodils – also known as Lent Lilies – spreads across the fields, through the forest and along the hedgerows and byways. The neighbouring communities are determined to conserve and celebrate this annual display. Since 1975, the three villages in Gloucestershire's so-called Golden Triangle have held daffodil weekends, raising funds for the parish church by organising walks and serving refreshments to locals such as Peter Barley, pictured here.

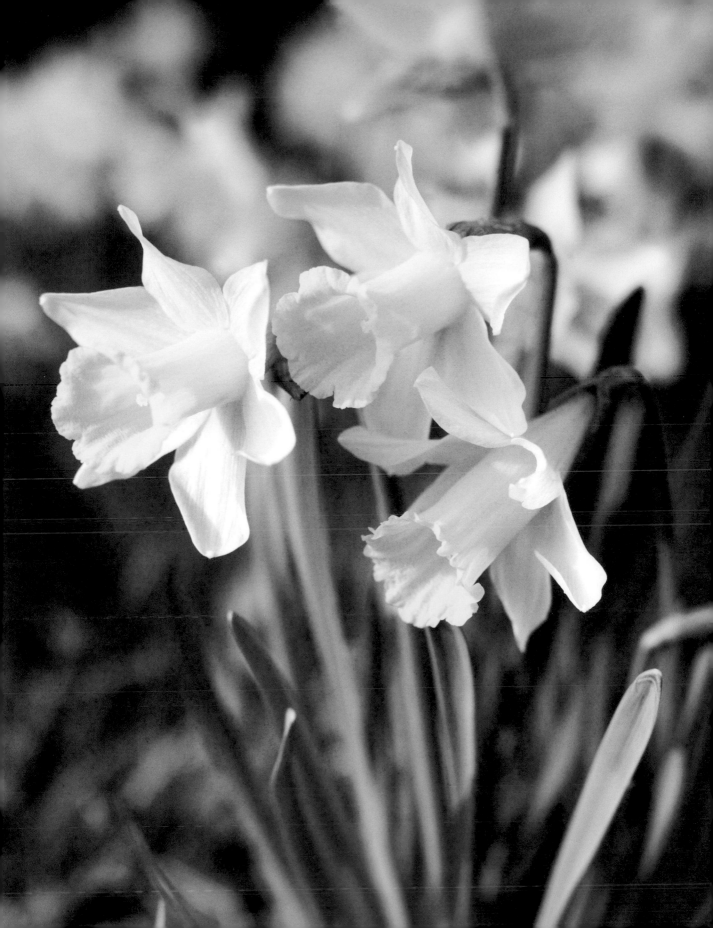

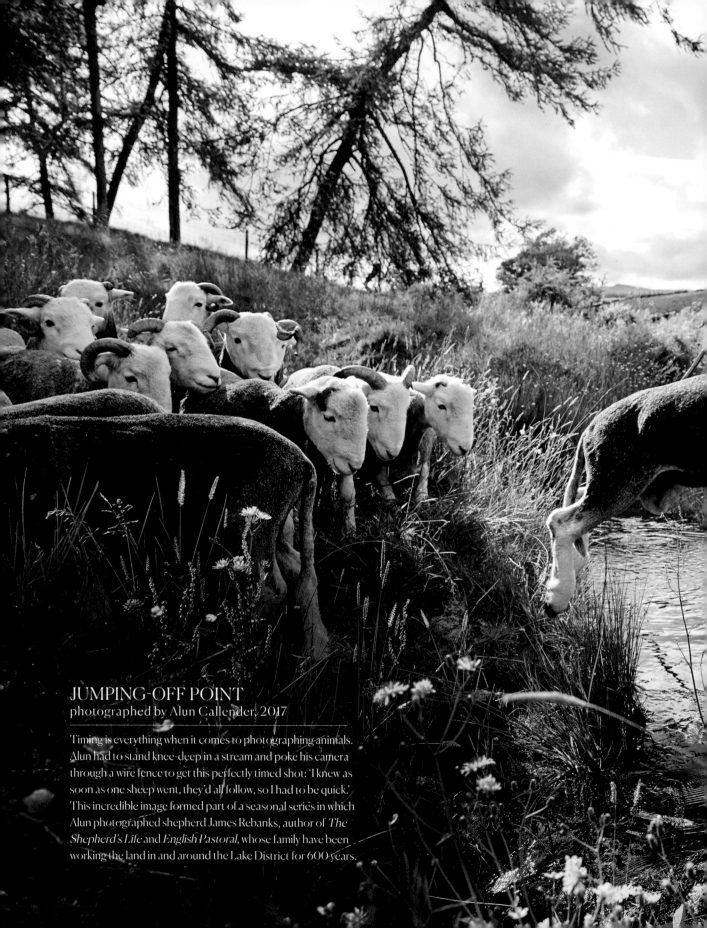

JUMPING-OFF POINT
photographed by Alun Callender, 2017

Timing is everything when it comes to photographing animals.
Alun had to stand knee-deep in a stream and poke his camera
through a wire fence to get this perfectly timed shot: 'I knew as
soon as one sheep went, they'd all follow, so I had to be quick.'
This incredible image formed part of a seasonal series in which
Alun photographed shepherd James Rebanks, author of *The
Shepherd's Life* and *English Pastoral*, whose family have been
working the land in and around the Lake District for 600 years.

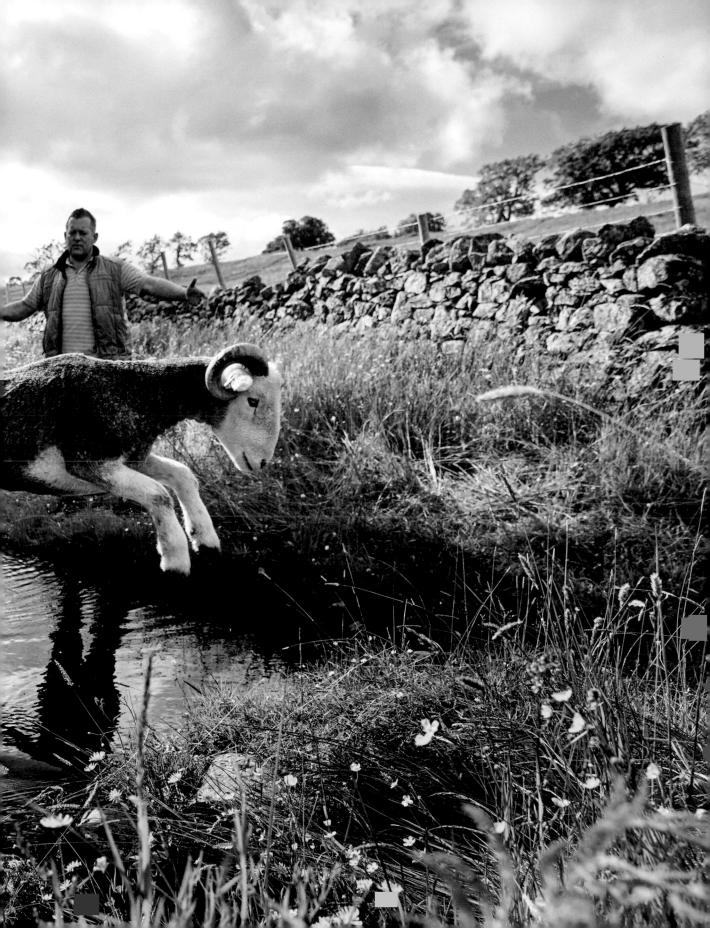

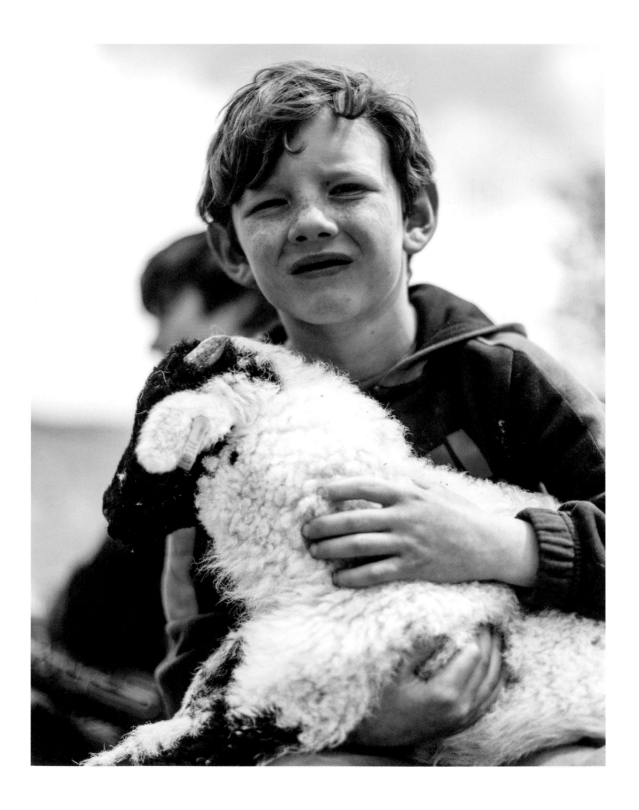

SIDNEY is one of Yorkshire SHEPHERDESS Amanda Owen's nine children, and LAMBING season means everyone mucks in. 'The kids were so hands-on with the ANIMALS,' photographer Chris says. 'This was an ORPHAN lamb the children had RAISED, so they were at ease with each other.'

MY FAMILY AND OTHER ANIMALS photographed by Chris Terry, 2020

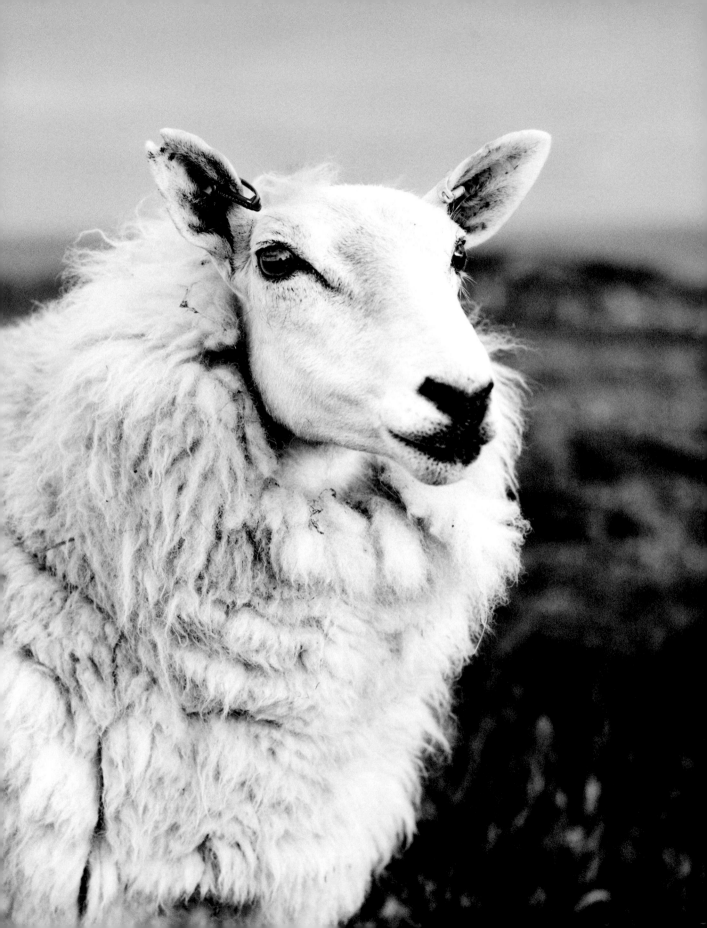

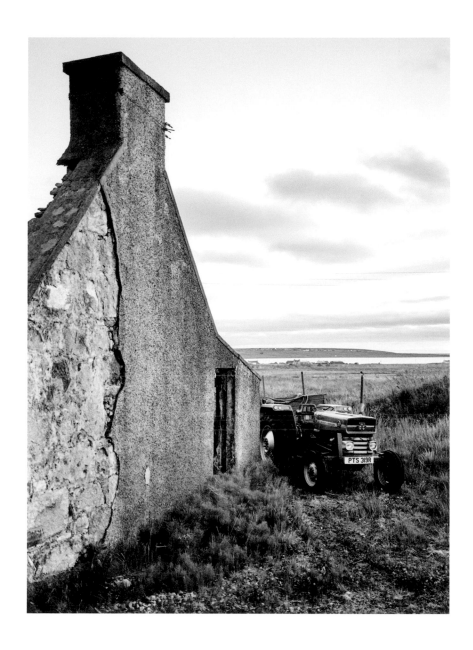

CROFT WORK photographed by Andrew Montgomery, 2021

Twenty-five-year-old crofter Donald MacKinnon, whose ancestors were crofter-weavers for Harris Tweed, raises his flock of Cheviots and Blackface sheep on inbye land (green grass) and shared common grazing land at Arnol on Lewis' west coast. Vice-chair of the Scottish Crofters Association, Donald lobbies the government on crofting policy. 'I feel connected to the land and the way of life,' he says. 'The land is different from how it would be if it was left to its own devices, and it's up to us, after changing it, to maintain it.'

SPRING GEM photographed by Richard Bloom, 2020

Early spring is a very special season at The Lyndalls, an enchanting wooded garden in a remote Herefordshire valley. While some gardeners might be content with a sprinkling of snowdrops either side of a path and a few hellebores around a tree, owner Stuart Donachie pulls out all the stops. His sparkling showstoppers include *Iris reticulata* 'Frank Elder', which has pale-blue veined flowers with a flush of yellow.

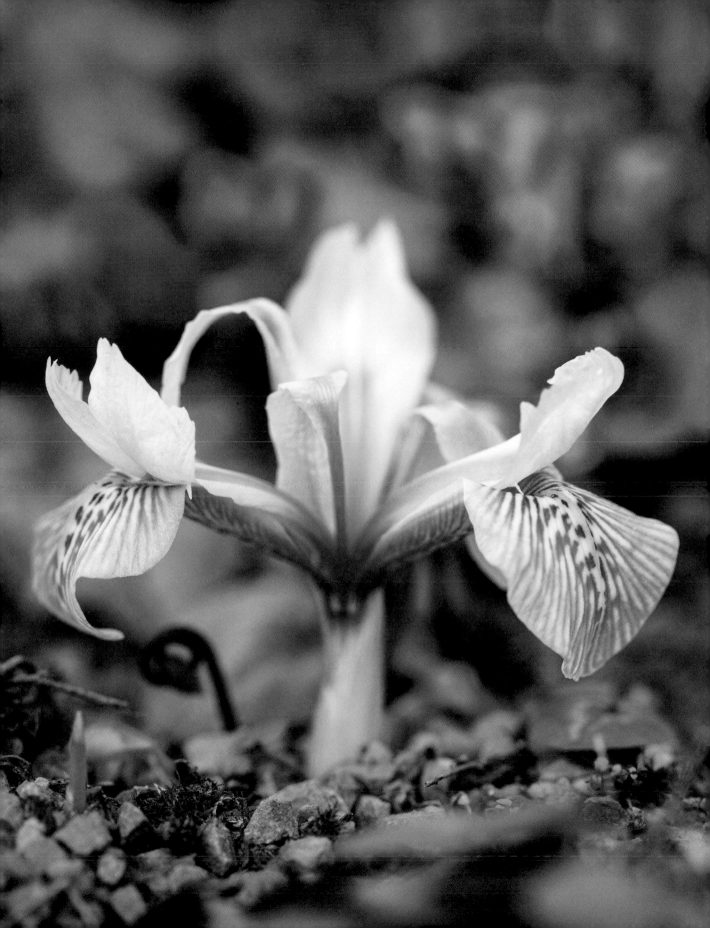

After spending the night on COASTAL pastures washed with salt spray, the DAIRY herd from Gubbeen farm, near the little harbour of Schull, in West Cork, are brought in for MILKING by Andrew Brennan along the narrow, hedged lanes of the ANCIENT Cow's Road.

PARLOUR MAIDS photographed by Andrew Montgomery, 2011

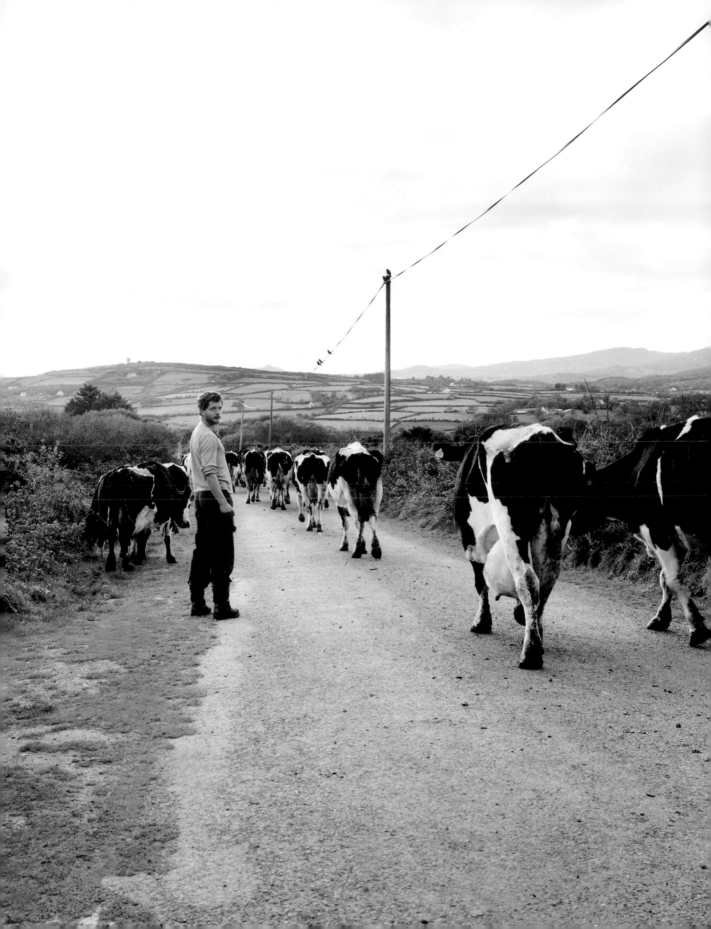

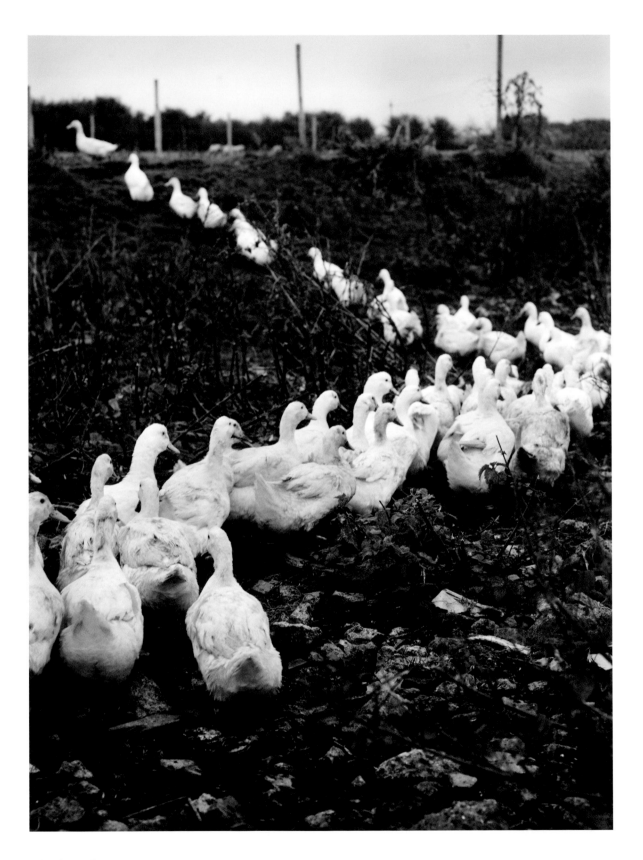

FOLLOW THE LEADER
photographed by Andrew Montgomery, 2018

At 7am each morning, Dan Wood goes to feed his flock of 120 Embden geese, kept a few hundred metres from his home in the Sparkford Vale, Somerset. Big, white-feathered and fond of a kerfuffle, they start humming and honking as soon as they hear him come into their field. 'I let them out of their overnight pen, scatter wheat for their breakfast and they dive in,' says Dan, who feels that watching his flock enjoy their first meal is the best start to his day. When it's goose egg season – from the end of February to July – he gathers up any newly laid eggs.

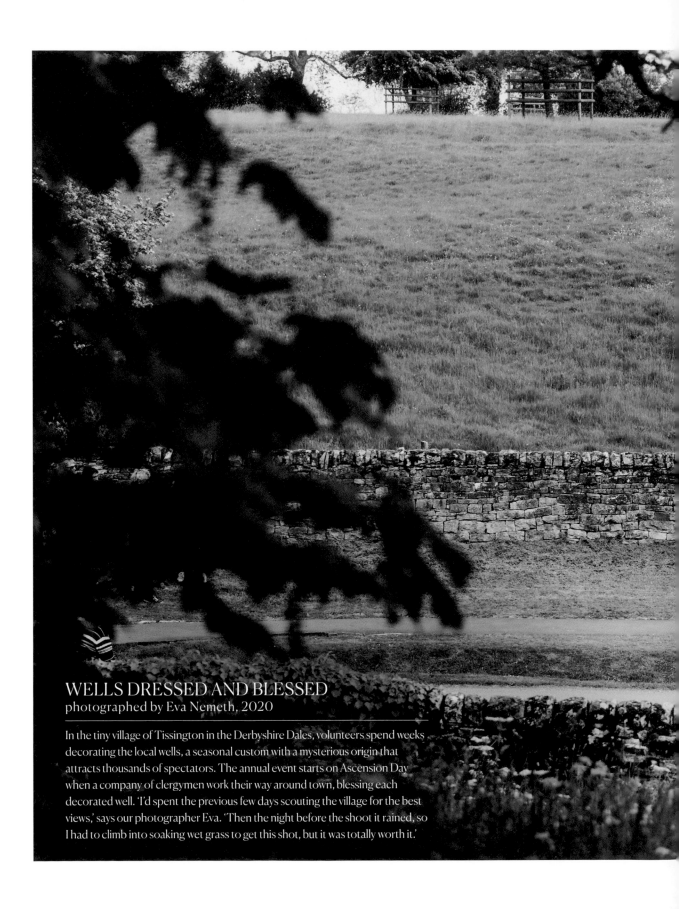

WELLS DRESSED AND BLESSED
photographed by Eva Nemeth, 2020

In the tiny village of Tissington in the Derbyshire Dales, volunteers spend weeks decorating the local wells, a seasonal custom with a mysterious origin that attracts thousands of spectators. The annual event starts on Ascension Day when a company of clergymen work their way around town, blessing each decorated well. 'I'd spent the previous few days scouting the village for the best views,' says our photographer Eva. 'Then the night before the shoot it rained, so I had to climb into soaking wet grass to get this shot, but it was totally worth it.'

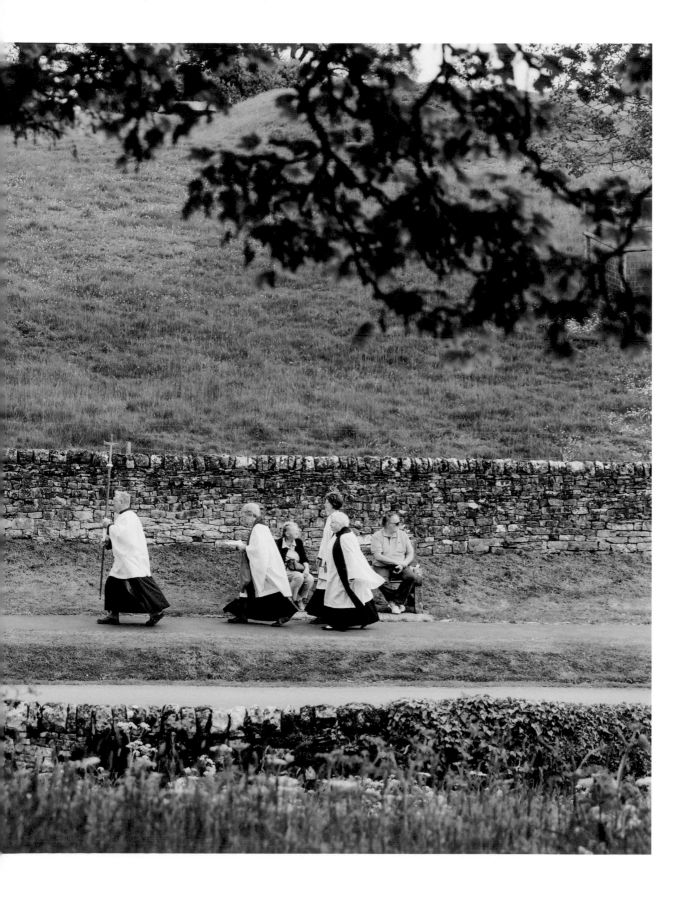

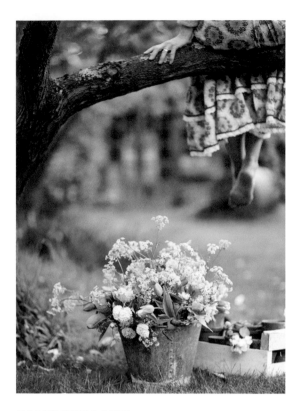

BUCKET LIST
photographed by Brent Darby, 2018

Informal containers, such as old watering cans, weathered terracotta pots and buckets, look at their best filled with a mix of cow parsley, blossom and flowers freshly picked from the burgeoning spring garden.

COUNTRY STYLE photographed by Brent Darby, 2018

'I like to keep things as spontaneous as I can,' says photographer Brent. 'It probably looks hilarious – a grown man with a camera chasing children chasing chickens – but that's what it took to get this wonderfully candid shot.'

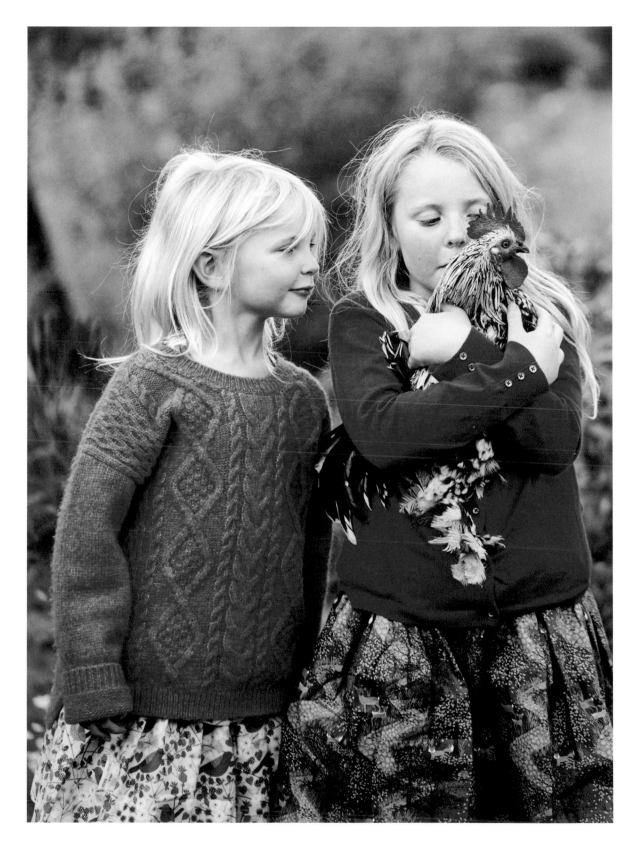

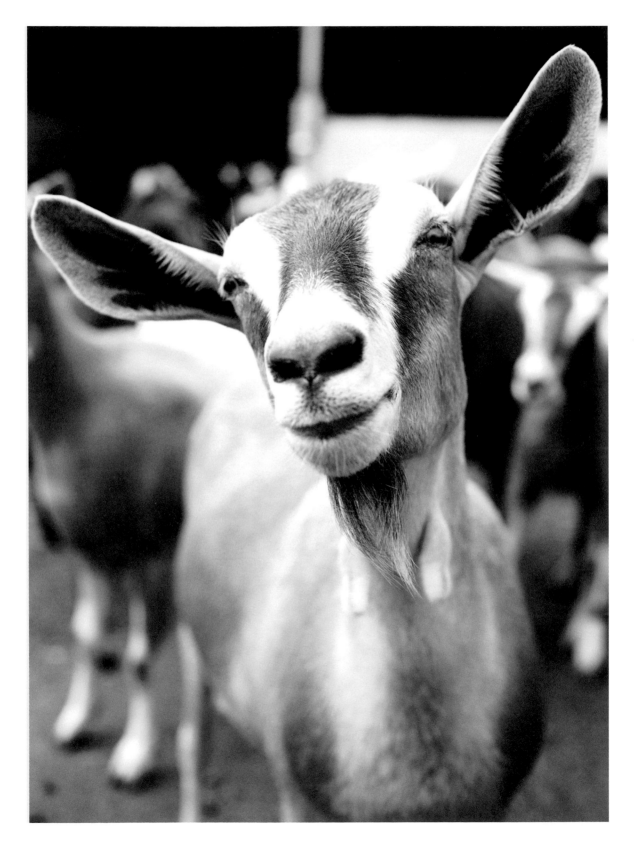

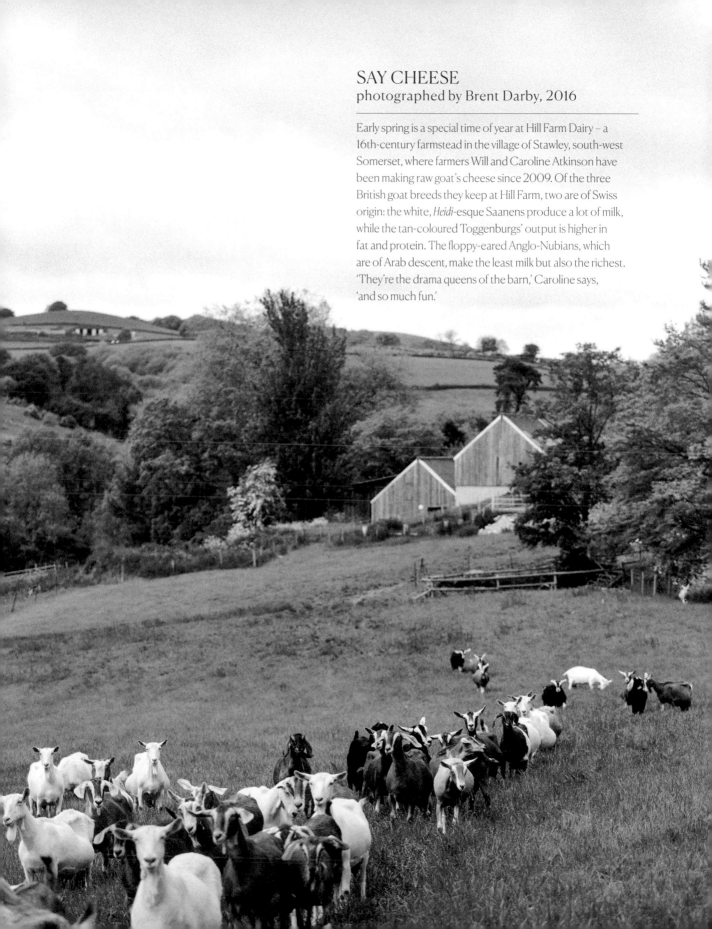

SAY CHEESE
photographed by Brent Darby, 2016

Early spring is a special time of year at Hill Farm Dairy – a 16th-century farmstead in the village of Stawley, south-west Somerset, where farmers Will and Caroline Atkinson have been making raw goat's cheese since 2009. Of the three British goat breeds they keep at Hill Farm, two are of Swiss origin: the white, *Heidi*-esque Saanens produce a lot of milk, while the tan-coloured Toggenburgs' output is higher in fat and protein. The floppy-eared Anglo-Nubians, which are of Arab descent, make the least milk but also the richest. 'They're the drama queens of the barn,' Caroline says, 'and so much fun.'

discover...

DUNNOTTAR CASTLE

On a rocky headland reaching out into the North Sea, this medieval fortress has been pivotal in a number of significant events, from the Wars of Independence in the 13th century to Oliver Cromwell's Scottish invasion in 1651. Although the surviving buildings date from the 15th and 16th centuries, it's thought the site was first fortified as far back as the Early Middle Ages.

DUNNOTTAR CASTLE, NEAR STONEHAVEN, ABERDEENSHIRE

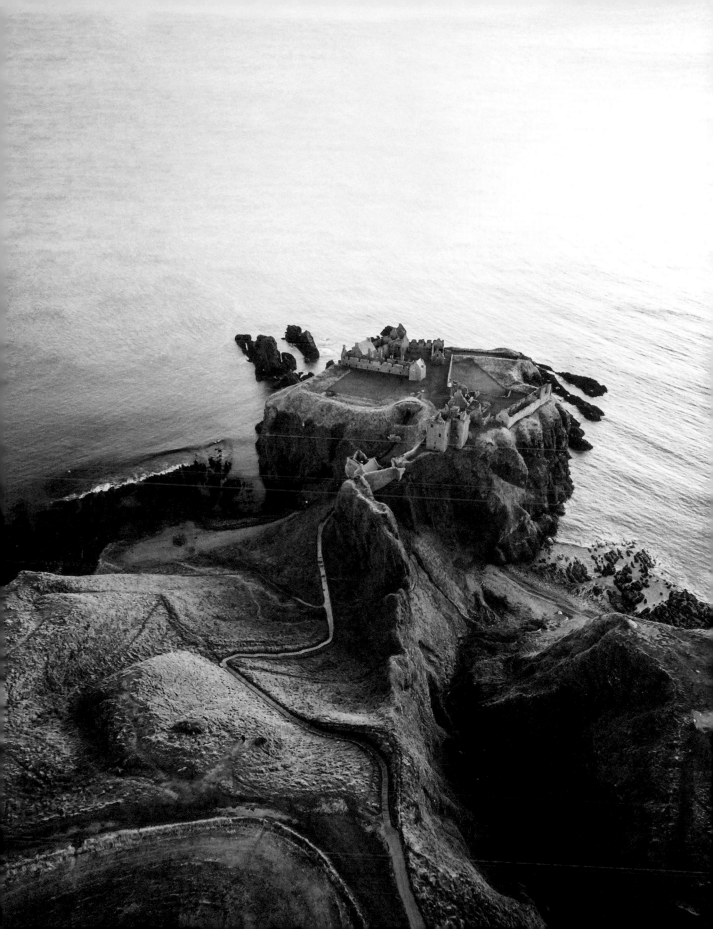

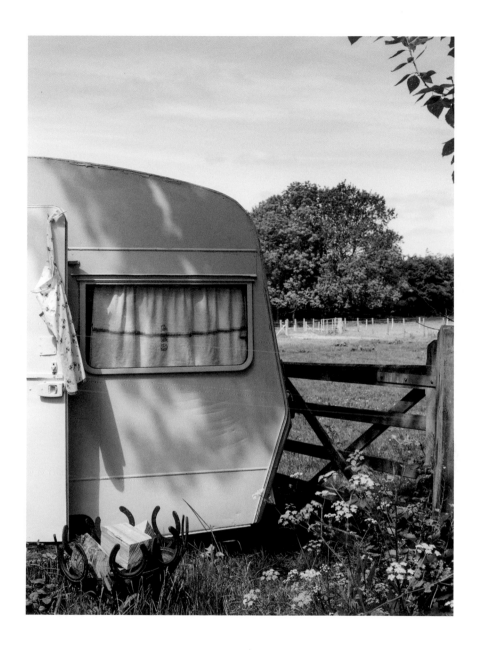

OFF THE BEATEN TRACK photographed by Eva Nemeth, 2019

The Beanstalk Tea Garden, set along an old coach road through the South Downs National Park, is the perfect place to stop and enjoy the peace and tranquillity of the English countryside. Winding paths are cut through swathes of cow parsley leading to secluded tables set with pretty vintage china and embroidered tablecloths. 'I fell in love with this little caravan when I was shooting there,' says Eva. 'It was a really sunny day, which can create challenging conditions for a photographer, but this shot perfectly captured that spring feeling.'

DUCKS belonging to Hannah Storton and Henry Knowles, founders of the Docker Duck Egg Company in CUMBRIA, waddle around joyfully, JUMPING in and out of the stream and CACKLING at top volume.

DUCK TALES photographed by Andrew Montgomery, 2019

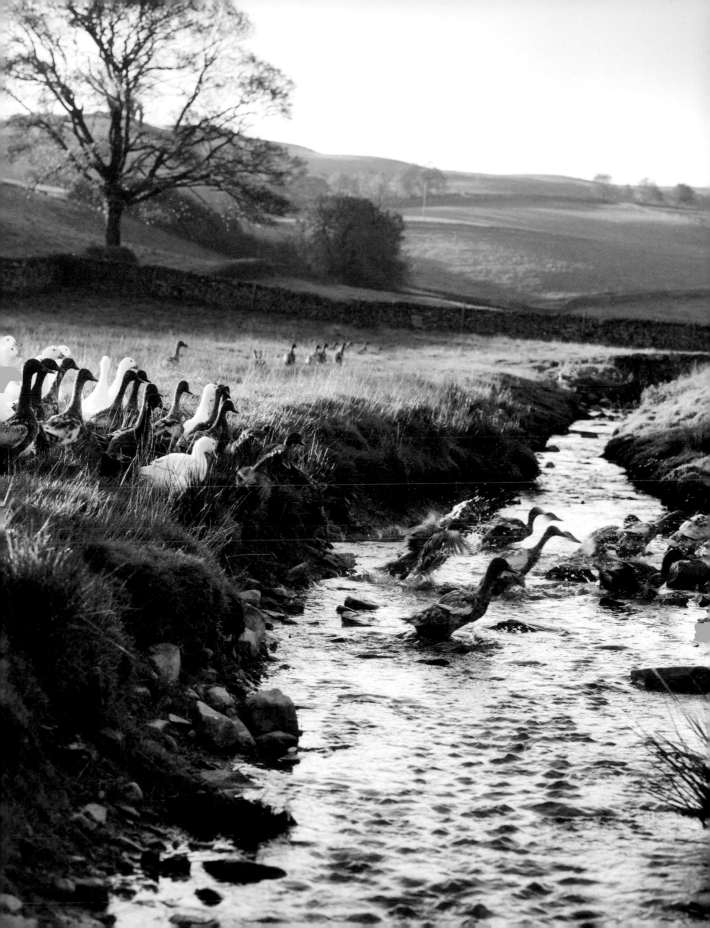

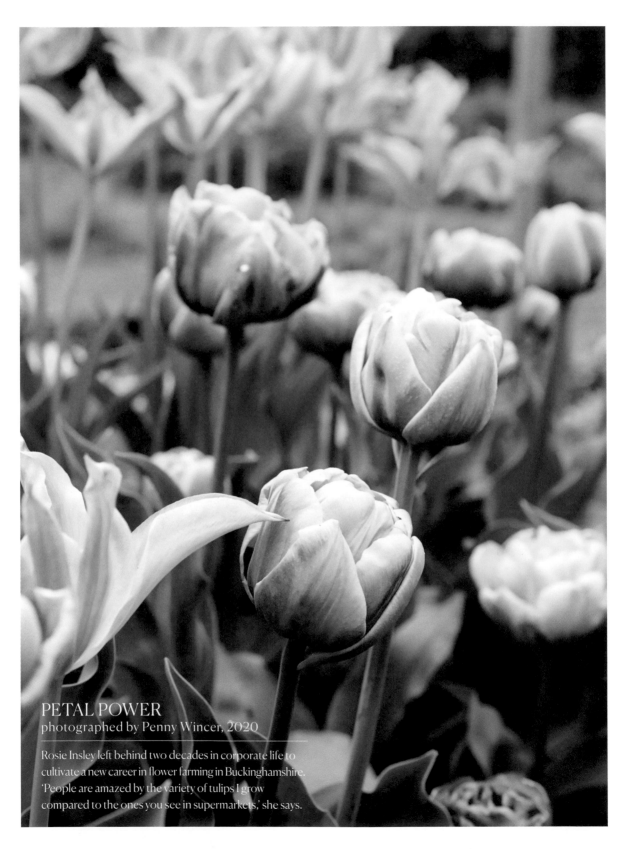

PETAL POWER
photographed by Penny Wincer, 2020

Rosie Insley left behind two decades in corporate life to cultivate a new career in flower farming in Buckinghamshire. 'People are amazed by the variety of tulips I grow compared to the ones you see in supermarkets,' she says.

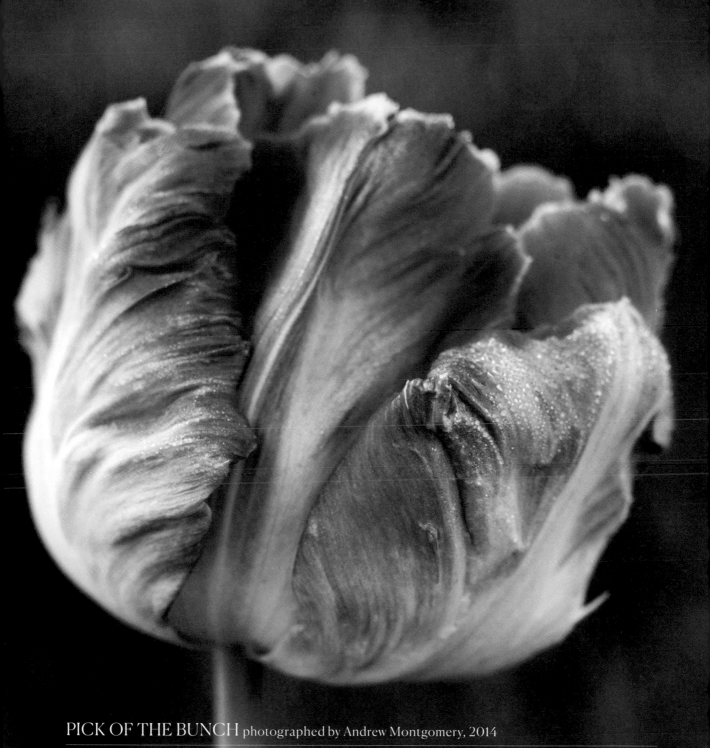

PICK OF THE BUNCH photographed by Andrew Montgomery, 2014

Back in 2011, Andy and Tish Jeffrey turned a corner of their Somerset dairy farm into Britain's first pick-your-own tulip field. In April and May, the plot, in the village of Farrington Gurney, is striped with blooms, from the palest sherbet to the deepest blackcurrant. And these are not just common tulips either: here you'll find ragged-edged parrot varieties, like this pink-flushed *Tulipa* 'Libretto Parrot', alongside showy peonies with their double crowns, and the elegant Champagne-flute-like heads of lily-flowering ones.

EBONY AND IVORY
photographed by Andrew Montgomery, 2017

Just a few months before Andrew took this beautiful, serene photograph, these two ponies were in a sorry state, having been found untended, thin and weak. They were restored to health at Jenny MacGregor's haven for mistreated horses in Monmouthshire, south Wales. Jenny sadly died in 2017, shortly after this feature was first published, having devoted more than 40 years of her life to saving abused and abandoned equines.

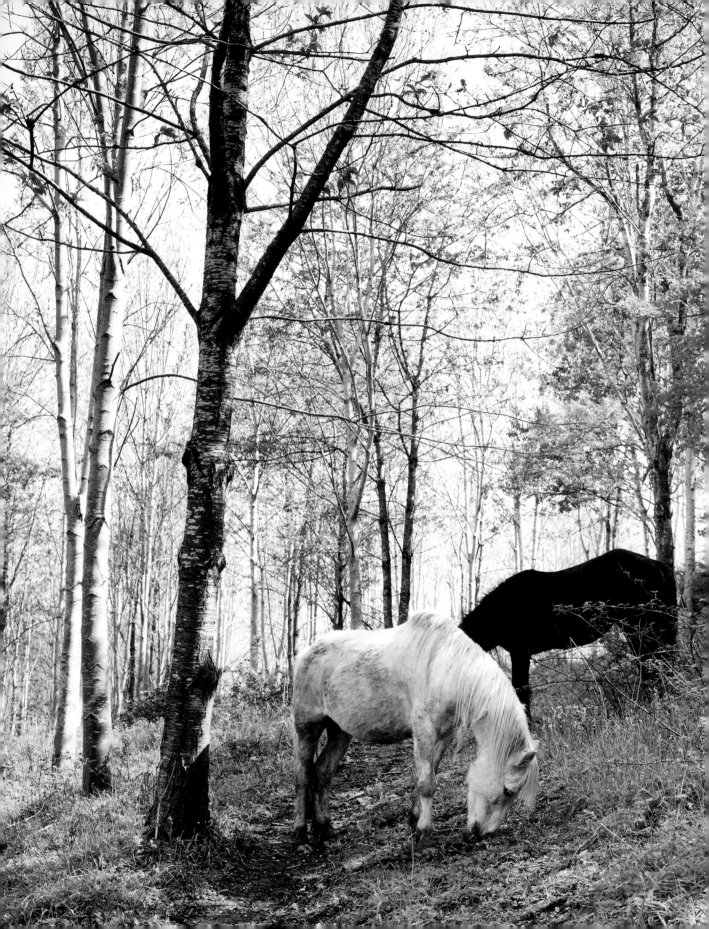

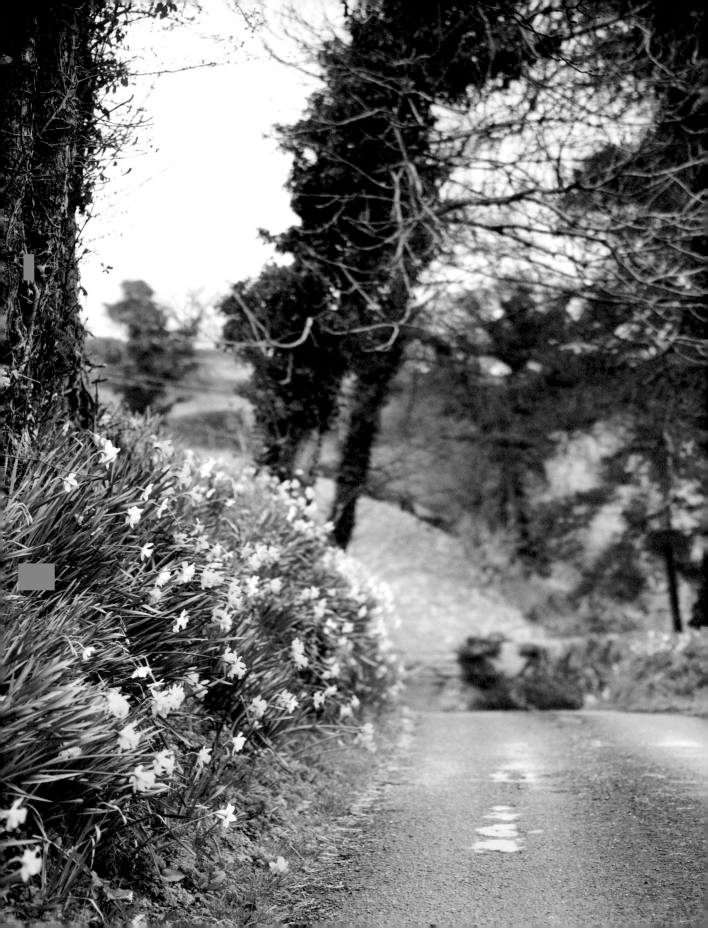

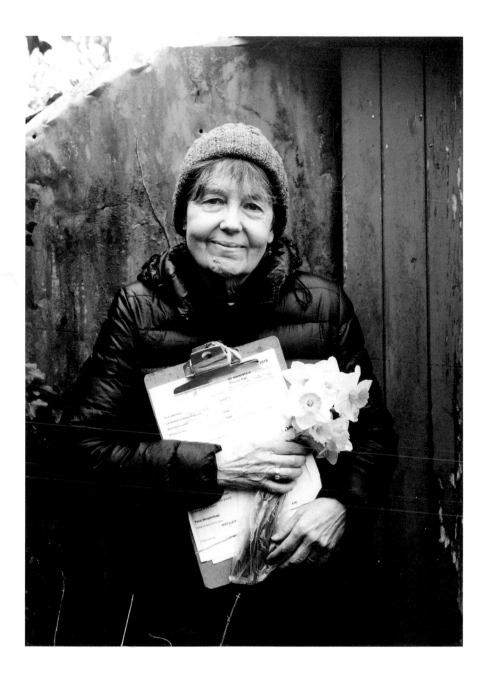

THE DAFFODIL DETECTIVE photographed by Andrew Montgomery, 2020

Andrew followed members of the Heralds of Spring project in Devon's Tamar Valley as, armed with nothing more than a clipboard and tape measure, they search for and catalogue the rare daffodils and narcissus that sprout up every spring. Looking for clues with a scientific eye, and measuring and photographing each species they find, Marlene Harris (above) and her fellow volunteers have discovered more than 100 'new' old varieties, sparking renewed interest and pride in local history and the region's floral legacy.

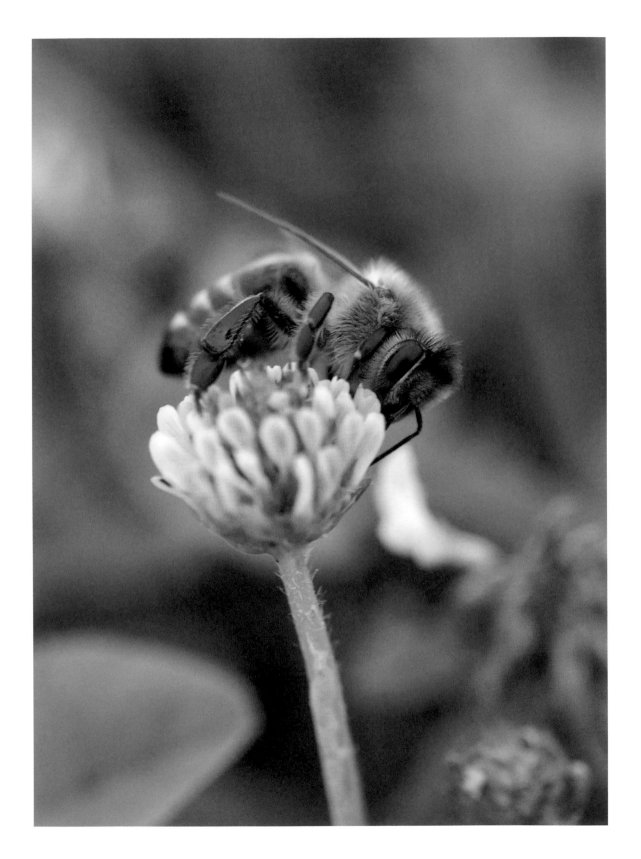

The humble honey BEE is worth her weight in gold. With populations declining, she can be ATTRACTED into your spring garden with plenty of shallow flowers where the NECTAR is easy to access, such as CLOVER, lavender, salvia and BUDDLEIA.

Extract from GIVE BEES A CHANCE Country Living wildlife campaign, 2018

MOTHERLY LOVE photographed by Alun Callender, 2017

For James Rebanks, the most important season of the shepherding year is when he welcomes the latest members of his flock. These fell lambs are born with their thick wool jackets on, ready, at just an hour old, for snow and rain and howling wind. They are jet-black everywhere – except their ears, which are snow white. 'Each family of ewes in my flock is a long, ongoing story and every lamb is like a new chapter in an old book,' says James.

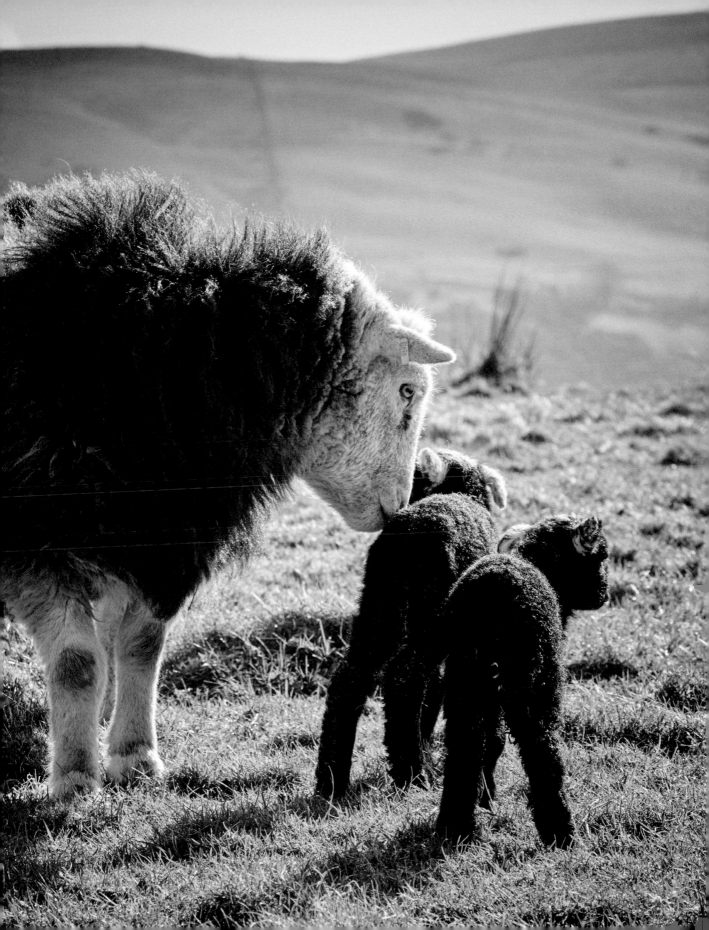

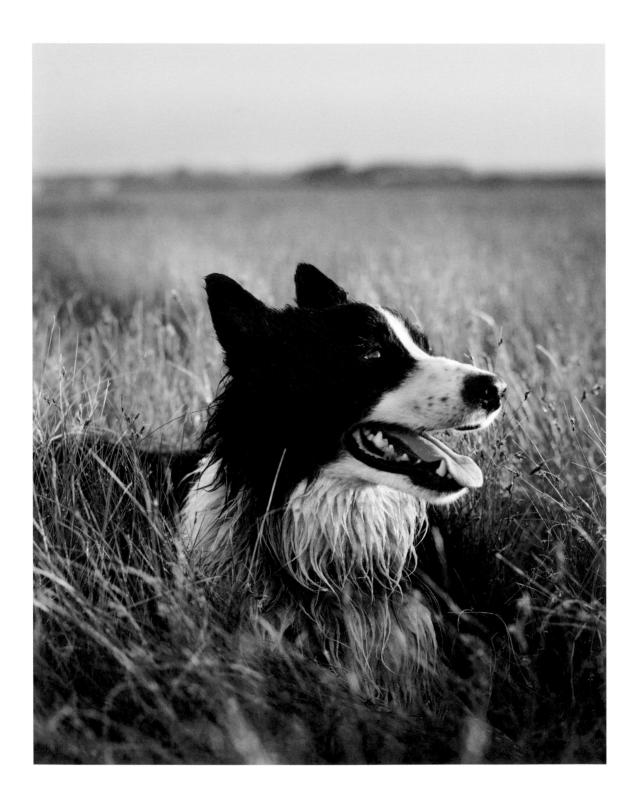

At Becket Barn Farm on the GRASSLANDS of Kent's Romney Marsh, LAMBING is the busiest time of year. For three weeks from 1 April, farmer Howard Bates is out tending his flock from DAWN until dusk, with help from his Border COLLIE sheepdog Brack.

HERD INSTINCT photographed by Andrew Montgomery, 2018

A BIRD IN THE HAND photographed by Andrew Montgomery, 2018

West Country poultry farmer Dan Wood with a quail from his flock. His Traditional Free Range Egg Company has won awards for its Foraging Free Quail Eggs. 'The market for speciality eggs is growing, and we want to be at the forefront,' says Dan.

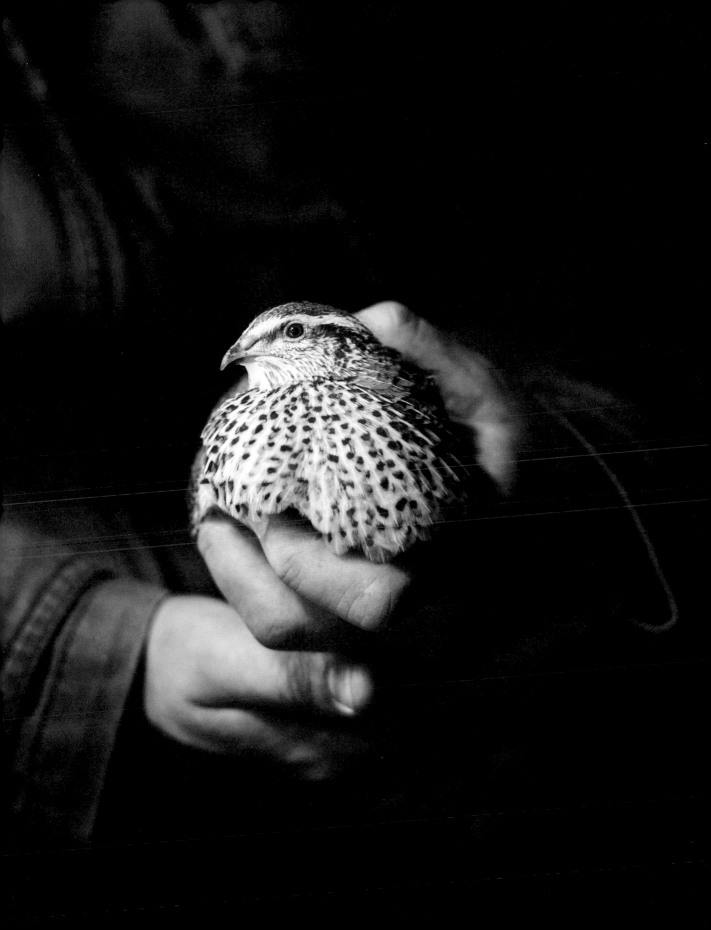

SUMMER

SUMMERTIME JOYS

Early June rarely feels like summer: the last vestiges of chill breezes and wet afternoons linger on. And yet, warm days are close at hand – at first just the odd day and then two, three, four in a row. The trees are laden with luminously new leaves, casting shade for the first time in months.

Honeysuckle, dog roses and elderflowers, with their muted, sweet scent, overrun the hedgerows. The nights are short – moths, owls and bats have to be quick to catch the darkness, often finding themselves slipping into dusk and dawn to make up for lost time.

July burns out June, with her glorious cloudless skies and early starts. The occasional scorching day takes everyone by surprise, not least the garden birds who seek shelter under the bushes and take turns at the birdbath. In the chicken run, the hens lounge listlessly in the dust, one wing outstretched like sun worshippers on a distant beach. The sheep crowd under the only tree in the field, a large, broken oak that casts a welcome shadow.

By August, the fields are alive with combine harvesters. Farmers watch the skies, waiting for the perfect fortnight that never quite comes. Expanses of golden waves are turned into stubble, scattered with dropped grains and flocks of greedy birds. Meanwhile, back in the vegetable plot, things have got out of hand. Everything's up at once, demanding attention, before sitting back down and going to seed. Even roadsides, with their blackberries and elderberries, are ripe for harvesting, if the thrushes don't beat you to it.

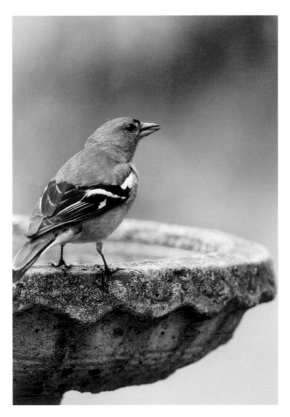

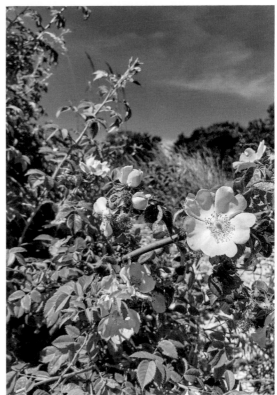

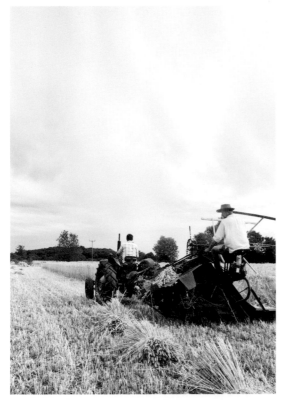

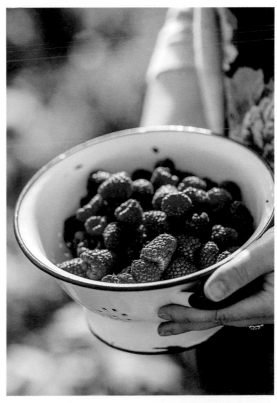

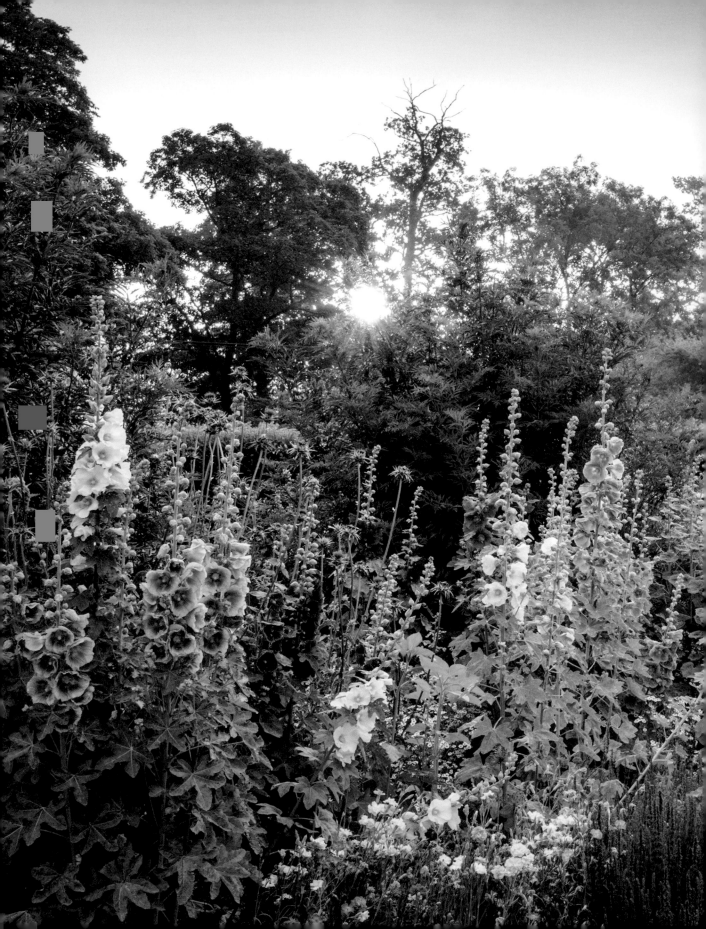

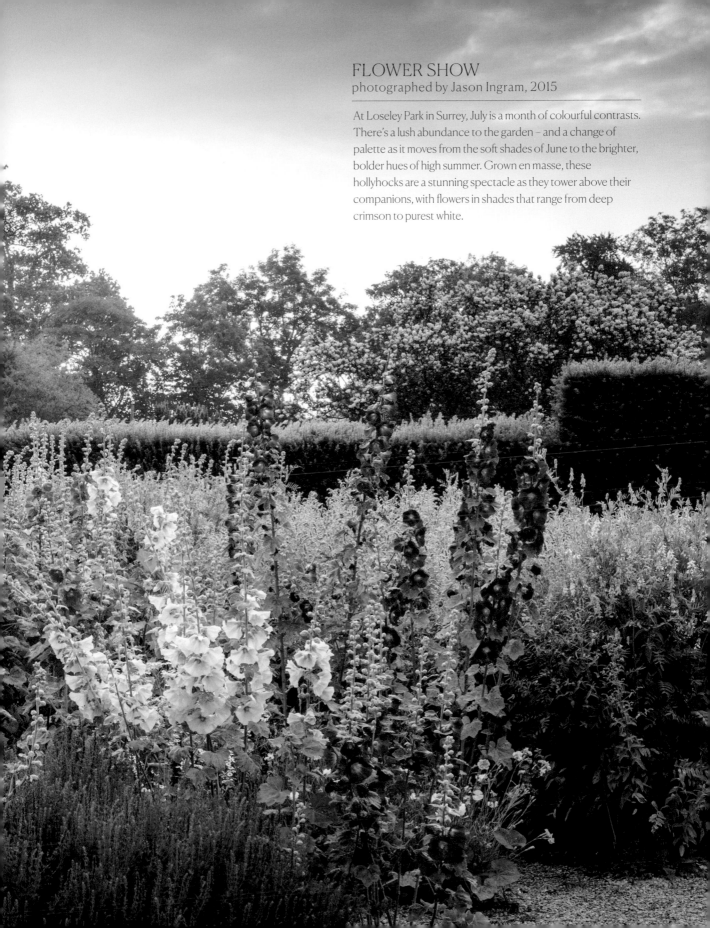

FLOWER SHOW
photographed by Jason Ingram, 2015

At Loseley Park in Surrey, July is a month of colourful contrasts. There's a lush abundance to the garden – and a change of palette as it moves from the soft shades of June to the brighter, bolder hues of high summer. Grown en masse, these hollyhocks are a stunning spectacle as they tower above their companions, with flowers in shades that range from deep crimson to purest white.

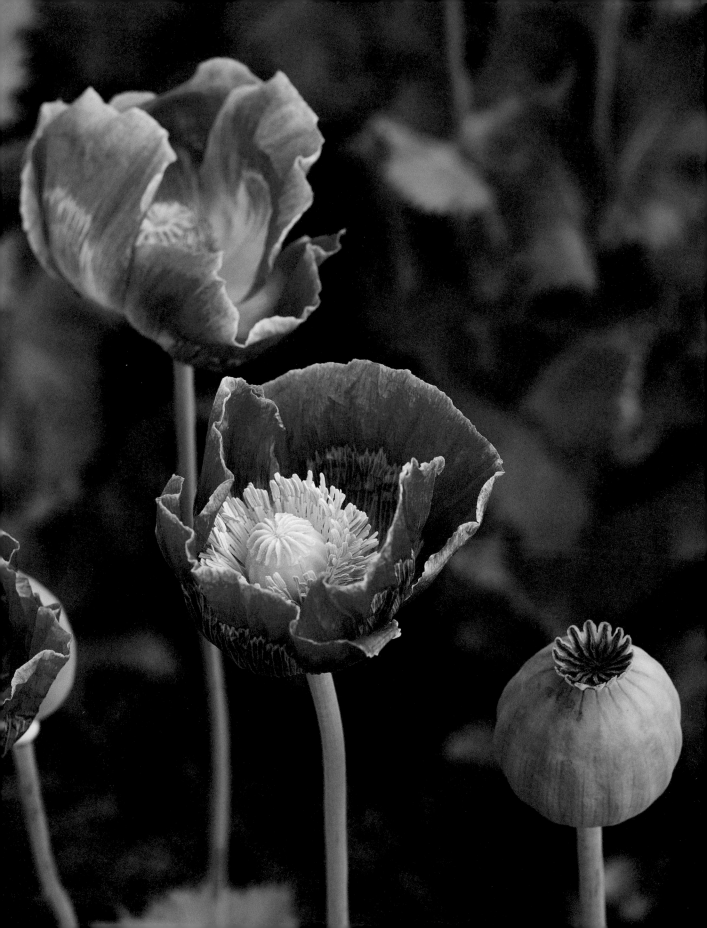

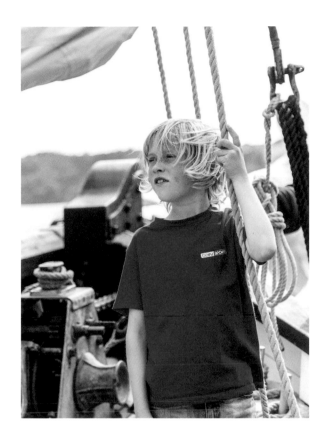

SON OF THE SEA
photographed by Chris Terry, 2020

From the age of one, Malachi Pomeroy-Rowden lived with his parents Marcus and Freya onboard the *Grayhound*. For many years, this three-masted lugger was the family home, office and ticket to adventure all rolled into one.

PETAL PARADE photographed by Alicia Taylor, 2020

Shropshire Petals grows an abundance of British flowers to create delicate, natural confetti. But when you're photographing a flower farm in the middle of summer, the trickiest part can be deciding which of the many beautiful blooms to focus on. 'It was blanketed in flowers, so the choice was almost overwhelming,' Alicia says. 'However, as a photographer, I look for the most beautiful light and shapes. So I borrowed an old wooden farm ladder and positioned it in a spot overlooking this patch of stunning poppies.'

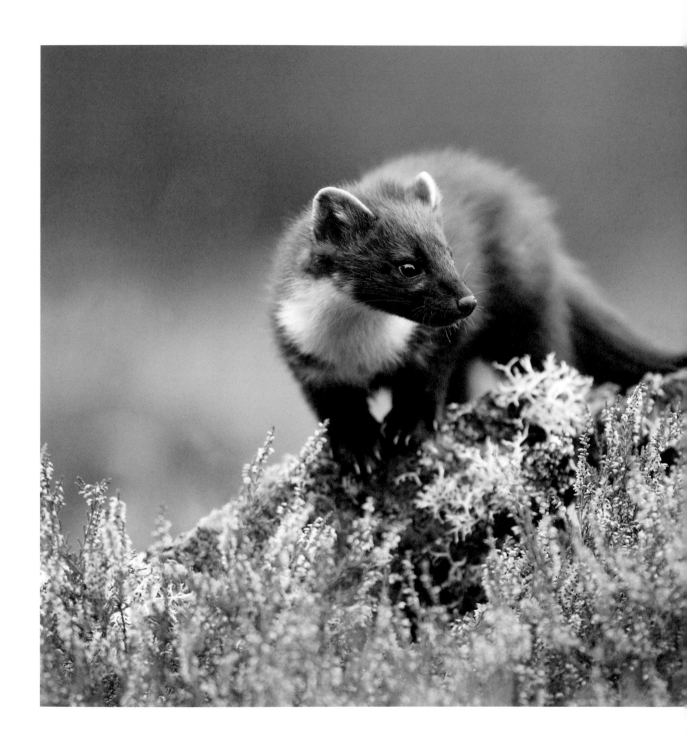

Spotters' guide...
PINE MARTEN

Don't be deceived by its cute, cuddly appearance – this little pine marten's teeth and claws are razor sharp! Once common throughout the UK, the elusive woodland mammal is now mostly found in central or northern Scotland, and this rare sighting was captured on camera amid the heather of the Cairngorms National Park. Chestnut brown with a pale yellow bib and long bushy tail, these secretive animals prefer to live alone, only coming together to breed in summer.

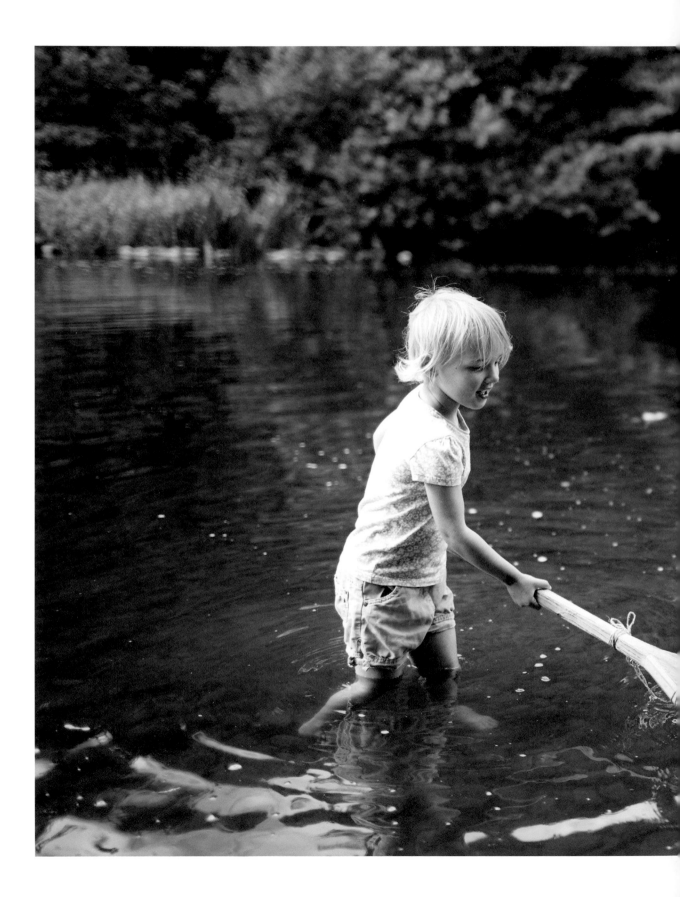

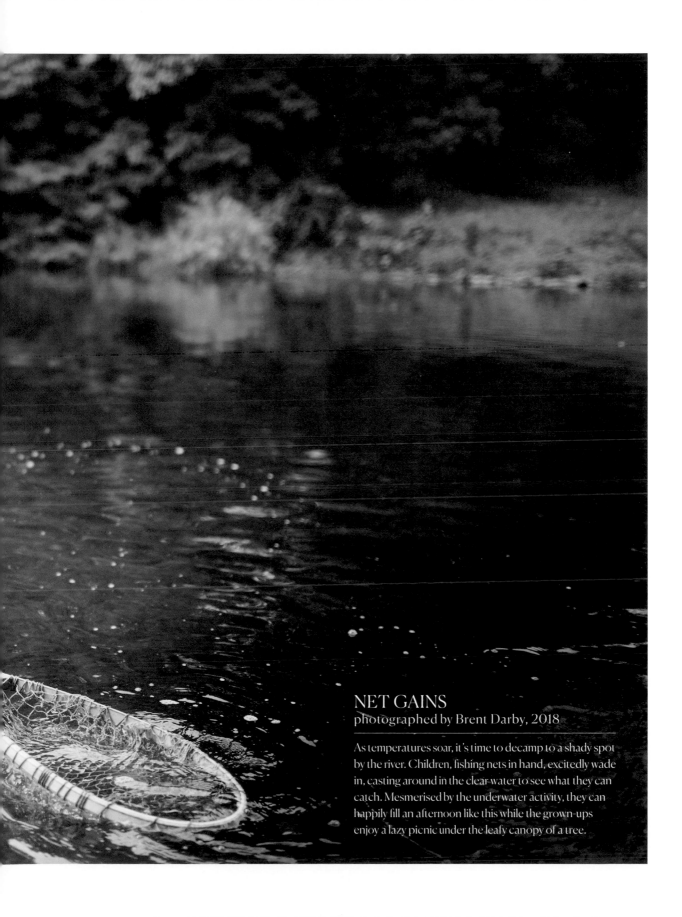

NET GAINS
photographed by Brent Darby, 2018

As temperatures soar, it's time to decamp to a shady spot
by the river. Children, fishing nets in hand, excitedly wade
in, casting around in the clear water to see what they can
catch. Mesmerised by the underwater activity, they can
happily fill an afternoon like this while the grown-ups
enjoy a lazy picnic under the leafy canopy of a tree.

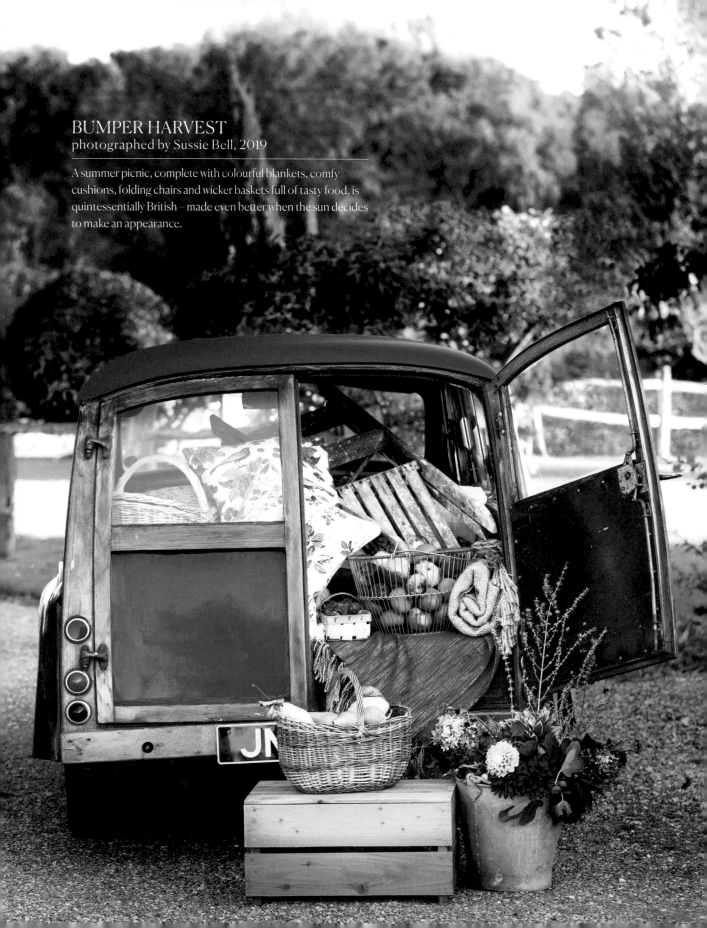

BUMPER HARVEST
photographed by Sussie Bell, 2019

A summer picnic, complete with colourful blankets, comfy cushions, folding chairs and wicker baskets full of tasty food, is quintessentially British – made even better when the sun decides to make an appearance.

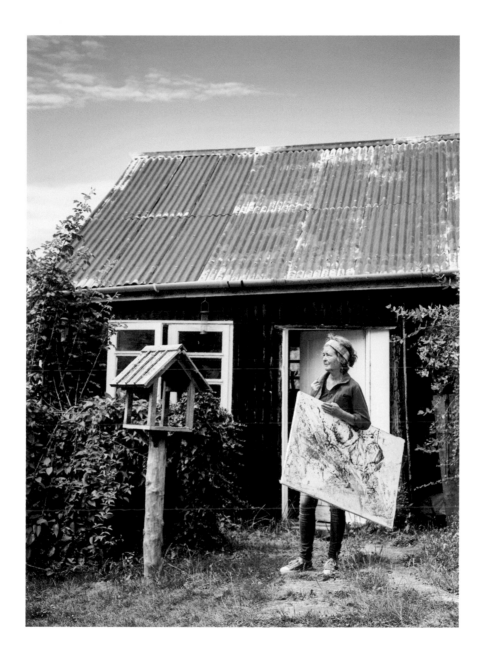

CAPTURED ON CANVAS photographed by Alun Callender, 2019

Artist Catherine Forshall is drawn to the colours of the landscape, from the red rocks of the Jurassic Coast to the shifting blues of the Atlantic. When she's not busy in the garden studio of her cob cottage home in Tedburn St Mary, Devon, she can be found etching in the elements or searching the shoreline for shells and seaweed, capturing 'shimmering little sea creatures' in paintings that are exhibited around the world. A love of water is something that Catherine can trace back to a childhood spent in Scotland, growing up near Loch Fyne.

LILAC HUES AND LAVENDER BLUES photographed by Nassima Rothacker, 2014

Echoing nature's palette inside your home – with pretty fabrics in soft, seasonal shades – is the perfect way to bring the outside in. In this image, a planting scheme of purple and mauve continues from the garden to the interior of the house, thanks to the violet salvia positioned just inside the door. The metal pot also picks up the galvanized-metal theme from the watering can and outdoor planters.

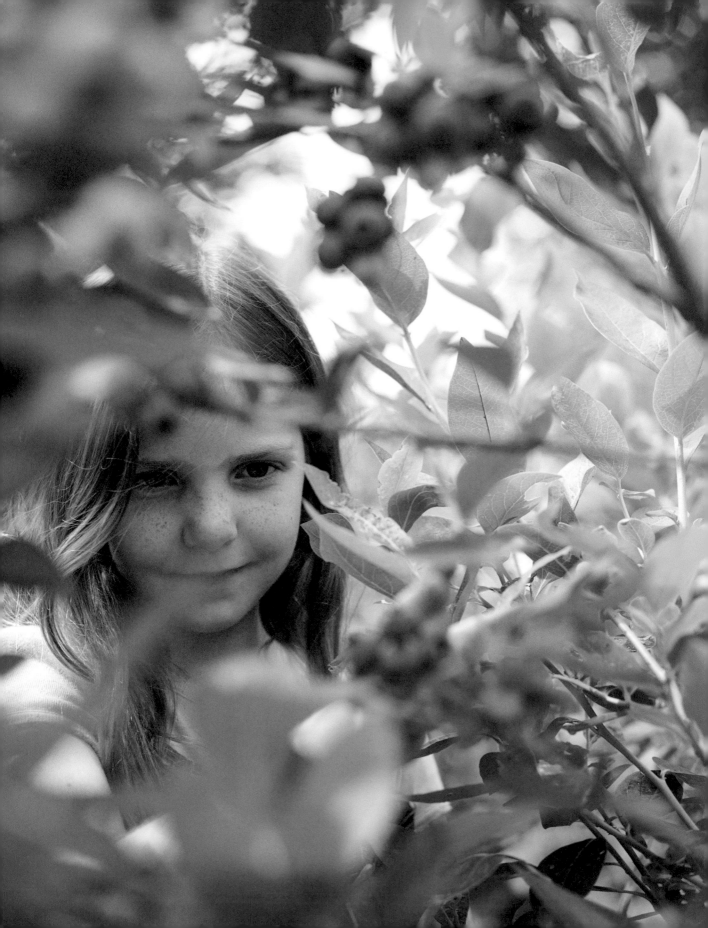

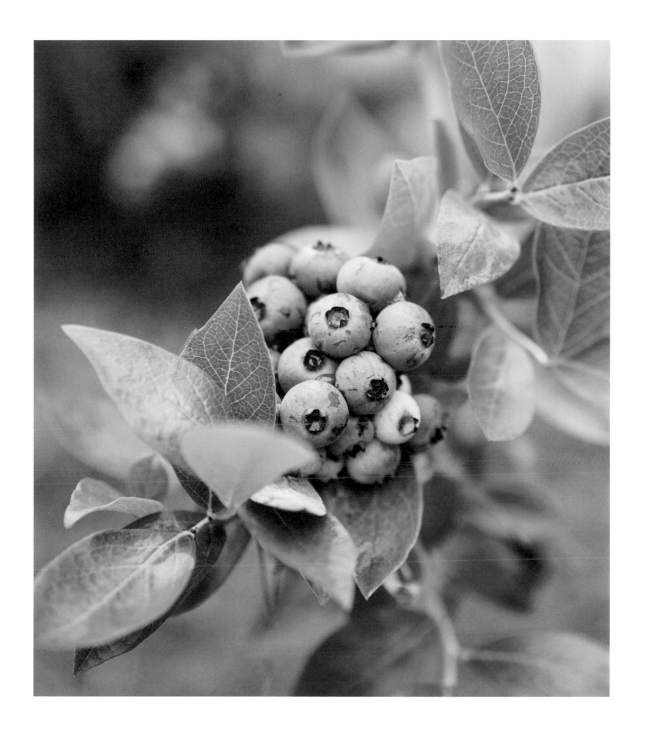

TRUE BLUE photographed by Lisa Linder, 2021

For six weeks from mid-July, Trehane Blueberry PYO farm in Wimborne, Dorset, is a hive of activity, with excited children darting between fruit-laden bushes, health-conscious couples picking and mixing antioxidant-rich berries to take home for smoothies and regular customers making a beeline for the rows of their favourite varieties to fill boxes to freeze for winter.

THE FINE ART OF FLOWERS
photographed by Andrew Montgomery, 2016

Creating an intimate and informal image such as this requires a surprising amount of patience and preparation. Andrew spent the day at Manor Garden on the Yorkshire-Durham border, documenting florist Clarey Wrightson in her cutting garden and studio. To capture this shot, he waited until the sun was low in the sky, casting an ethereal glow impossible to replicate with artificial lighting. 'Light is as much a part of my equipment as the camera,' he says. 'That's the secret to great pictures.'

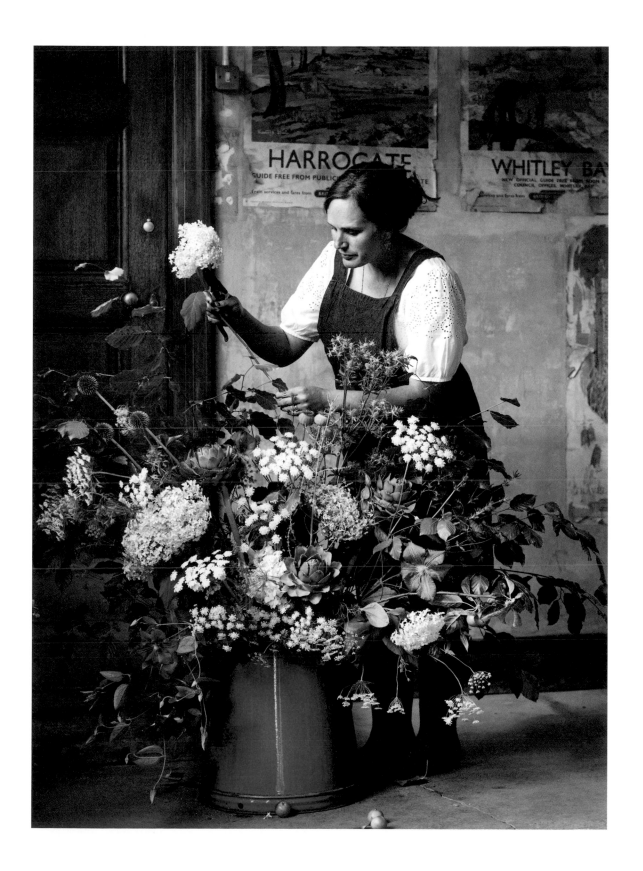

CUT AND DRIED photographed by Andrew Montgomery, 2019

In high summer, the 'rush hour' begins at first light for Felicity Irons, one of the last rush weavers in England. She punts along rivers in Bedfordshire, Northamptonshire and Cambridgeshire to hand-harvest 'bolts' of bulrushes. From June until August, she's up at 5am so she can be out on the water by seven. Armed with punt poles and slim, scythe-shaped blades, she boards one of four aluminium punts and the little fleet spends the next eight hours or so harvesting up to two tonnes of bulrush. Cutting and securing stems that can reach up to ten feet requires Amazonian strength and stamina.

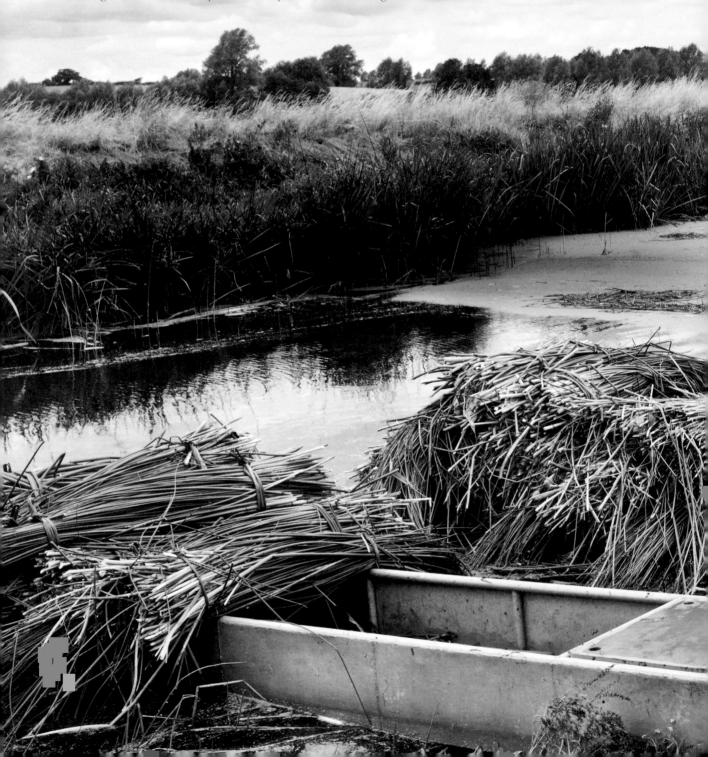

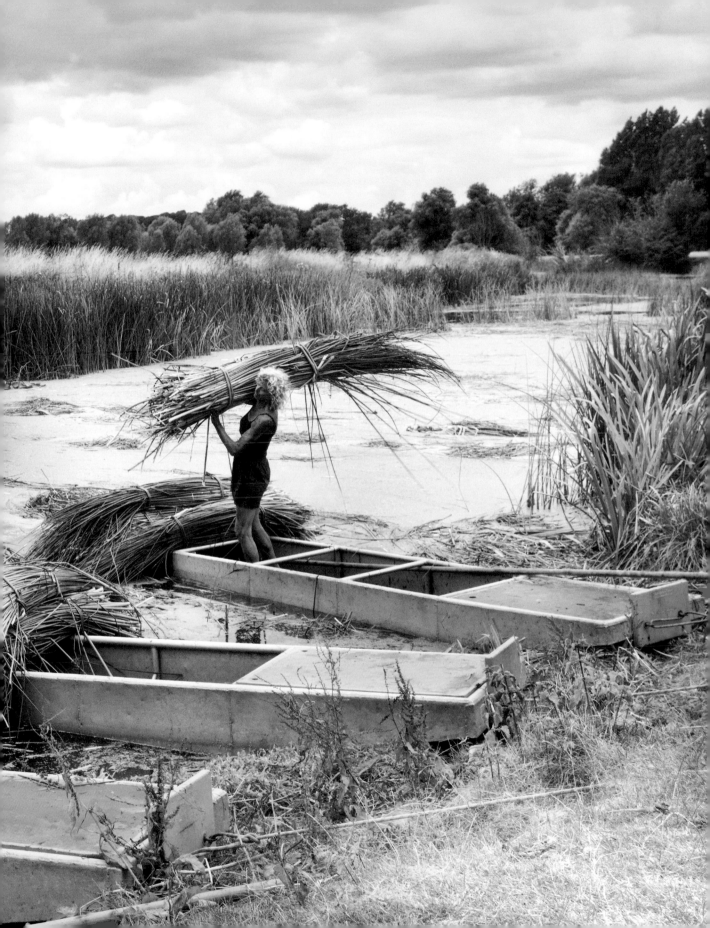

SALAD DAYS photographed by Andrew Montgomery, 2017

Although cut flowers are the mainstay of farmer Rachel Siegfried's blooming business, Green and Gorgeous, one whole acre of the six-acre plot is devoted to fruit, herbs and vegetables including crisp lettuce. These vegetables and punnets of soft fruit are displayed in the Saturday Shop, held in the packing shed, when Green and Gorgeous is open for farm-gate sales. 'It's very social and relaxed – we have regulars who come because it makes an enjoyable day out,' Rachel says, proud that the farm has become a community hub.

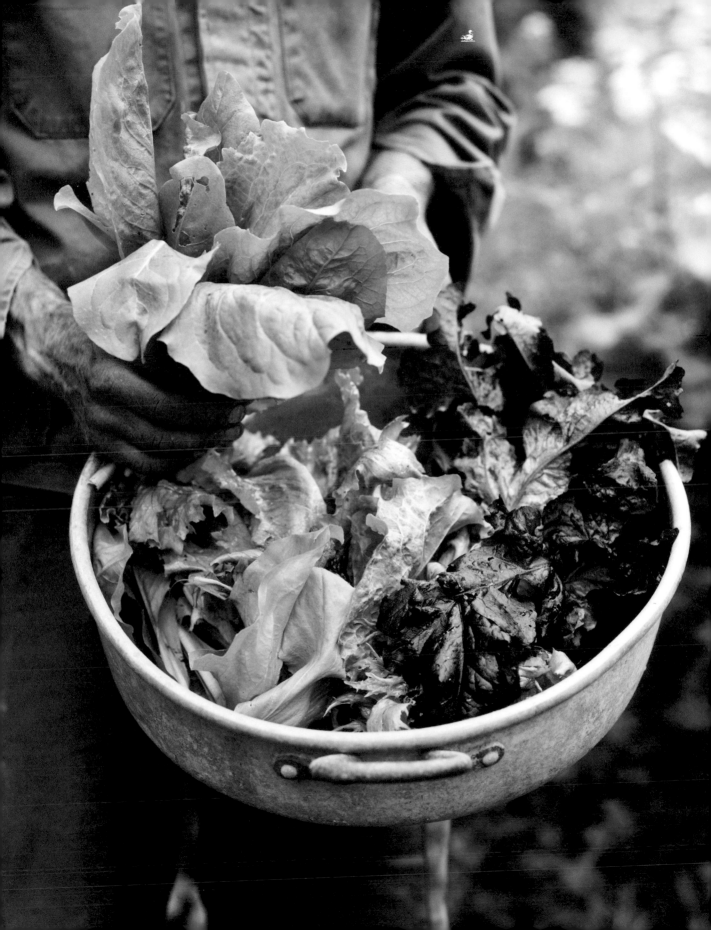

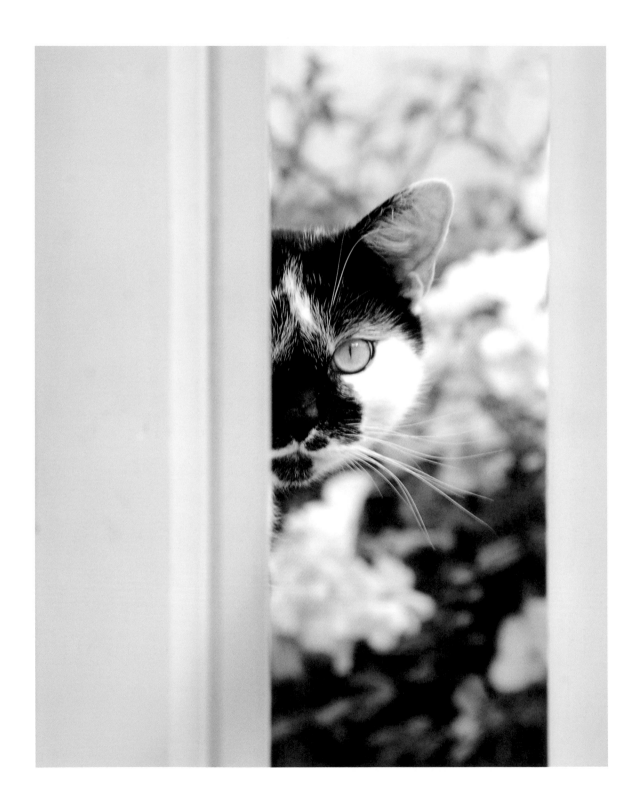

While PHOTOGRAPHER Charlie was busy SHOOTING the floral-filled interiors of a former fisherman's COTTAGE in Whitstable, this curious cat POPPED its head round the open door to FIND out what was going on.

PEEPING TOM (CAT) photographed by Charlie Colmer, 2013

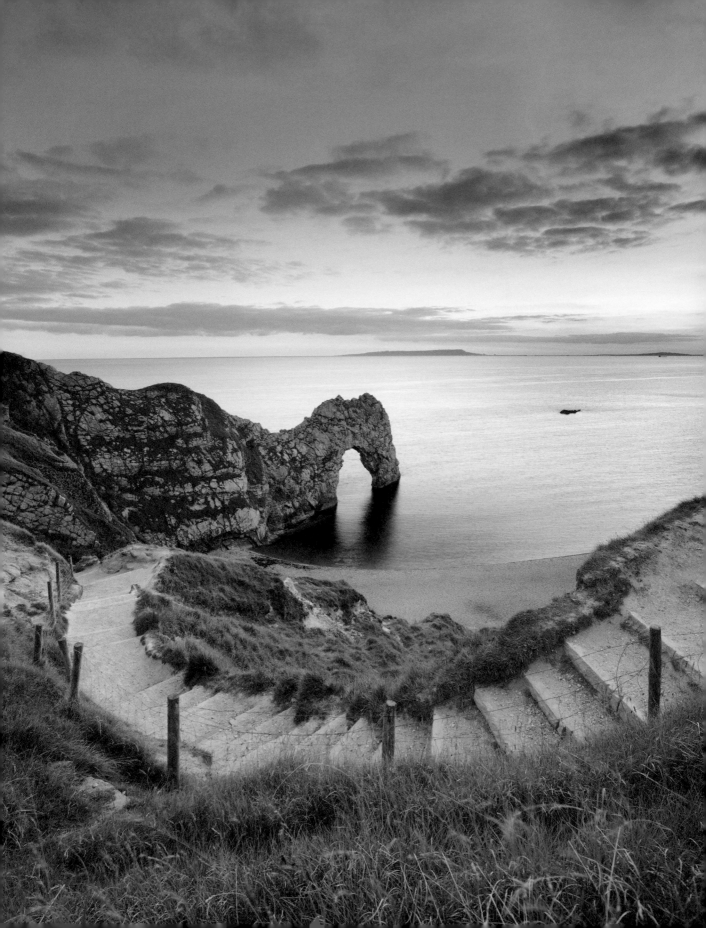

discover...

DURDLE DOOR

This iconic arch of Portland limestone jutting into the sea near Lulworth in Dorset forms part of the famous Jurassic Coast, designated a Unesco World Heritage Site. In the summer months, this much-photographed landmark, and the surrounding area, is a draw for tourists. For a closer look, follow the natural cliff path leading down to the shingle beach and the caves, carved out by the sea, at the base of the chalk cliffs.

DURDLE DOOR, NEAR LULWORTH, DORSET

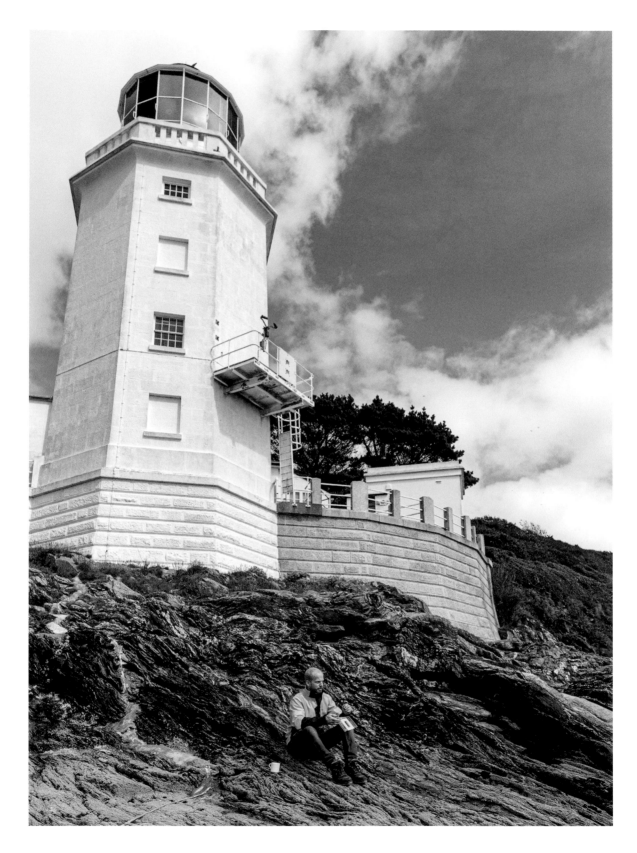

It's Scott Tacchi's job to maintain LIGHTHOUSES all across England's south-west COAST, including this one at St Anthony Head, Cornwall.

GUIDING LIGHTS photographed by Chris Terry, 2020

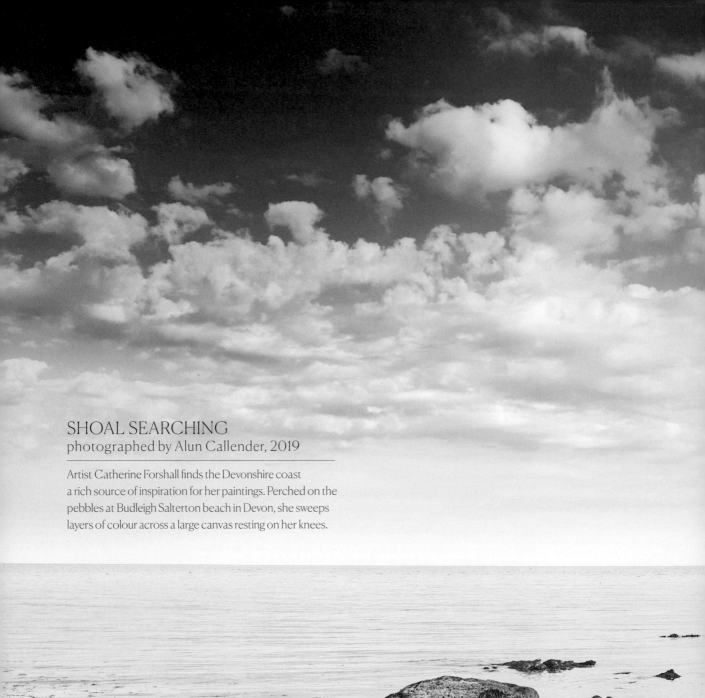

SHOAL SEARCHING
photographed by Alun Callender, 2019

Artist Catherine Forshall finds the Devonshire coast
a rich source of inspiration for her paintings. Perched on the
pebbles at Budleigh Salterton beach in Devon, she sweeps
layers of colour across a large canvas resting on her knees.

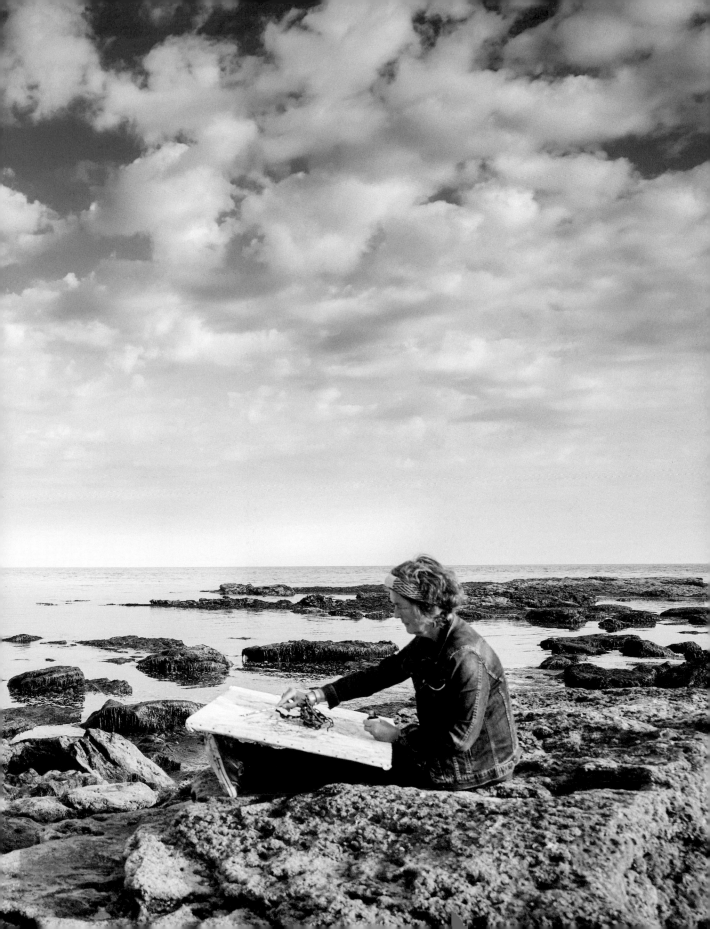

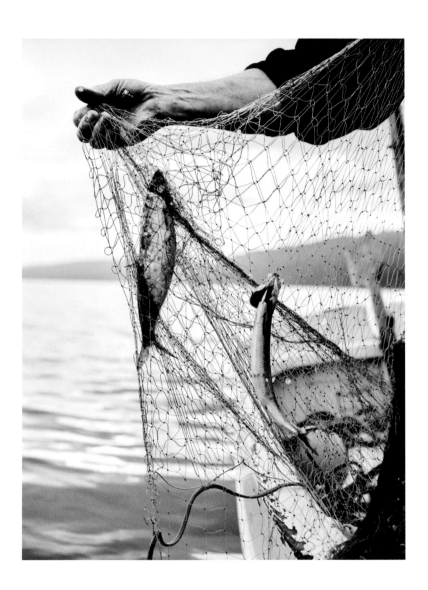

TALES OF HERRING-DO photographed by Andrew Montgomery, 2020

In the 18th century, there were a hundred herring boats in Clovelly, Devon – now there are just a handful. The local herring festival celebrates the village's heritage and supports the fishermen, attracting visitors and locals alike. 'I saw this man, Mick Dunn, walking along the harbour, so asked if he'd mind having his photo taken,' Andrew says. 'He didn't say much, but I think his face tells the story.'

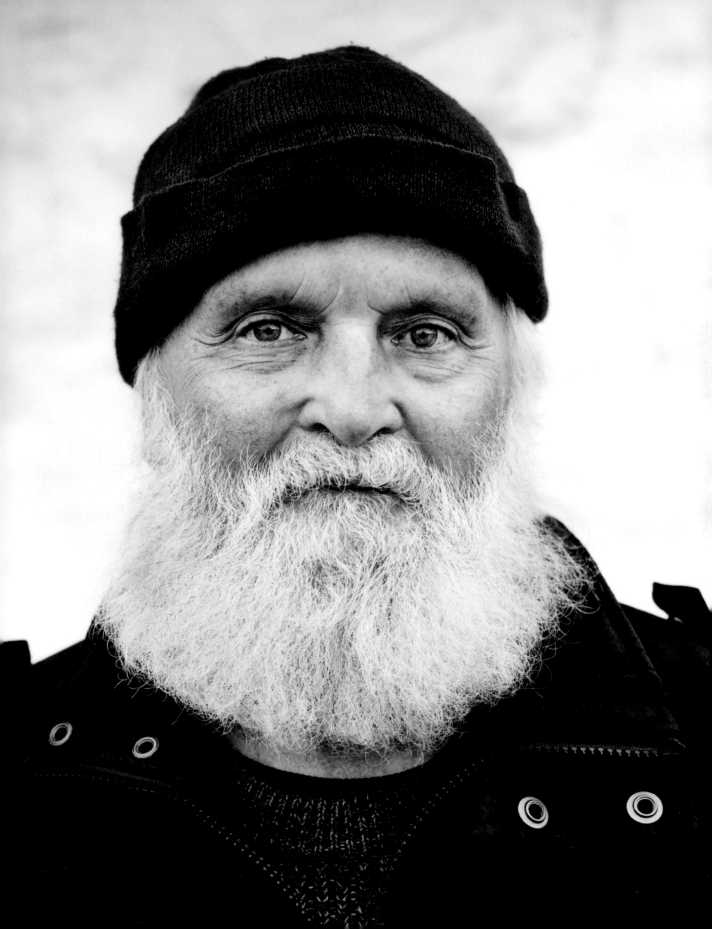

FEEDING FRENZY photographed by Cristian Barnett, 2018

By July, the hugely anticipated Cromer crab season is well under way, and going out on a small boat from the north Norfolk coast to capture the fishermen at work meant an early start for photographer Cristian. 'We left around 4am, when it was still pitch black,' he says. 'It was magical to watch the sun rise.' This image was taken on the journey back to harbour. 'The fishermen start to process the haul, throwing the bits they don't use overboard,' Cristian explains, 'and the gulls dive to scavenge the bits of crab.'

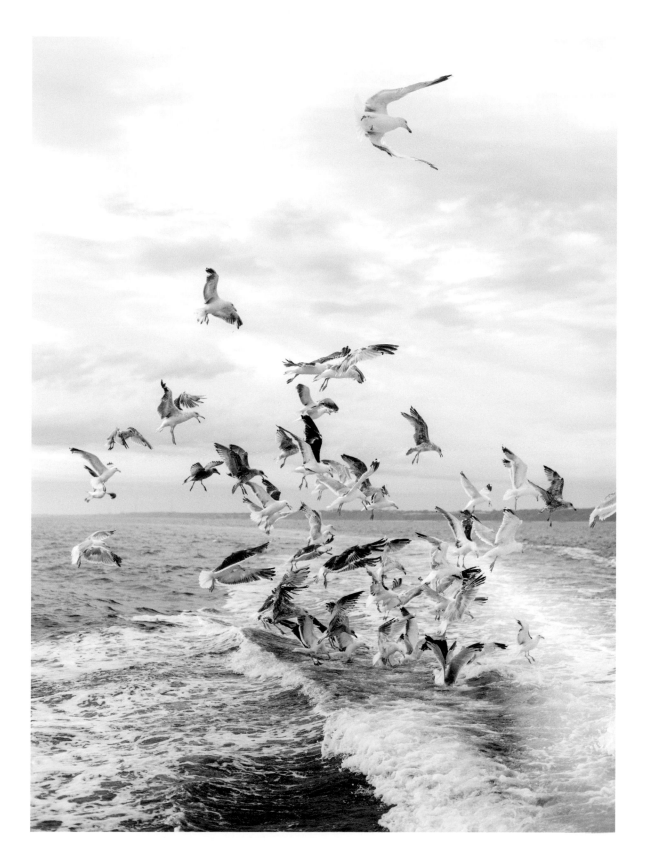

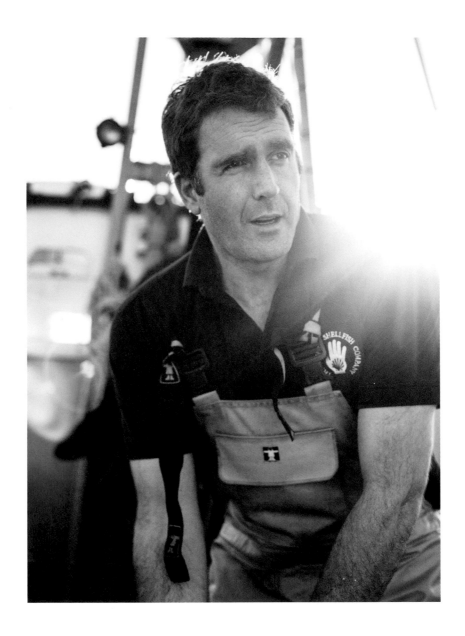

HARVEST FROM THE DEEP photographed by Cristian Barnett, 2015/2018

Beneath the briny waves off the Isle of Mull, Guy Grieve (above) hand-dives for succulent, fan-shaped sustainable scallops that are prized for their freshness, sweet flavour and firm texture. Year-round, for four days a week, he begins his search at 6am for the sought-after shellfish hidden beneath the sands around the island's jagged shores. Off the coast of Cromer in north Norfolk, Stephen Barrett (opposite) is part of a four-man crab-fishing crew that sets out before dawn, travelling to each 'shank' of pots (an anchored line of 25 roped together), which are up to 12 miles from the coast. Stephen hauls them out of the water via a hydraulic winch prior to sorting and grading.

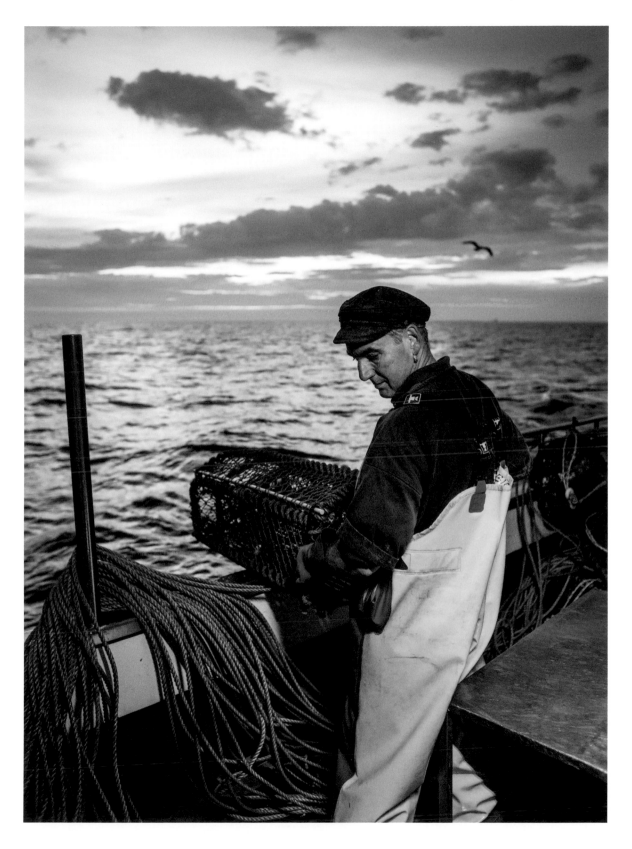

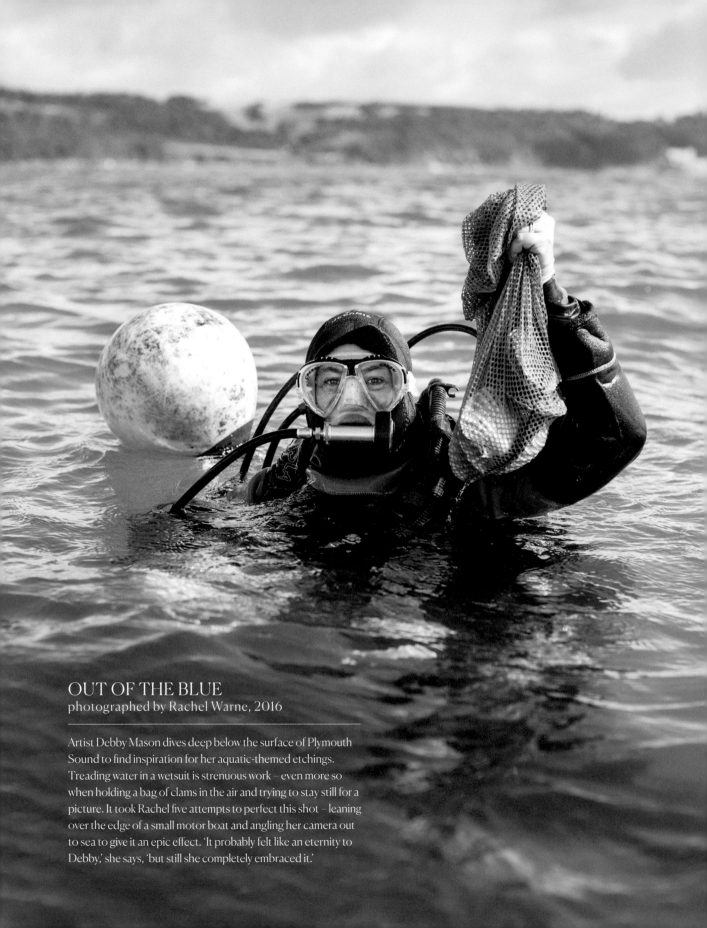

OUT OF THE BLUE
photographed by Rachel Warne, 2016

Artist Debby Mason dives deep below the surface of Plymouth
Sound to find inspiration for her aquatic-themed etchings.
Treading water in a wetsuit is strenuous work – even more so
when holding a bag of clams in the air and trying to stay still for a
picture. It took Rachel five attempts to perfect this shot – leaning
over the edge of a small motor boat and angling her camera out
to sea to give it an epic effect. 'It probably felt like an eternity to
Debby,' she says, 'but still she completely embraced it.'

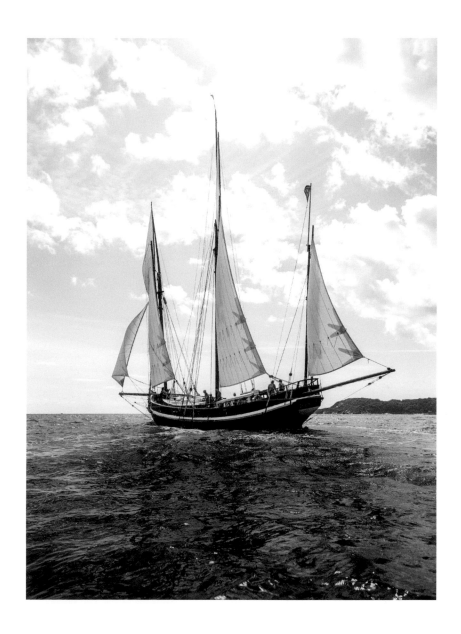

HOME ON THE HIGH SEAS photographed by Chris Terry, 2020

Three hundred years ago, luggers like this were a common sight, importing cargo such as tea and cocoa from the Caribbean. Known for their speed, they were often used for smuggling, which then became so rife that the government temporarily banned lugger building to stop illegal activity. *Grayhound*, built by Marcus and Freya Pomeroy-Rowden with a team of shipwrights, is the first British three-masted lugger in two centuries.

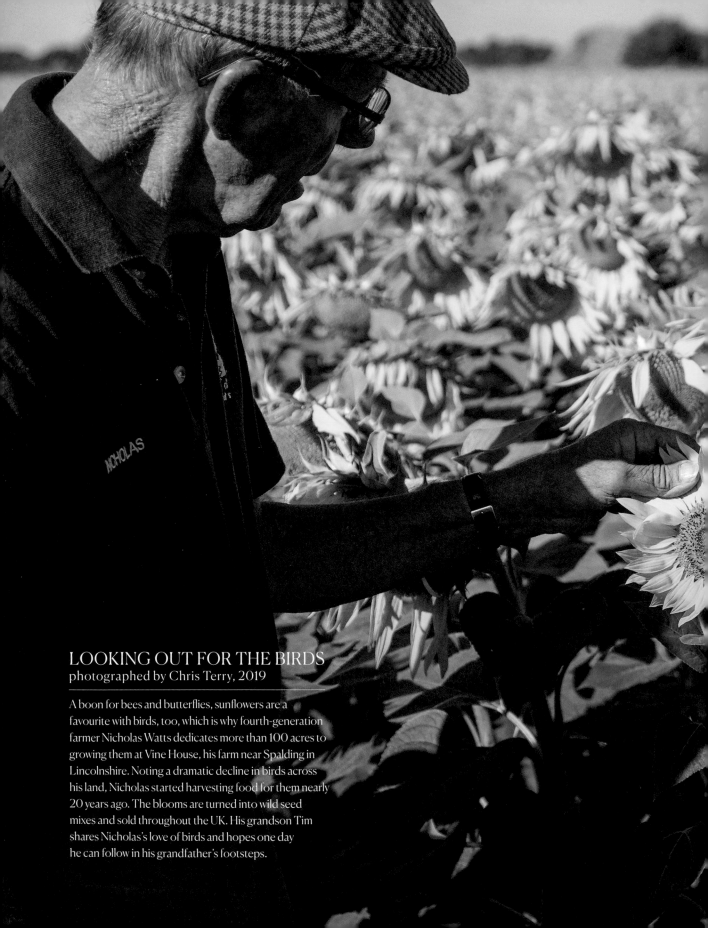

LOOKING OUT FOR THE BIRDS
photographed by Chris Terry, 2019

A boon for bees and butterflies, sunflowers are a
favourite with birds, too, which is why fourth-generation
farmer Nicholas Watts dedicates more than 100 acres to
growing them at Vine House, his farm near Spalding in
Lincolnshire. Noting a dramatic decline in birds across
his land, Nicholas started harvesting food for them nearly
20 years ago. The blooms are turned into wild seed
mixes and sold throughout the UK. His grandson Tim
shares Nicholas's love of birds and hopes one day
he can follow in his grandfather's footsteps.

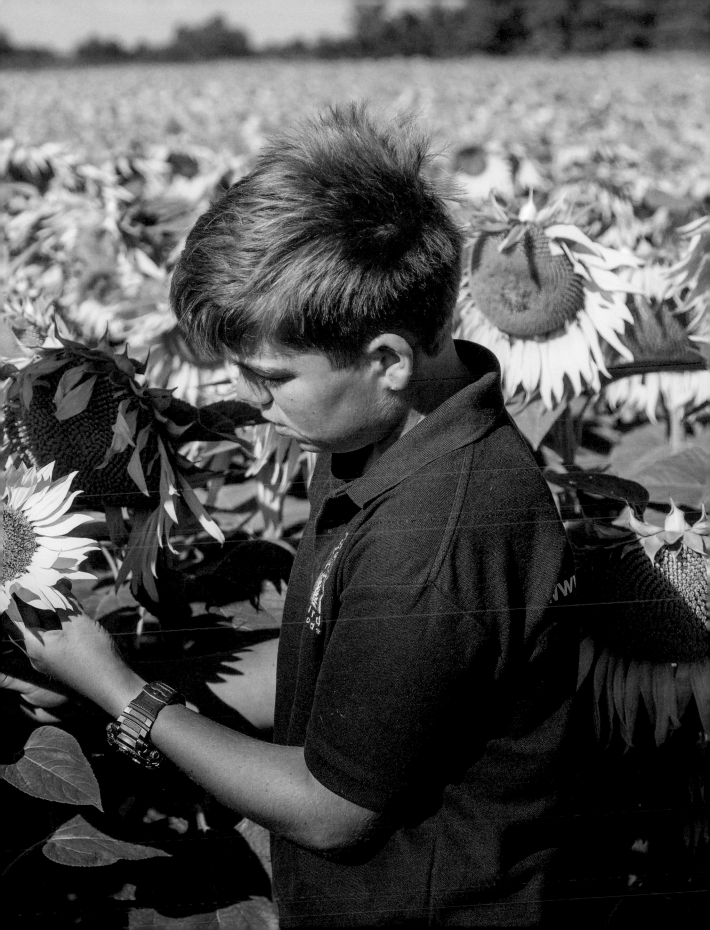

DOWN BY THE RIVER
photographed by Brent Darby, 2018

High summer brings heady heat and hazy days,
the air filled with dandelion seeds and dragonflies.
On this secluded stretch of river, screened by trees,
a young girl has hastily removed her shoes and
socks before carefully picking her way across the
pebbles to enjoy a cooling paddle in the shallows.

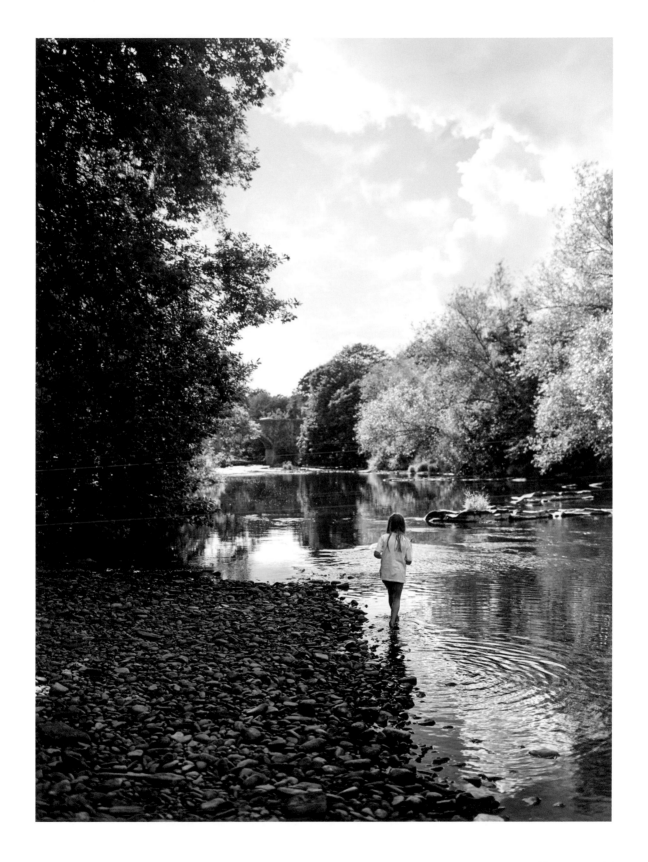

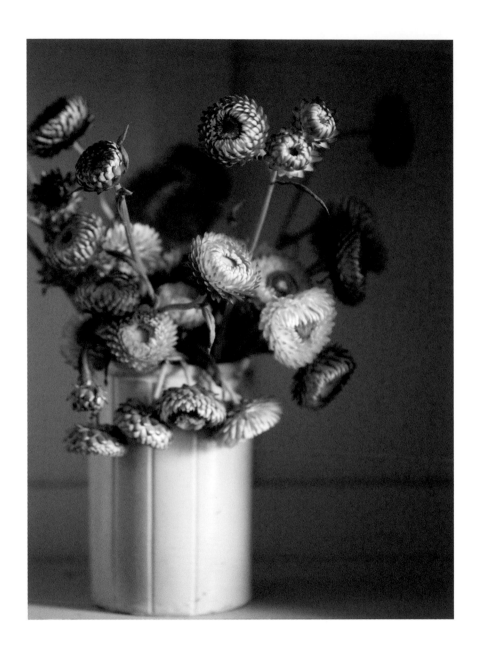

IN FULL BLOOM photographed by Britt Willoughby Dyer, 2021

Eight years ago, Tammy Hall gave up architecture to launch Wild Bunch Flowers, growing and selling traditional English garden flowers from her home in Shropshire. Her design background gives her an understanding of colour, composition and texture, which she imparts to students at her floristry workshops.

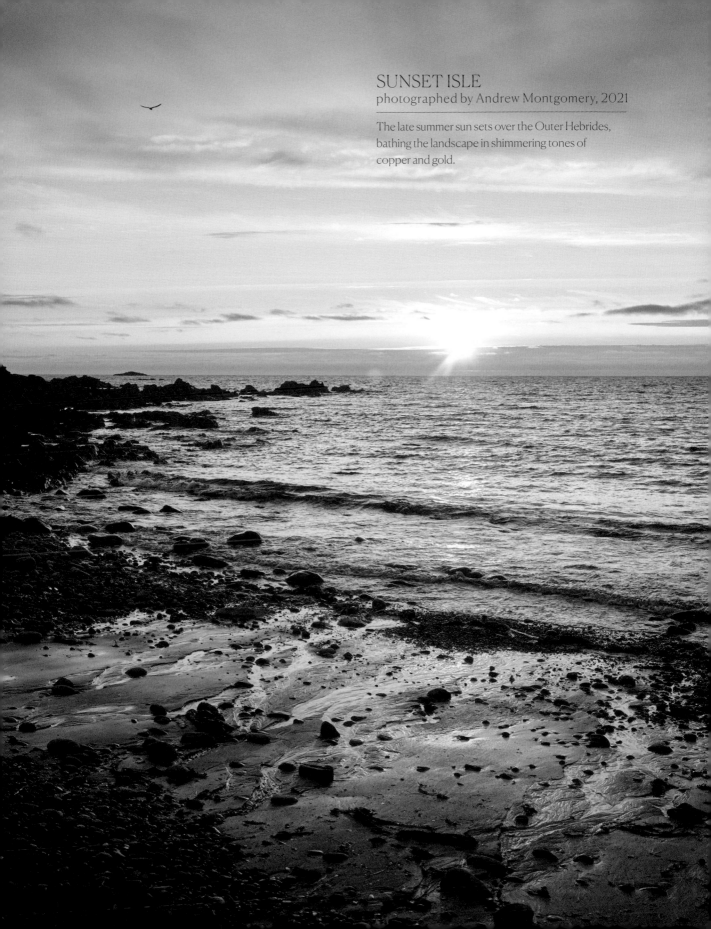

SUNSET ISLE
photographed by Andrew Montgomery, 2021

The late summer sun sets over the Outer Hebrides,
bathing the landscape in shimmering tones of
copper and gold.

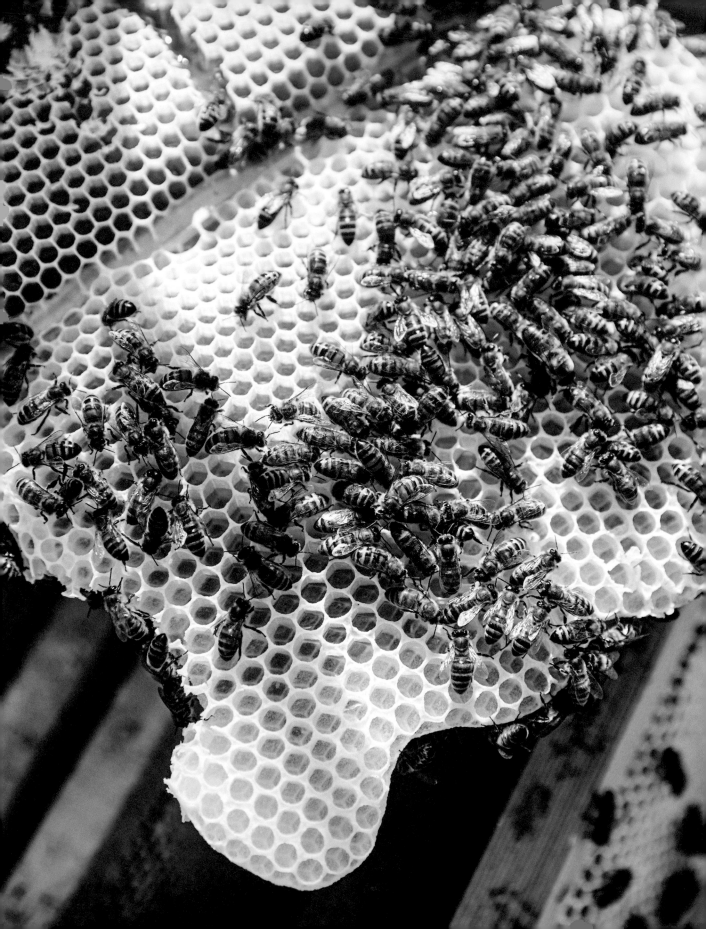

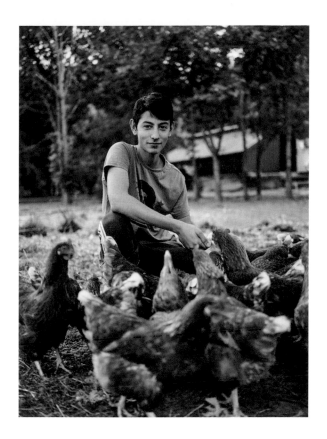

A GOOD LIFE
photographed by Andrew Montgomery, 2021

Willowbrook Farm is the UK's first halal and tayib farm. 'Halal'
is Arabic for 'lawful', 'tayib' means 'natural'. These ideas, say
the Radwans – Lutfi, Ruby and their five children – underlie
Islamic farming: animals must be reared well. 'Ideas of being
wholesome and sustainable come into it,' Ruby says. 'We
should live in a way that is balanced and good and healthy.'
Sixteen-year-old Ali, who is studying for his A-levels, feeds
the chickens after school.

BUZZ WORDS photographed by Nato Welton, 2019

Pollinators such as bees are integral to the production of £690-million worth of UK crops every year, so, by keeping hives on
farms across the county, the Northumberland Honey Co team, founded by Luke and Suzie Hutchinson, is potentially helping
farmers increase their harvests. 'It's mutually beneficial because our bees increase their yields, and their yields support our bees,'
Suzie explains. 'With the help of these insects, crops are increased by about one tonne an acre. It really is a win-win.'

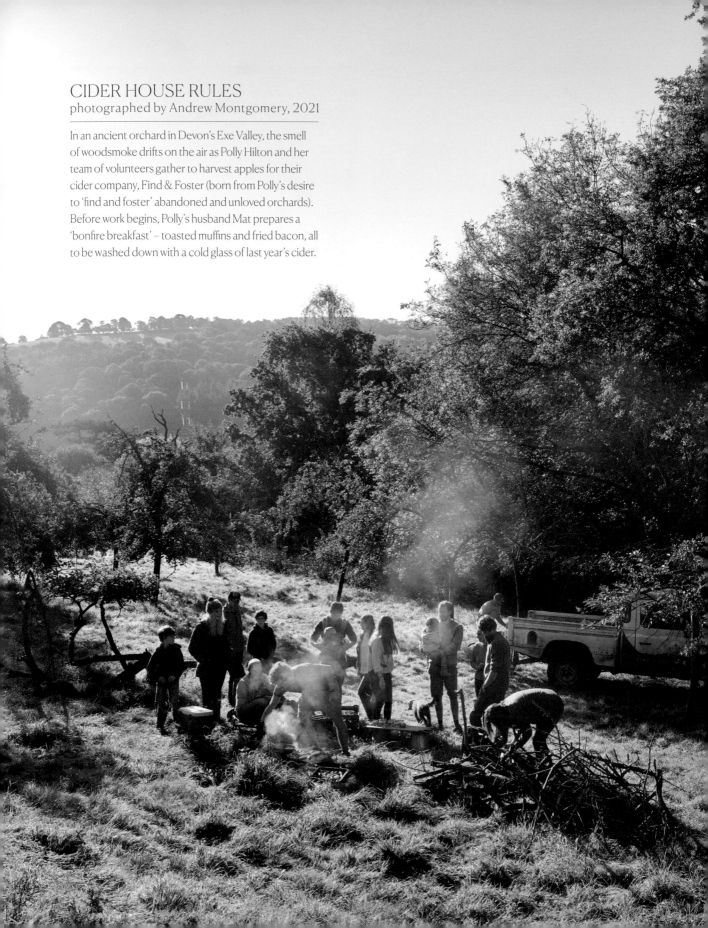

CIDER HOUSE RULES
photographed by Andrew Montgomery, 2021

In an ancient orchard in Devon's Exe Valley, the smell of woodsmoke drifts on the air as Polly Hilton and her team of volunteers gather to harvest apples for their cider company, Find & Foster (born from Polly's desire to 'find and foster' abandoned and unloved orchards). Before work begins, Polly's husband Mat prepares a 'bonfire breakfast' – toasted muffins and fried bacon, all to be washed down with a cold glass of last year's cider.

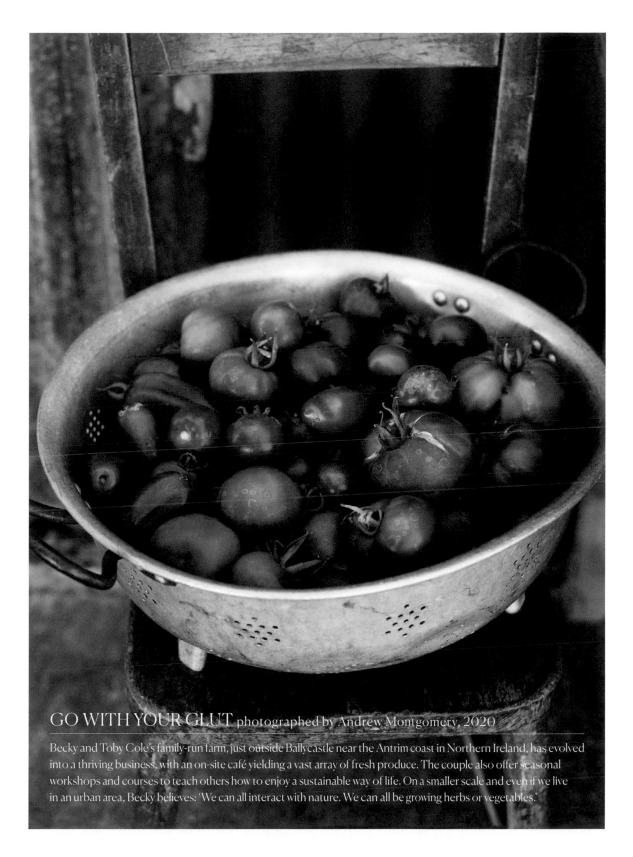

GO WITH YOUR GLUT photographed by Andrew Montgomery, 2020

Becky and Toby Cole's family-run farm, just outside Ballycastle near the Antrim coast in Northern Ireland, has evolved into a thriving business, with an on-site café yielding a vast array of fresh produce. The couple also offer seasonal workshops and courses to teach others how to enjoy a sustainable way of life. On a smaller scale and even if we live in an urban area, Becky believes: 'We can all interact with nature. We can all be growing herbs or vegetables.'

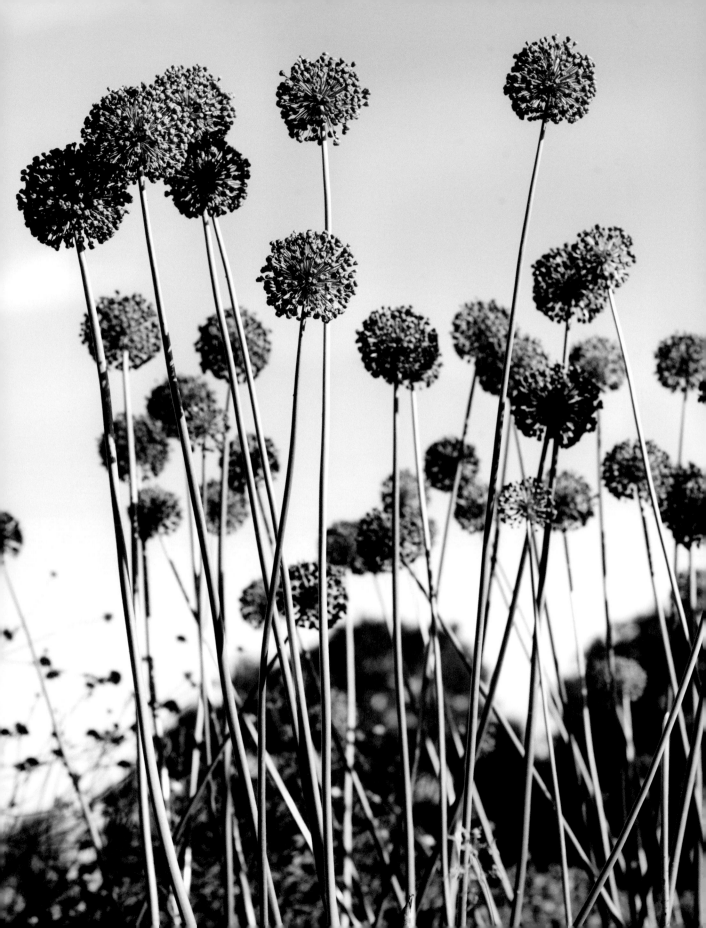

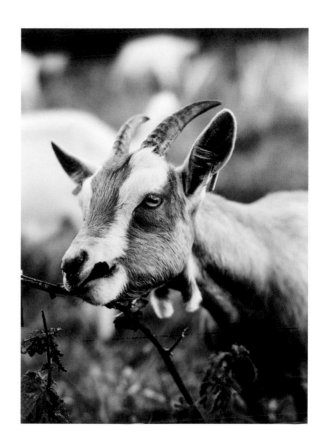

BILLY THE KID
photographed by Andrew Montgomery, 2020

Broughgammon in Northern Ireland is a 50-acre farm with a cluster of stone barns, a cottage and a farmhouse at the end of a winding path. Friesian calves and kid goats graze the fields, while apple trees, hedgerows and a pond pepper the landscape.

A BLOOMING SUCCESS photographed by Andrew Montgomery, 2017

At flower farmer Rachel Siegfried's Green and Gorgeous cutting garden in Little Stoke, Oxfordshire, the air is alive with the trilling of birds and the buzzing of pollinators feeding on the abundant nectar on offer.

The summer HARVEST brings together the honey hues and SUN-BLEACHED tones of flowers, wheat, oats and grasses gathered from the FIELDS and hedgerows.

FIELDS OF GOLD photographed by Brent Darby, 2019

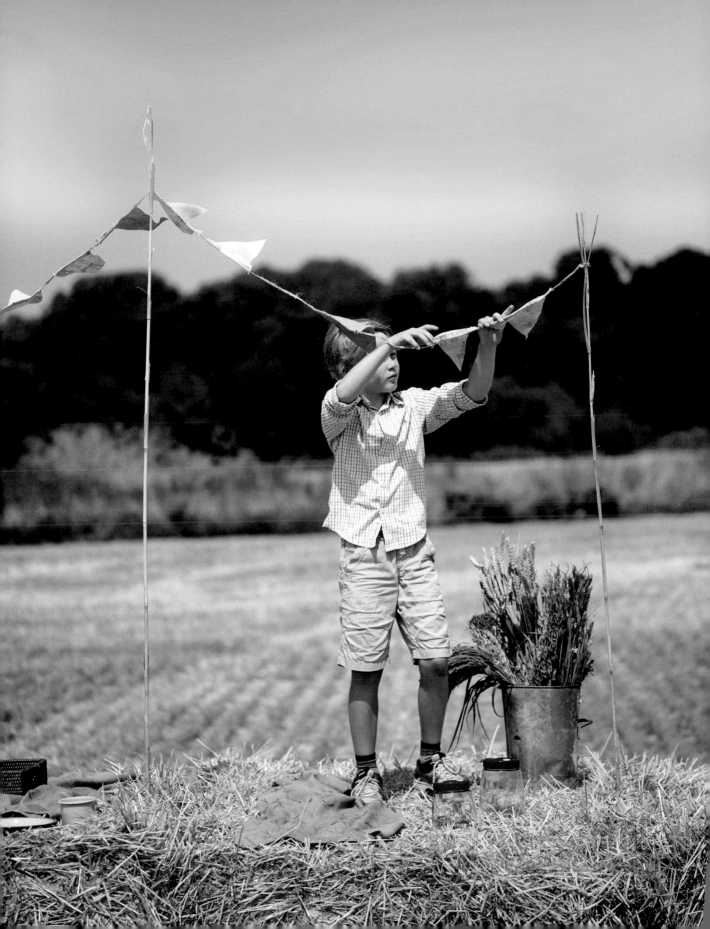

A DOG'S LIFE
photographed by Andrew Montgomery, 2020

Djuk is one lucky little dog. He's always happy to tag along with his owner, printmaker Bridget Tempest, as she sets out from their remote cottage home on the southern tip of the Yorkshire Dales in search of artistic inspiration. As well as being a rich source of creativity for Bridget, the vast moorland is Djuk's playground and he scampers around excitedly while she sits sketching or carefully inscribing marks on copperplate prior to making her prints.

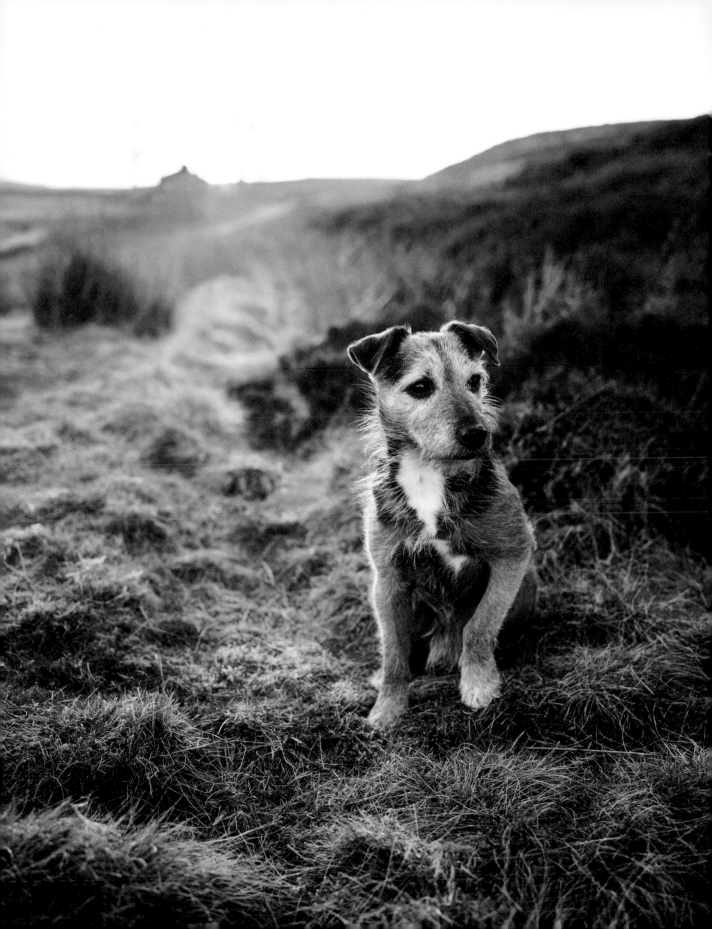

AUTUMN

AUTUMN MISTS

September can be the finest month, with its unexpectedly warm start. The countryside is putting on her swan-song, a last hurrah of blooms and butterflies. Gardens burst with mature colour – sedums and verbena keep pollinators in nectar supplies – while fruit trees get ready to drop their treasures. By the end of the month, however, there's no escaping the arrival of cooler days. Hibernating creatures start to think about bedding down, but for those who choose to ride out the autumn there's still a bounty of rich pickings on offer: trees full of sweet-chestnuts, rosehips and whinberries on the hills.

October is orange with its pumpkins, glowing leaves and dramatic sunsets. Many of our much-loved insects – ladybirds, bumblebee queens, solitary bees – go into suspended animation, crawling into holes, cracks and leaf litter ready for the freeze ahead. Damselfly and dragonfly nymphs – who'll spend next summer divebombing the pond – sink to the bottom, waiting out the winter insulated by the warmth of the water above their heads.

By November, the last of autumn's fireworks have fizzled out and the dark grey weather moves in. The only animals putting on a display are the starlings, with their swooping murmurations. Thousands of hypnotising birds dive and twist as an aerial display team, gathering over roosting sites. They perform stunt after stunt before heading down for the night into the trees, which, thanks to a week of blustery showers, are now completely stripped, ready for nature's next quarter.

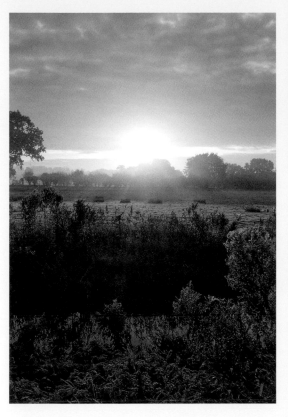
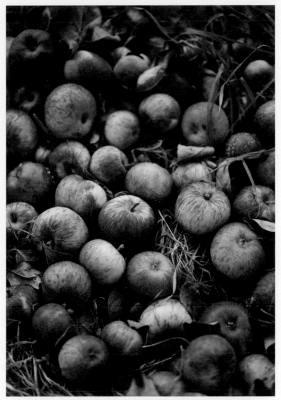

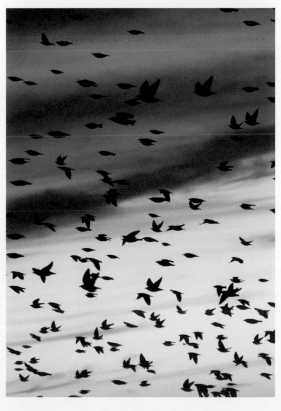

FRIENDS OF THE FEN photographed by Andrew Montgomery, 2015

At Woodwalton Fen, near Huntingdon in Cambridgeshire, Andrew Cuthbert is part of a team of volunteers who work tirelessly to restore the waterways to their former glory, after they were drained for peat in the 17th century. He uses a long-handled scythe to battle the reeds. 'It's a joy to photograph people who work in nature,' Andrew Montgomery says. 'It's the opposite of a high-stress environment – they're never in a rush.' He waited until sunset to achieve this shot, with the low autumn light casting a soft glow over the long grass and still water. 'This is a timeless picture,' he says. 'I love to create images that could have been taken yesterday or 100 years ago.'

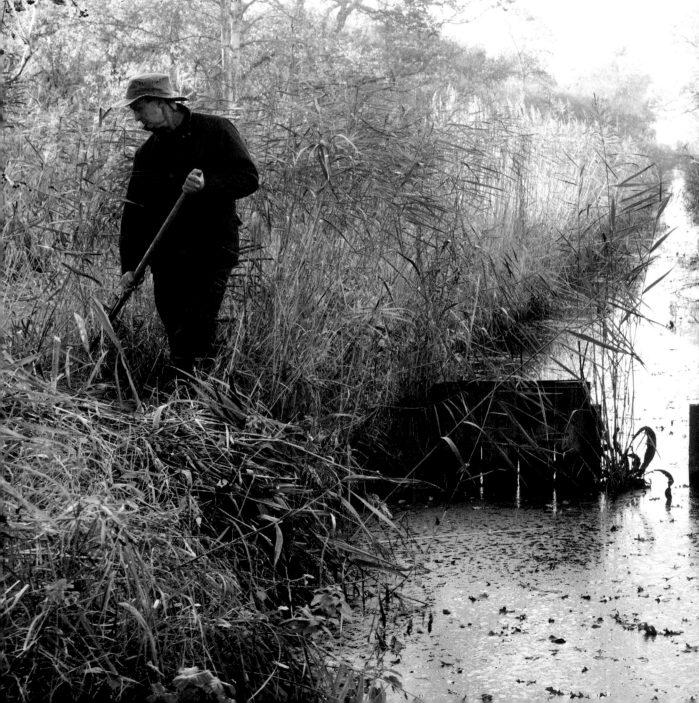

SWANS are very photogenic – and easy to CAPTURE on camera, according to our photographer. 'You put bread on the ground and they come to you,' he says, LAUGHING. 'It's not quite the same as photographing an eagle.' Still, the resulting shot is UNDENIABLY showstopping.

SWANNING AROUND photographed by Andrew Montgomery, 2014

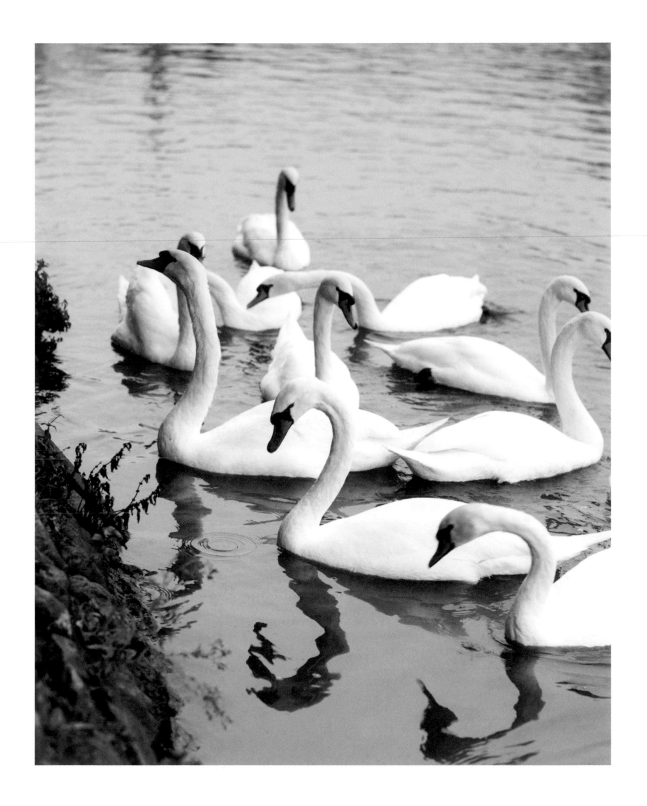

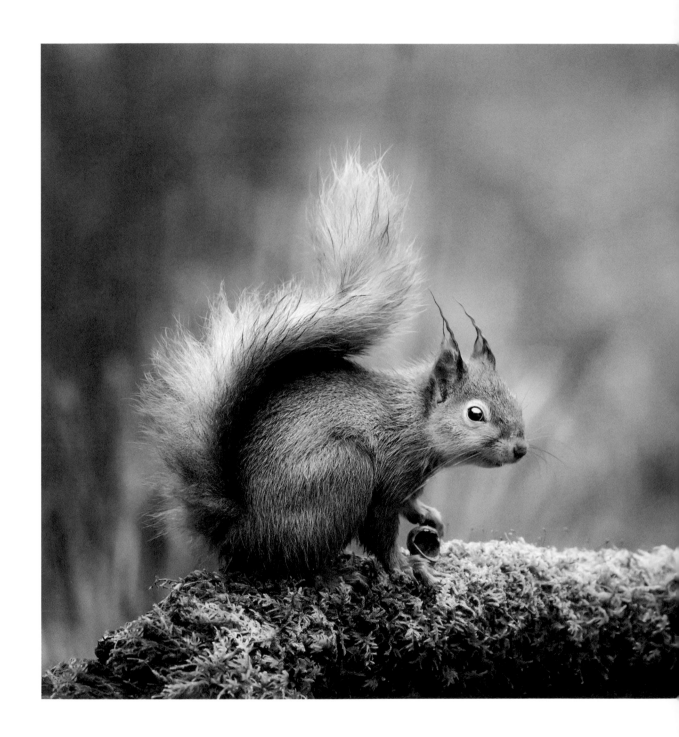

Spotters' guide...
RED SQUIRREL

They've been living in the British Isles for around 10,000 years. However, our native red squirrel population has now retreated to strongholds in wilder, remote locations, and is vastly outnumbered by the grey species, which was introduced from North America by the Victorians. The best time to spot this much-loved endangered species is autumn, when they are busy foraging for nuts to see them through winter.

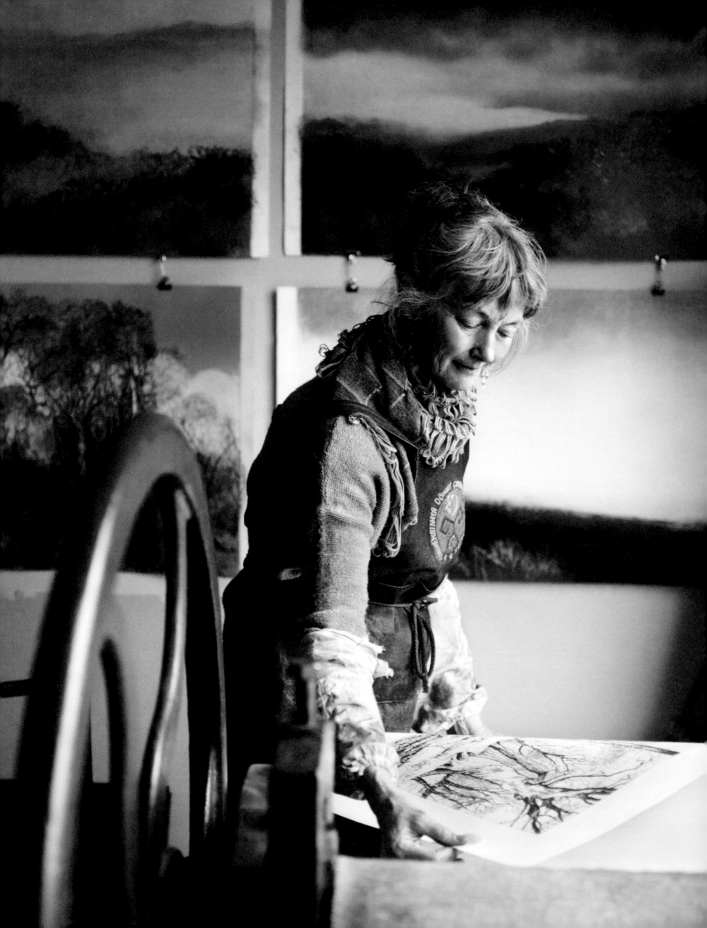

DRAWING ON THE DALES photographed by Andrew Montgomery, 2020

'I love working with artists,' Andrew says. 'They're visual people, so they care about the shot as much as I do.' On a grey autumn day, he visited printmaker Bridget Tempest in Yorkshire to record her artistic process. Here, she is using a printing press to create intricate artworks, transferred from a copper etching plate. Behind the scenes, Andrew is perched precariously on a ledge to get just the right angle. He selected the images in the background from Bridget's collection to create a subtle sense of atmosphere: 'The colours, the light, the ambience... shots like this don't happen every day.'

THE PARLIAMENT OF OWLS
photographed by Andrew Montgomery, 2012

Spook the barn owl was one of many rescued by avian enthusiast Chrissie Harper. 'Chrissie lived and breathed these birds,' Andrew says. 'The small back garden of her home in Stonesfield, Oxfordshire, was lined with aviaries, and she carefully opened the door of each so I could take the shots. The owls all had such different characters, which I think comes across in their photographs.'

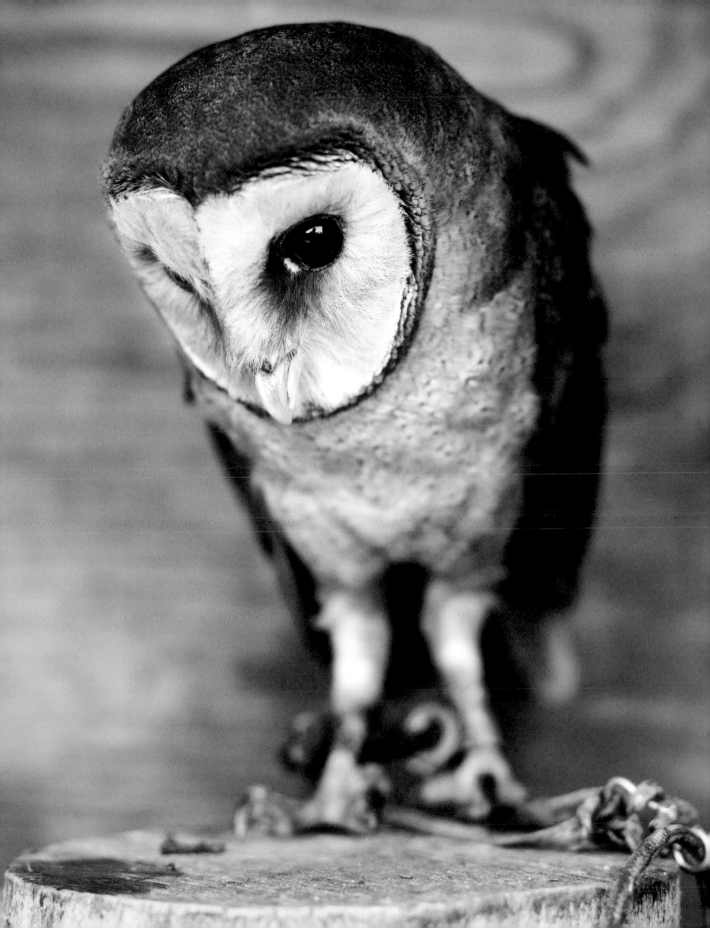

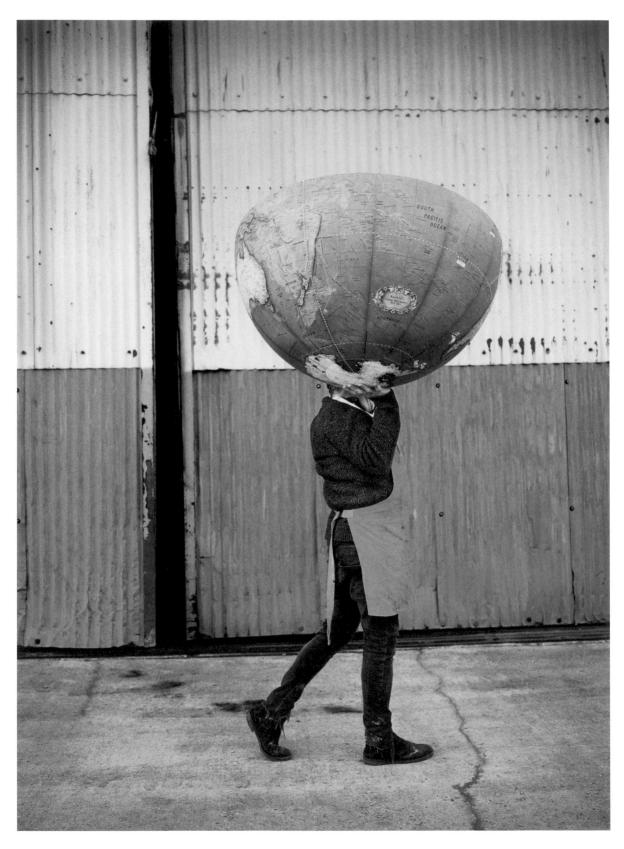

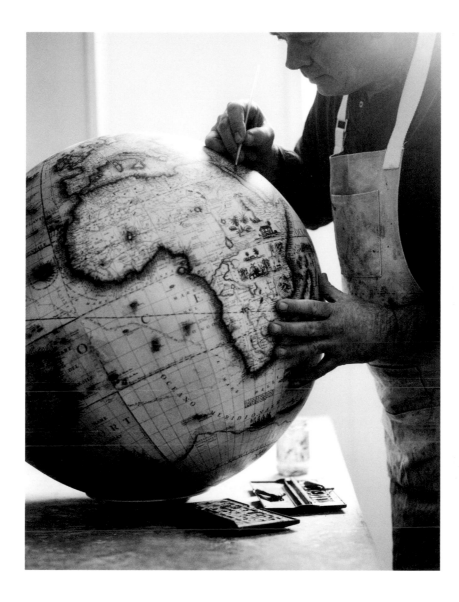

MAN OF THE WORLD photographed by Andrew Montgomery, 2020

In a boatyard on the Isle of Wight, Chris Adams of Lander & May maps out the future – making handcrafted globes using age-old techniques. 'There aren't many of us left now,' he notes. 'Just three in this country, to my knowledge; it's a heritage craft relying on a very small pool to keep it alive.' Except for the addition of a few modern tools such as Photoshop, the techniques used remain unchanged since the late 15th century when globemakers printed gores, or flat map sections, and stretched them over papier-mâché and plaster balls.

'Oxford Sandy and Blacks are pigs suited to OUTDOOR living, as they don't get SUNBURNT,' says Nick Ivins, who keeps them at Walnuts Farm, HIGH on the SUSSEX Weald.

LIFE AT WALNUTS FARM photographed by Brent Darby, 2014

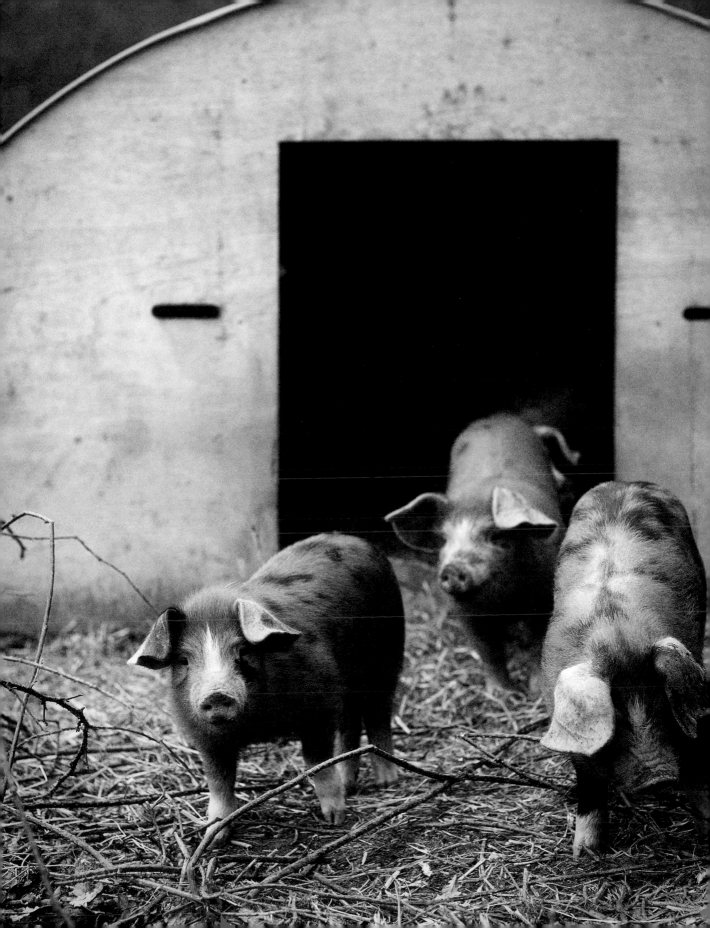

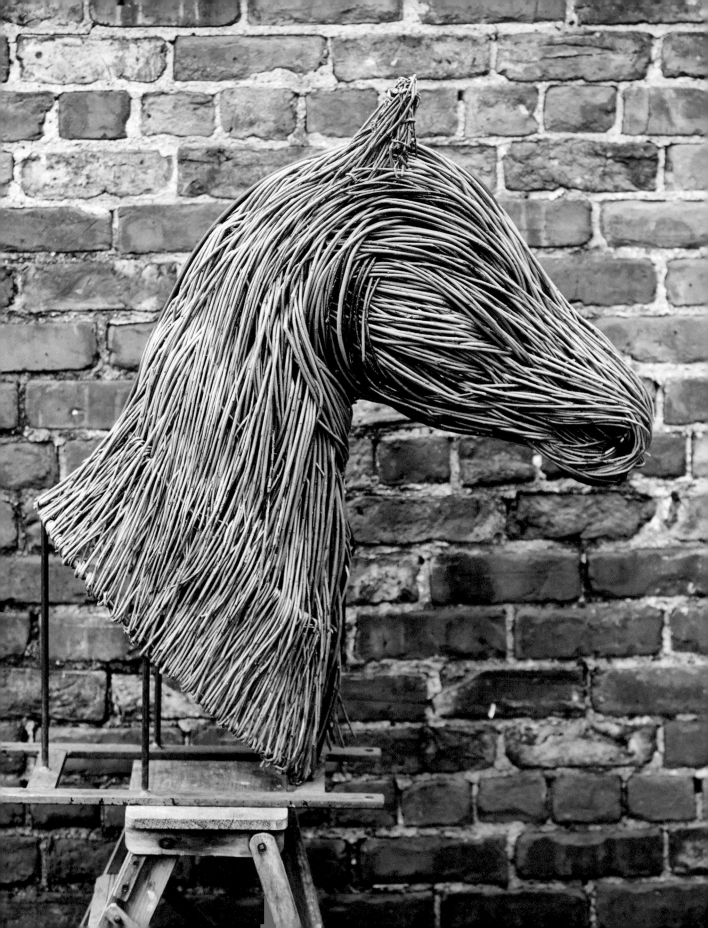

DREAM WEAVING photographed by Alun Callender, 2020

Anna Cross was torn between a career in zoology and a passion for art. Then, in the magical craft of willow sculpting, the Ripon-based weaver found a vocation that combined both. This striking horse's head, perfectly rendered in willow, has an elegant, if abstract, simplicity, yet every sinewy curve and line is lifelike. From the muzzle and nostrils to the wide, strokable cheeks and strong neck, each detail displays an artist's fluid expression. For those familiar with horses, the proportions are beautifully, anatomically correct.

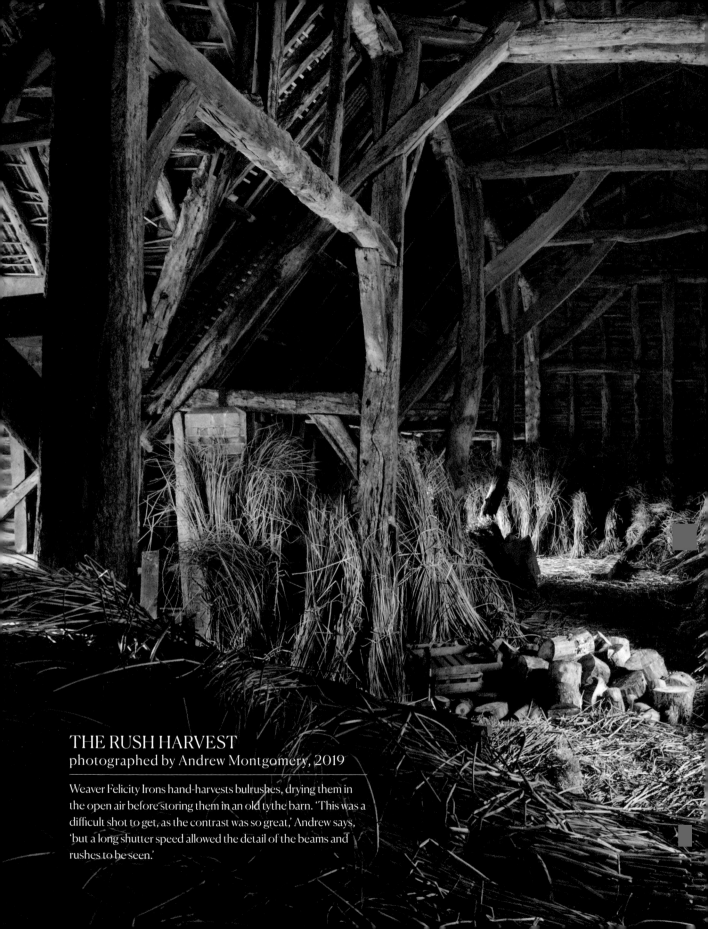

THE RUSH HARVEST
photographed by Andrew Montgomery, 2019

Weaver Felicity Irons hand-harvests bulrushes, drying them in
the open air before storing them in an old tythe barn. 'This was a
difficult shot to get, as the contrast was so great,' Andrew says,
'but a long shutter speed allowed the detail of the beams and
rushes to be seen.'

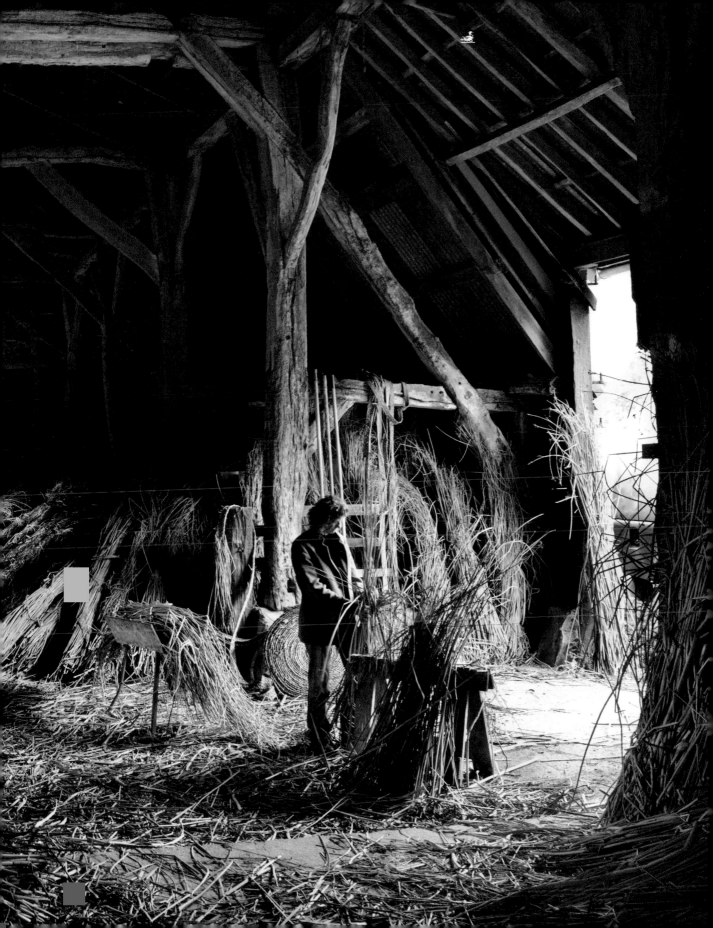

Among the apple orchards of HEREFORDSHIRE, Fair Oak Farm craft cider is produced in a RESTORED 17th-century mill, driven by horse power and a passion for TRADITION.

TAKE YOUR PICK photographed by Andrew Montgomery, 2017

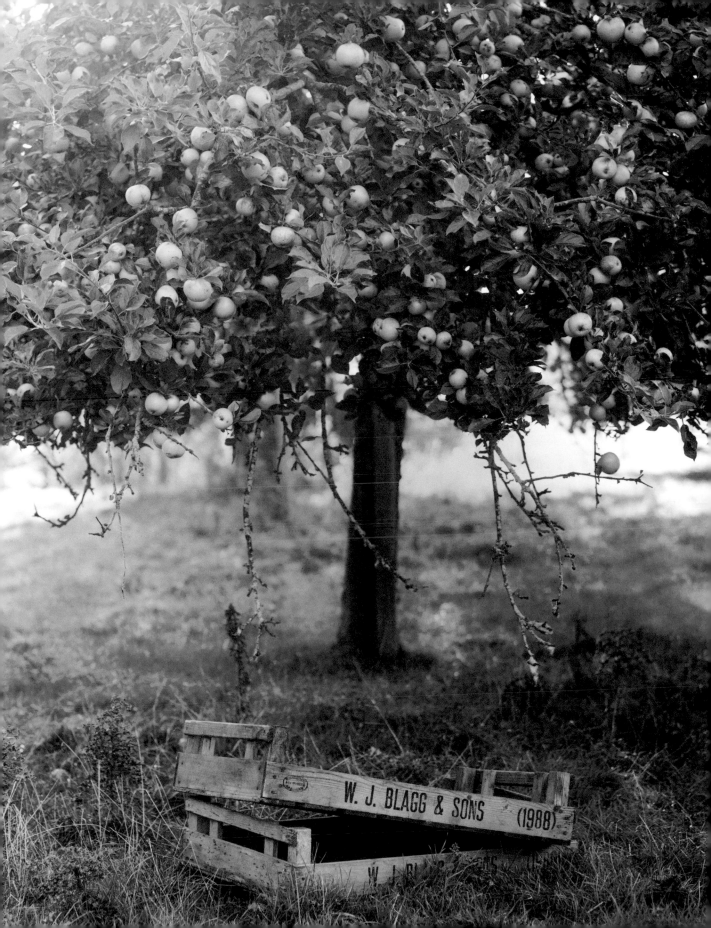

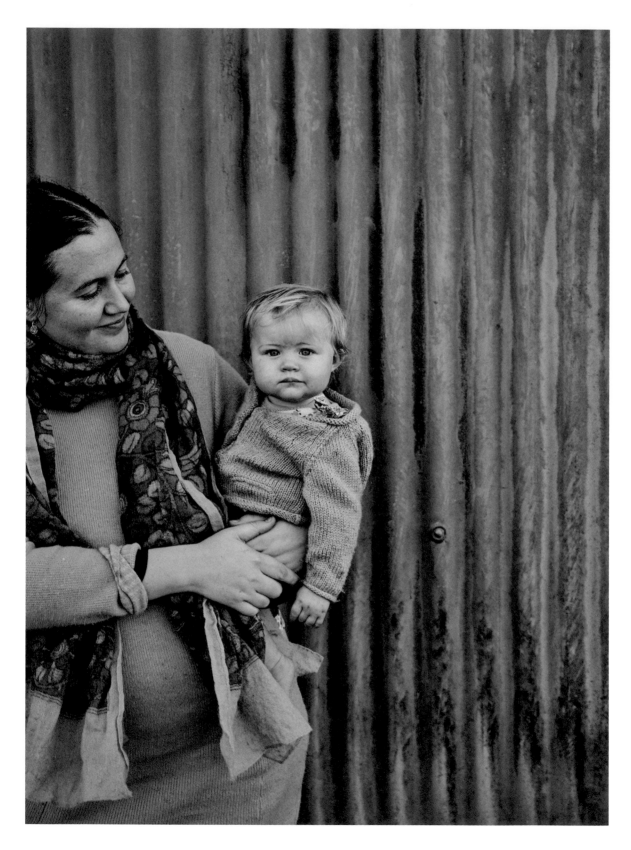

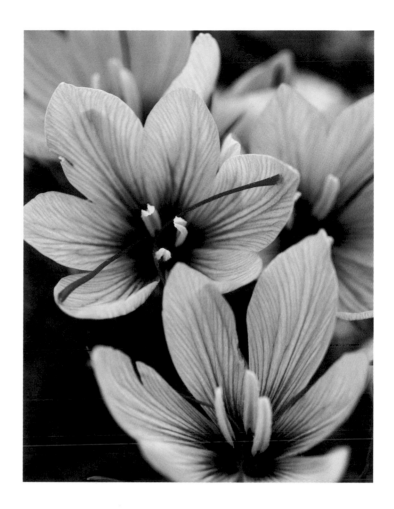

MORE PRECIOUS THAN GOLD
photographed by Rachel Warne, 2014

Doctor Sally Francis likes it when the clocks change, as she gets a little bit longer on her dawn starts during the autumn saffron harvest. Once golden light begins to shine through the shadows on the horizon, she is out gathering *Crocus sativus* on her family's two-acre smallholding on the north Norfolk coast. The precious mauve-tinged blooms, which bear deep-crimson stigmas, must be collected before they spoil.

WE ARE FAMILY photographed by Nato Welton, 2021

Wild By Nature, a field-to-fork farm and restaurant in Longtown, Herefordshire, is a real family affair, where Fran (left) and husband Ed, along with Ed's brother-in-law Jake and his wife Amie, serve guests delicious meals of wood fire-cooked meat from home-reared, traditional-breed animals. Ed and Fran run the farm with their three children, making sure the animals have the highest possible welfare, while Amie and trained chef Jake head up the hospitality side.

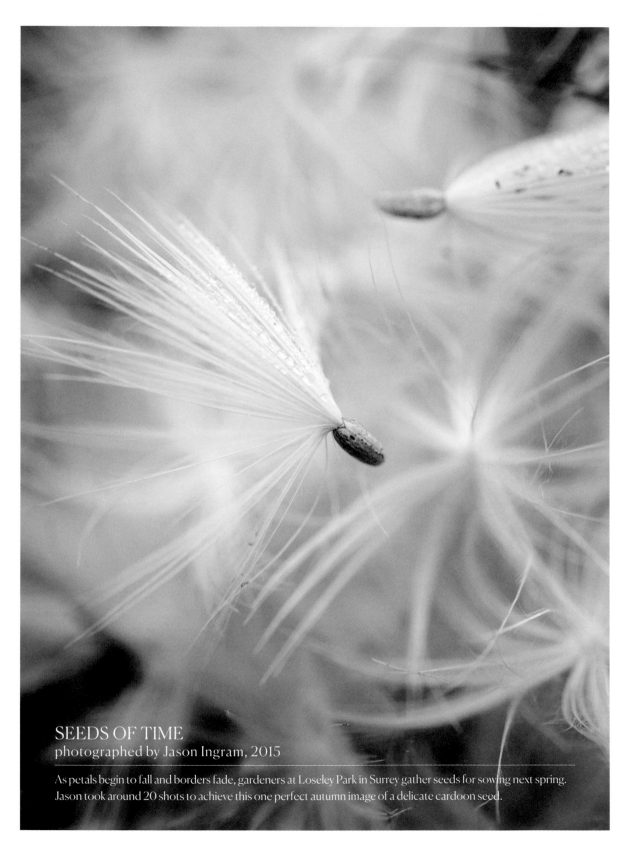

SEEDS OF TIME
photographed by Jason Ingram, 2015

As petals begin to fall and borders fade, gardeners at Loseley Park in Surrey gather seeds for sowing next spring.
Jason took around 20 shots to achieve this one perfect autumn image of a delicate cardoon seed.

A BREED APART
photographed by Rachel Warne, 2019

Don't let their fearsome looks deceive you – Longhorn cattle are known for being a docile and quiet breed. In the Stour Valley near Colchester in Essex, farmer and pie-maker Sophie Gurton has a herd of 60 of them. During summer, they graze on clover-rich pasture but switch to home-grown hay in autumn. 'Cows tend to keep still while eating, which helped me capture the image,' our photographer Rachel says – although the middle one seems more interested in the camera than its dinner.

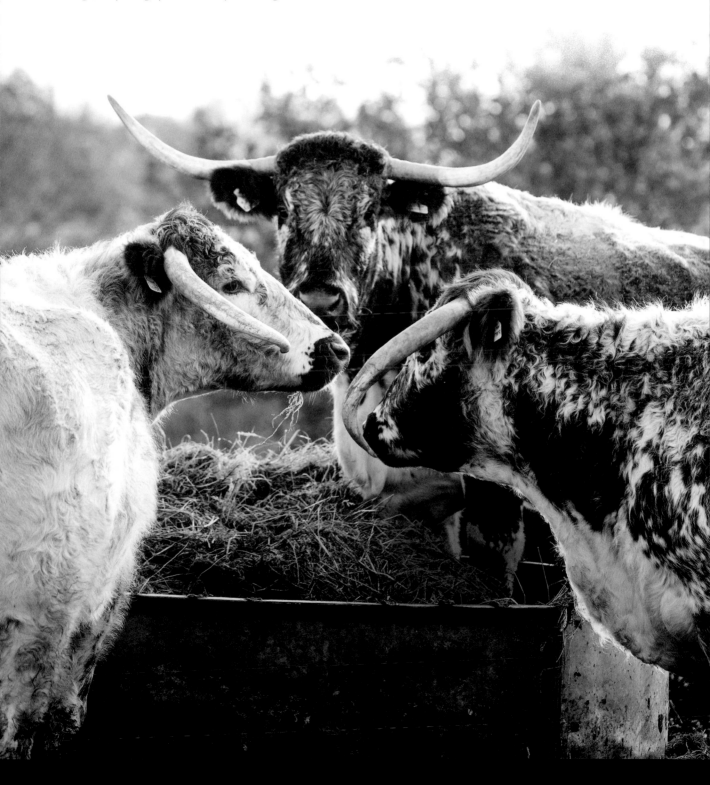

ESCAPING a frenetic city job in the world of fashion, Becky Cole has embraced NATURE and slow living on a free-range GOAT farm in Northern Ireland.

THE KIDS ARE ALRIGHT photographed by Andrew Montgomery, 2020

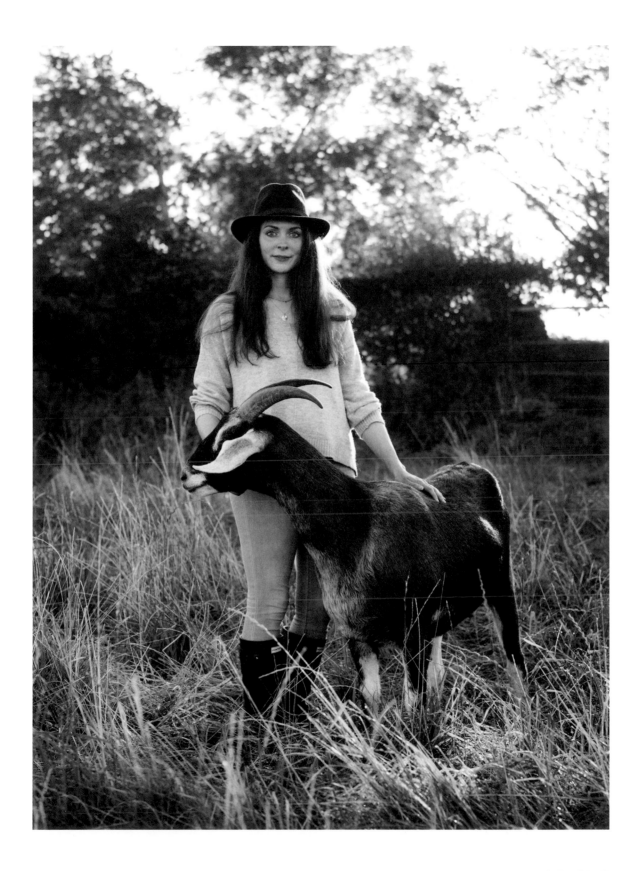

COLOURS OF THE COUNTRY
photographed by Andrew Montgomery, 2016

A family-run Donegal tweed company in the village of Ardara, close to Ireland's Atlantic coast, Molloy & Sons have been weaving cloth on the same spot for six generations. The colours of the tweed reflect the romantic yet rugged countryside that surrounds them: the purple and brown of the heather-clad Blue Stack Mountains, the grey of the stormy seas and the deep greens of the hillside where you'll find their home and weaving sheds.

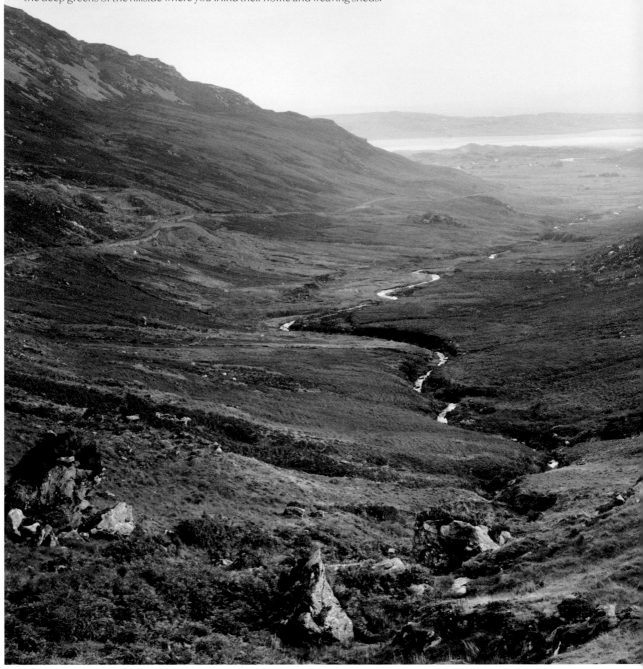

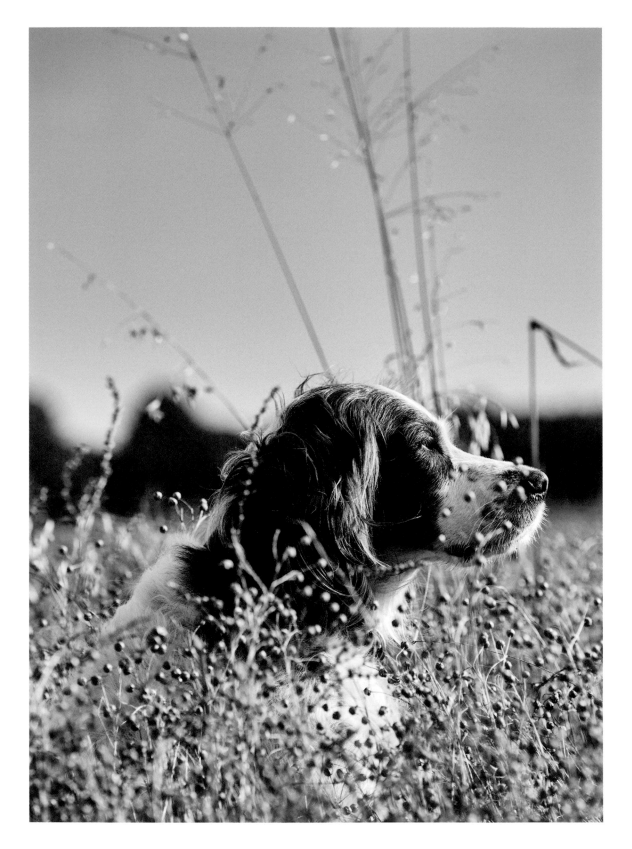

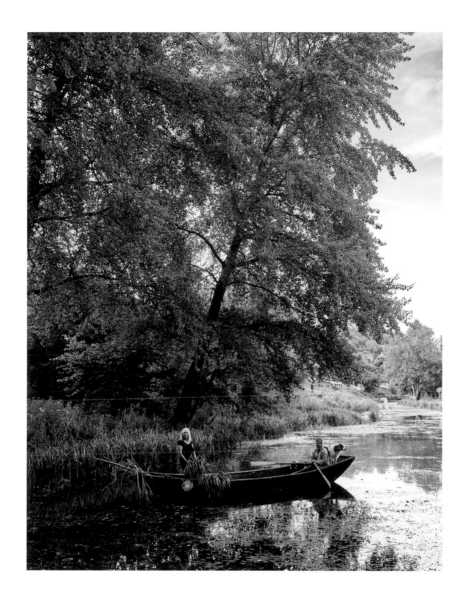

GROW, GROW, GROW THE BOAT photographed by Alun Callender, 2021

Simon and Ann Cooper launched their company, Flaxland, in 2008 from their Cotswolds smallholding. The idea grew from their love of farming, fishing and natural fibres, so when they were looking for a strong fabric to cover the frame of the currachs, coracles and canoes they were building using larch and ash from their farm, flax seemed the perfect solution. 'We liked the idea of growing our own boat,' Simon says. Spaniel Alizee (named after the first type of flax the couple grew) also benefits from the crop with a flax-rich meal plan.

This baby barn OWL needed to be returned to the NEST swiftly after having a tracking ring attached to its leg. 'It was TRICKY to get the shot in less than five minutes,' our photographer Andrew says. 'Sharing RARE sights like this is what makes the job so SPECIAL.'

TAG TEAM photographed by Andrew Montgomery, 2017

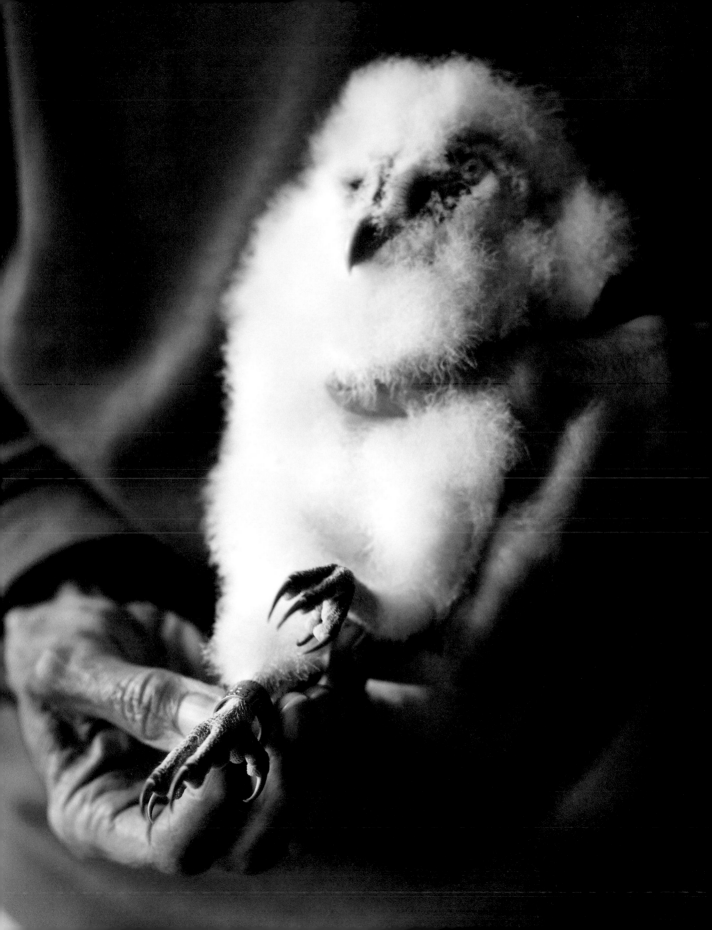

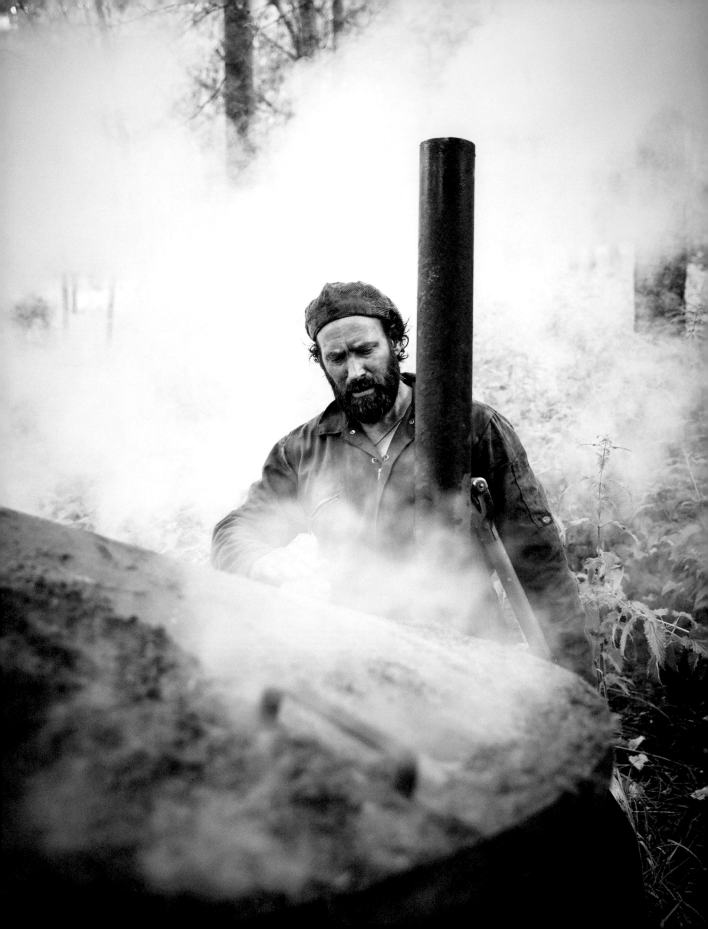

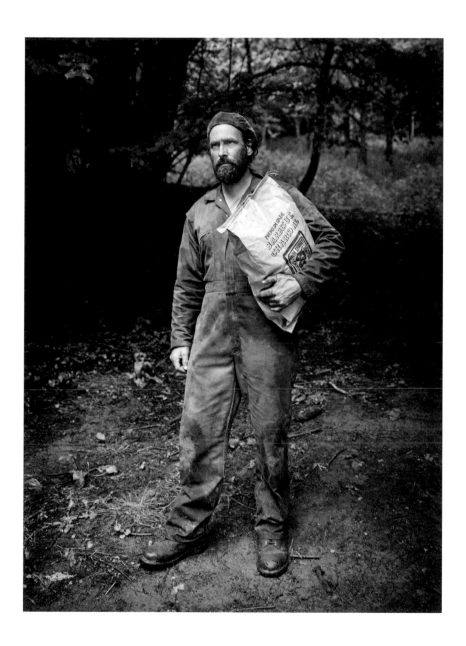

THE CHARCOAL BURNER photographed by Nato Welton, 2018

Ben Short makes his living in the woods of west Dorset as a charcoal burner. It's held to be one of the most ancient crafts in Britain, dating back thousands of years. The large log-pile kilns built for slowly carbonising timber – along with the soot-covered charcoal burners or 'colliers' who tended to them – would once have been a familiar sight in woodlands across the country. 'As with all craft, there's been some resurgence,' says Ben. 'More people are getting the message that we should be buying British charcoal, but it is still a very small industry.'

TAKING UP THE REINS photographed by Nato Welton, 2018

A keen rider from the age of four, Helen Reader makes bridles and saddles by hand to the highest standards, using traditional tools. Inside her Carmarthenshire workshop, shelves are piled high with sheets of leather, each hide traceable back to the cow it came from. Her two horses and ponies, including Mulberry (opposite), who shares a stable with outdoor cats Lynx and Sox, have free rein over the 20 acres of family-owned land in South Wales where Helen lives and works.

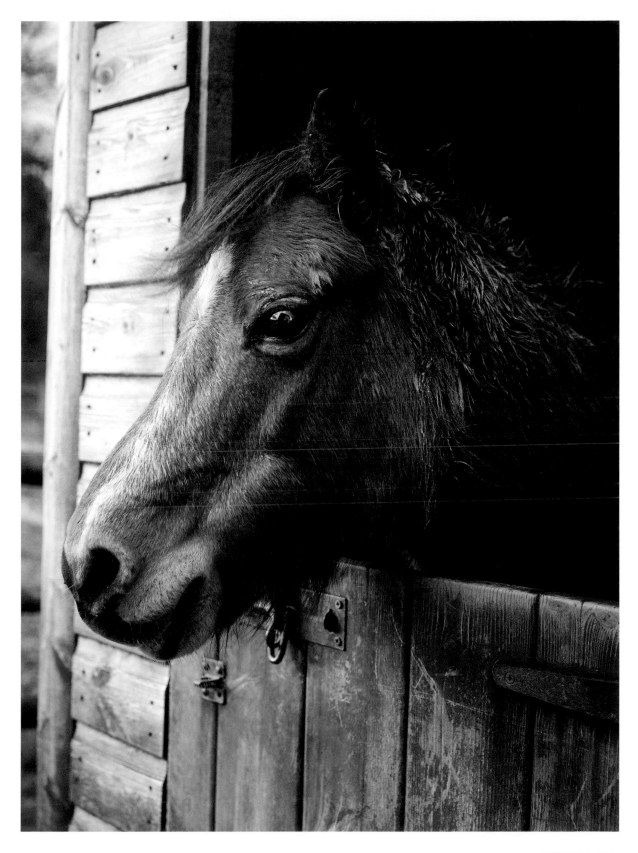

discover...

KILCHURN CASTLE

On a small peninsula jutting out into the aptly named Loch Awe, near Dalmally in Argyll and Bute, stands the imposing ruins of Kilchurn Castle, once the powerbase of the mighty Campbell clan. Originally built around 1450, the castle was abandoned after being badly damaged by a lightning strike in 1760. This shot vividly captures its breathtaking backdrop of sweeping hills amid a dramatic explosion of fiery autumn colour.

KILCHURN CASTLE, NEAR DALMALLY, ARGYLL AND BUTE

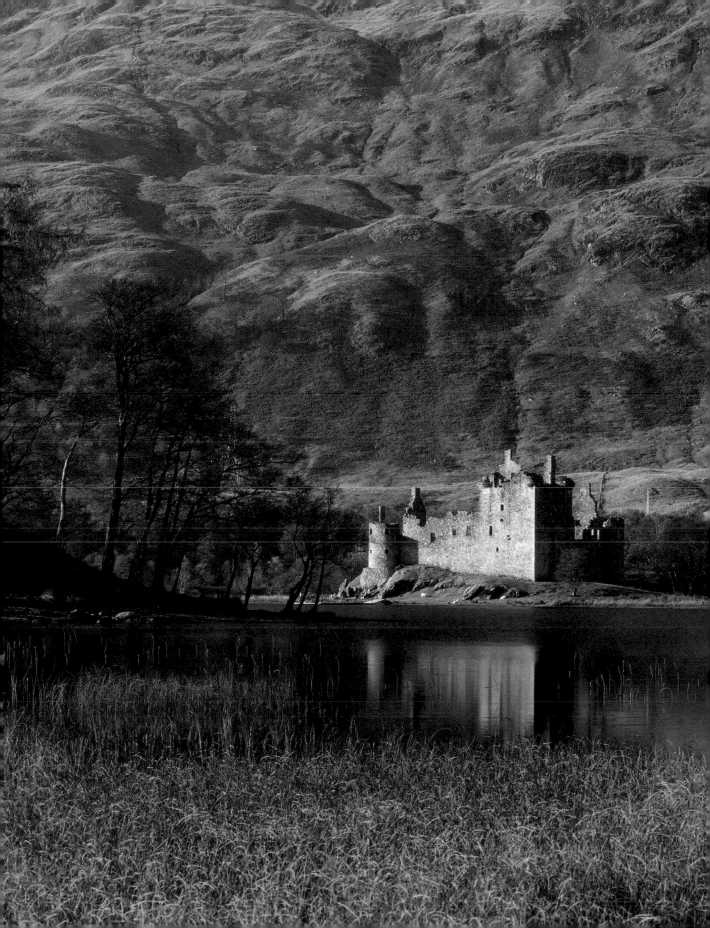

Autumn is the season when MAGIC happens. Nature puts on its annual PYROTECHNICS display and those bright, crisp days are PERFECT for stepping outside to appreciate the trees ABLAZE with golden yellow and fiery auburn HUES. So grab your coat and take in the show.

AUTUMN HUES photographed by Brent Darby, 2020

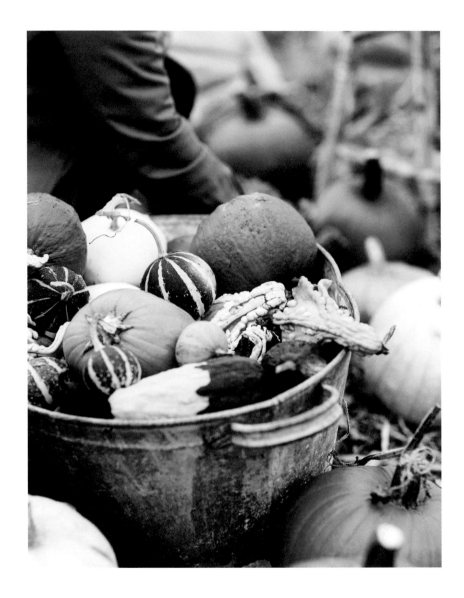

PUMPKIN PATCH photographed by Brent Darby, 2019

As synonymous with the season as leaves falling from the trees, pumpkins and squashes are quintessential autumn fruit (for fruit they are, botanically speaking, growing from the flowers of the plant and encasing their seeds inside their colourful skins). Piled high in their burnished glory, these Halloween favourites create a vibrant autumnal display, interspersed with fruits, foliage and flowers in a selection of rustic pots, buckets and vases.

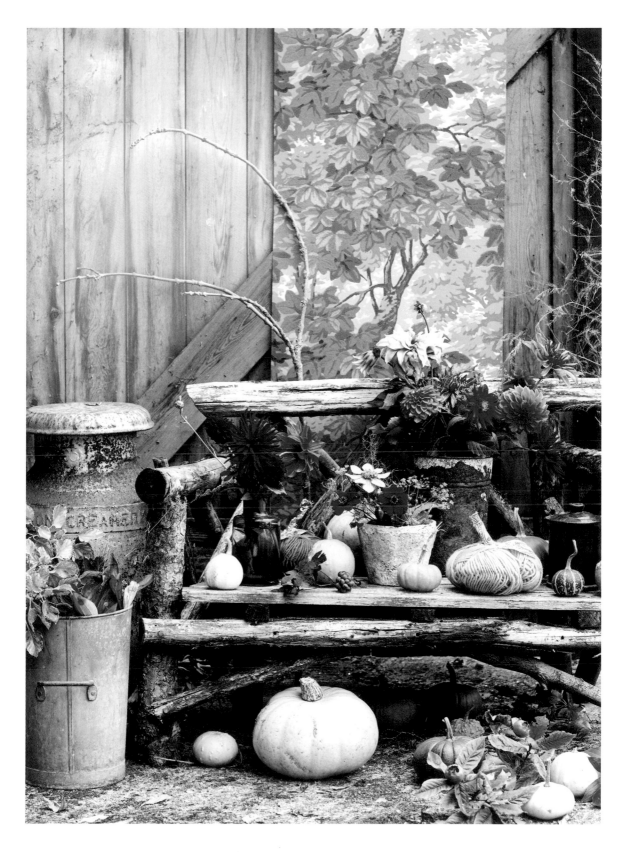

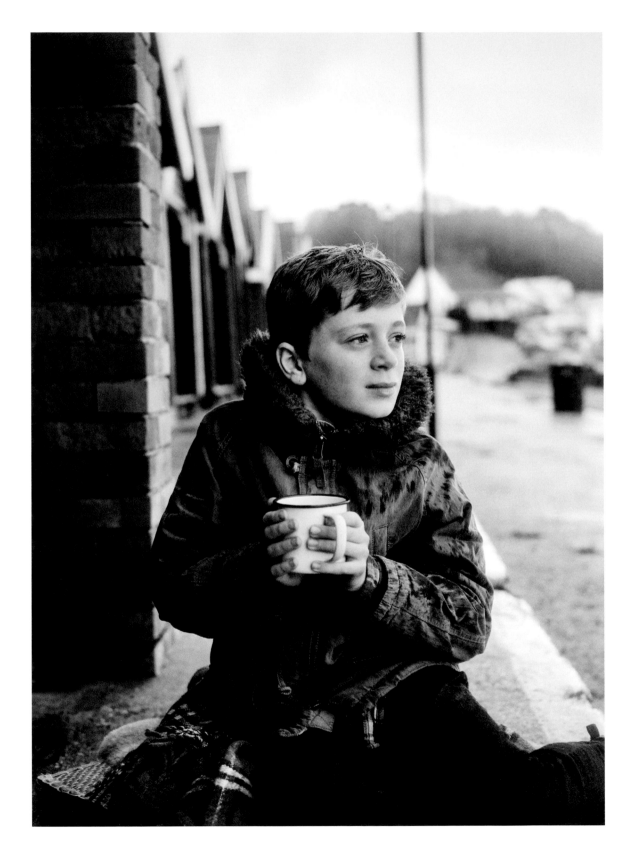

CANDID CAMERA photographed by Andrew Montgomery, 2020

Sometimes, the perfect picture happens when you least expect it. During a break from shooting a feature about Isle of Wight globemaker Lander & May and its owner Chris Adams, photographer Andrew came across Chris's son Charlie in a candid moment outside the business's boatyard workshop. There are very few craftsmen still skilled in the age-old tradition of globemaking, and Andrew's informal image has a certain timeless quality that seems to capture this connection with the past.

As the GARDEN begins to wind down, it's a great opportunity to sort your shed – hanging up watering cans, CLEANING hand tools and storing vegetables, such as PARSNIPS, for winter.

ROOTS OF THE EARTH photographed by Sussie Bell, 2019

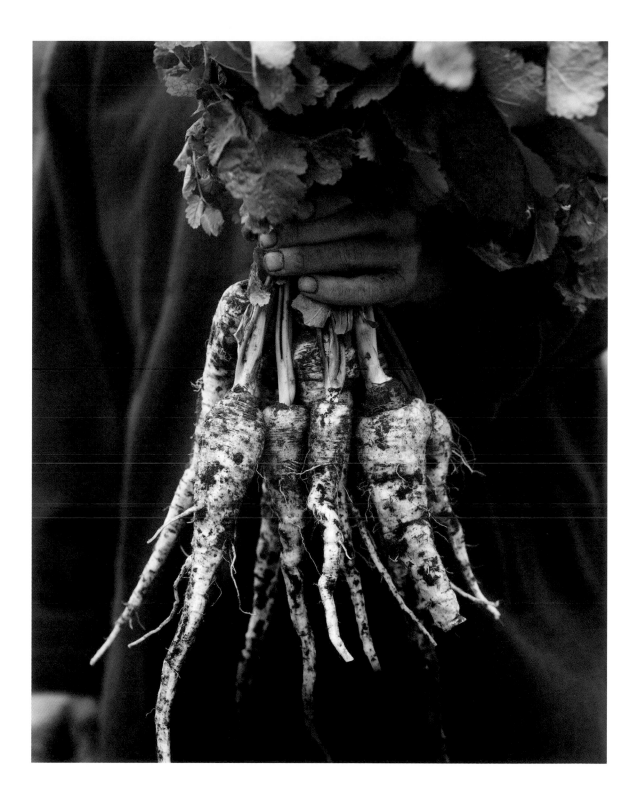

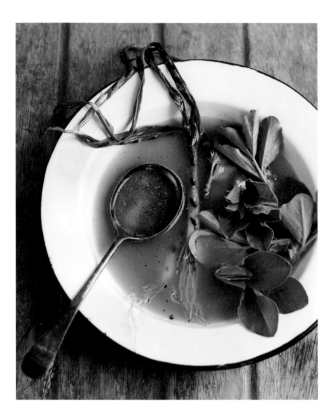

A TASTE OF THE SEASON
photographed by Andrew Montgomery, 2016

Chef Gill Meller has lived in the west Dorset/east Devon area all his life and has been involved in sourcing sustainable and ethical foods. The field-to-fork mentality of good ingredients simply prepared is key to his approach. 'My cooking is not so much about the end result as the whole journey,' explains Gill, who has built up relationships with local producers, growers and farmers. 'Everything I do hangs on these amazing people,' he says, 'and respecting their part in this chain.'

CLOTH OF AGES photographed by Andrew Montgomery, 2016

The textile tradition in Donegal has deep roots, stretching back centuries, and as recently as the 1950s, every family in the parish would have had at least one weaver. The industry has long been under threat, but Molloy & Sons – weavers for six generations – is making a global success of this heritage product. The tweed produced at this family-run company is all woven to order and used mostly to make menswear, as worn here by local Donal McMenamin, but also for womenswear, blankets and upholstery.

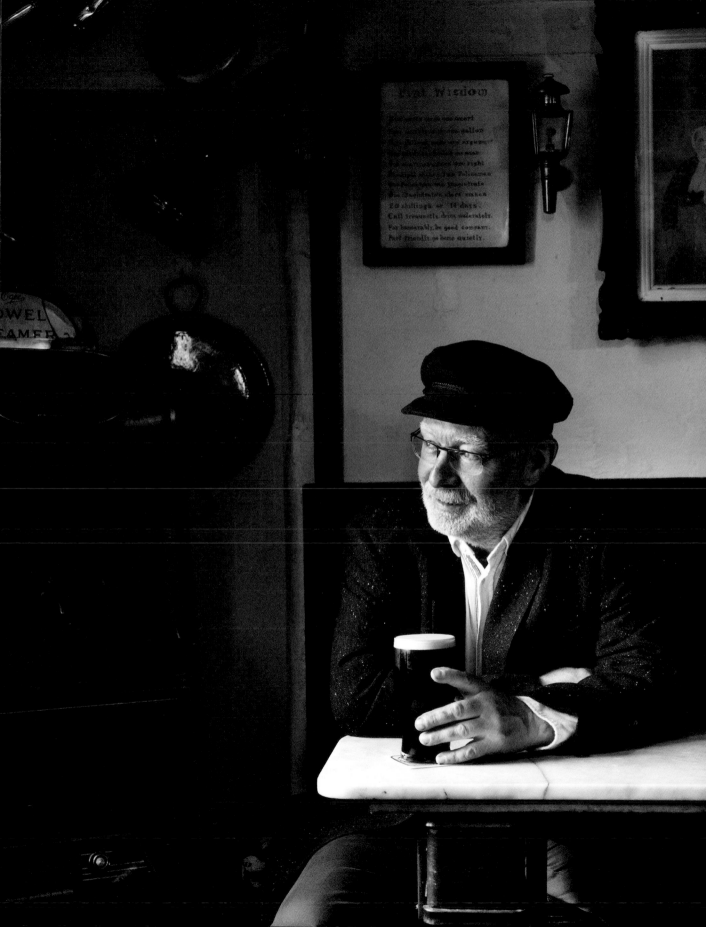

Not your average FUNGI, these oyster mushrooms were GROWN on recycled coffee grounds at the Espresso MUSHROOM Company in Sussex.

NATURAL PERFECTION photographed by Jan Baldwin, 2015

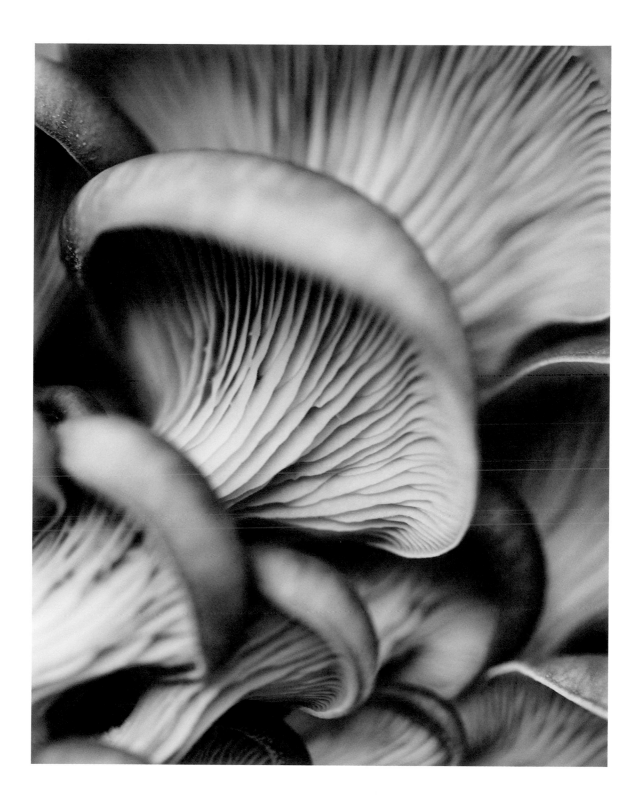

SEASON OF MISTS photographed by Alun Callender, 2019

With a carpenter father and boat-builder grandfather, a love of wood is in Alice Blogg's blood. At her hillside workshop in Dorset, the furniture-maker creates elegant pieces – from chests of drawers and teasel-shaped lampshades to 12-seater dining tables and solid-wood kitchens – all with intricate detailing that reveals the natural beauty of the local timber. 'Working up in the hills gives me more room to do what I want,' says Alice. 'I naturally appreciate the trees more, too. I have always loved learning about nature and habitats.'

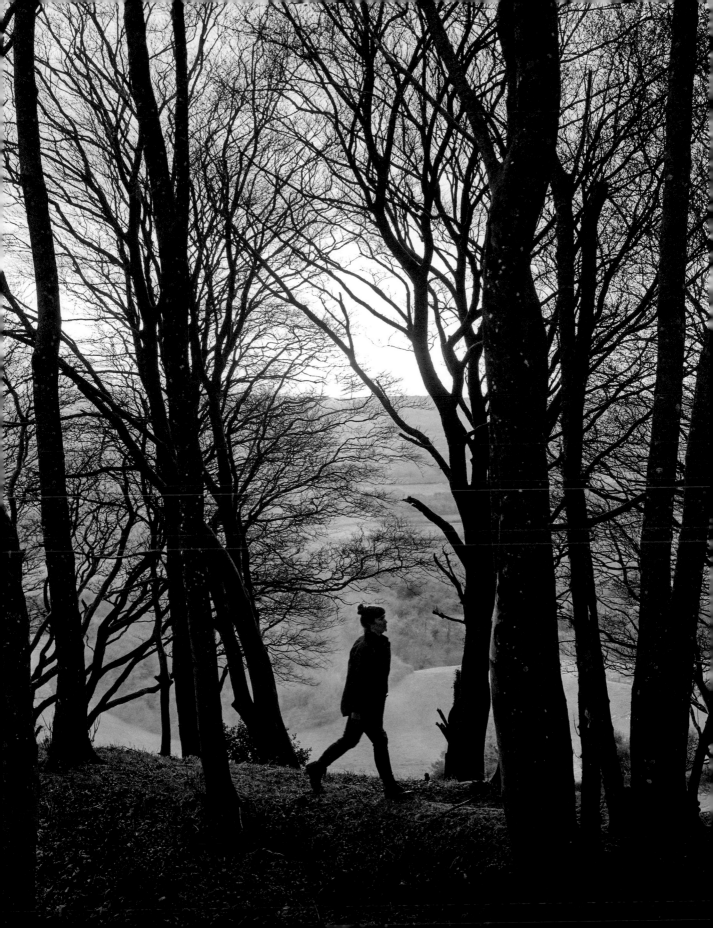

WINTER

WINTER'S TALES

December, the month of sleep. Dormice, hedgehogs and badgers have taken themselves off to bed and the earthworm has headed deeper into the soil in search of warmth. Deciduous trees are bare, revealing any hidden bunches of mistletoe with their waxy, grey-white berries and oval-ended leaves. Not all the trees are naked – evergreens come into their own during the winter months: thick-coated yews, firs and pines stand like sentinels, their strong branches ready to take the weight of the first fall of snow.

Cottage chimneys smoke with wood gathered and stacked in the months before, the ultimate act of faith in the seasonal cycle. January needs cheer more than any month – Christmas is over and spring still feels out of reach but in the garden there's already a reason to smile: snowdrops begin to emerge through the frozen soil, gently chastising our impatience. Up on the moors common gorse, with its distinctive coconut perfume, begins its six-month bloom.

Come February, while many animals are still laying low, the brown hare begins her breeding season; when she's ready to mate, she'll start a game of kiss-chase that tests the stamina of any males fast enough to follow her through the open farmland. With luck, just six weeks later, the arrival of tiny furred leverets signals that spring is just around the corner.

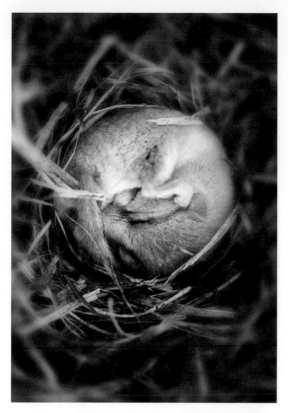
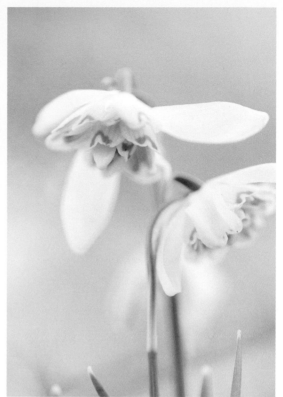
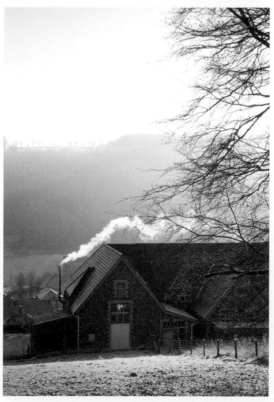
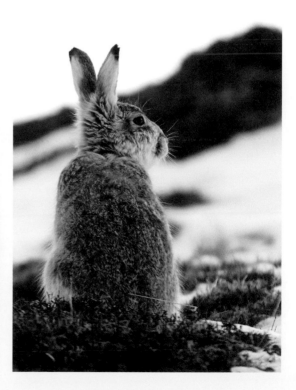

THE FARM AMONG THE FELLS photographed by Andrew Montgomery, 2014

At 900 feet above sea level, Far Six Acre field is the coldest corner of Old Stoddah Farm where Jane Emerson and her partner Peter Stoeken began producing venison in 1987. 'It took three years to make this picture happen,' photographer Andrew says. 'We waited and waited for the snow to fall.' When it finally did, he dashed north and was rewarded with this fairy-tale shot of red deer in the snow-covered landscape. 'It's challenging to work in such blistering cold conditions because you're dressed up like a Michelin man, but have to take the gloves off to operate the camera – then can't operate the camera because your fingers are too cold,' he laughs. Even the hardy herd were later moved indoors to warm up in a shed.

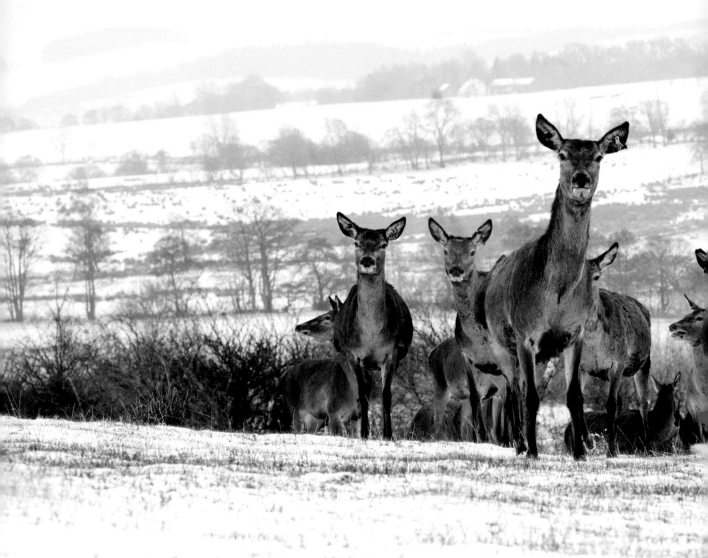

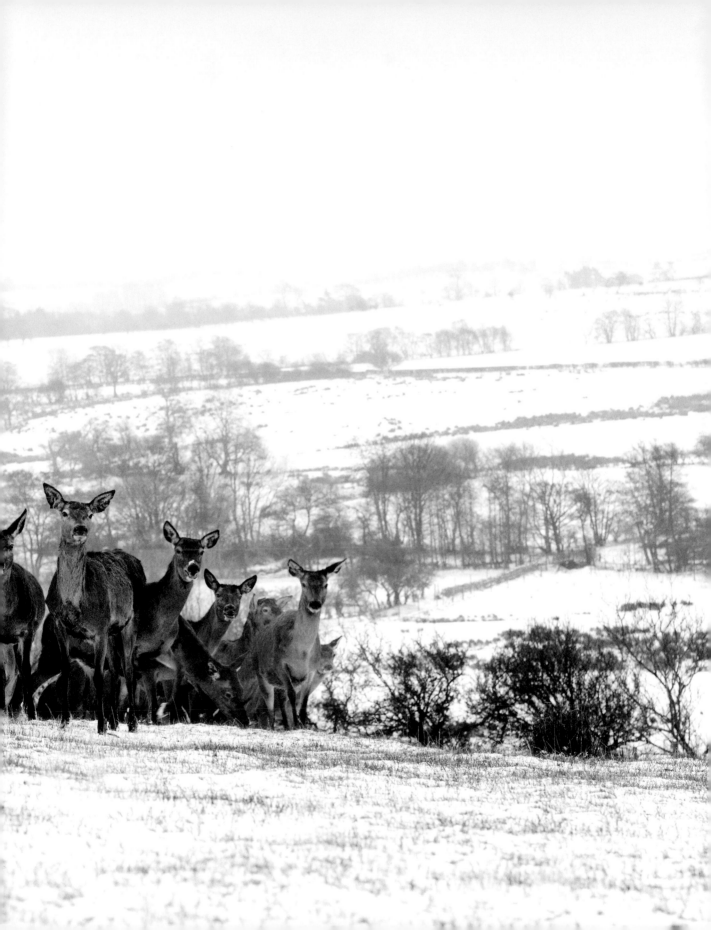

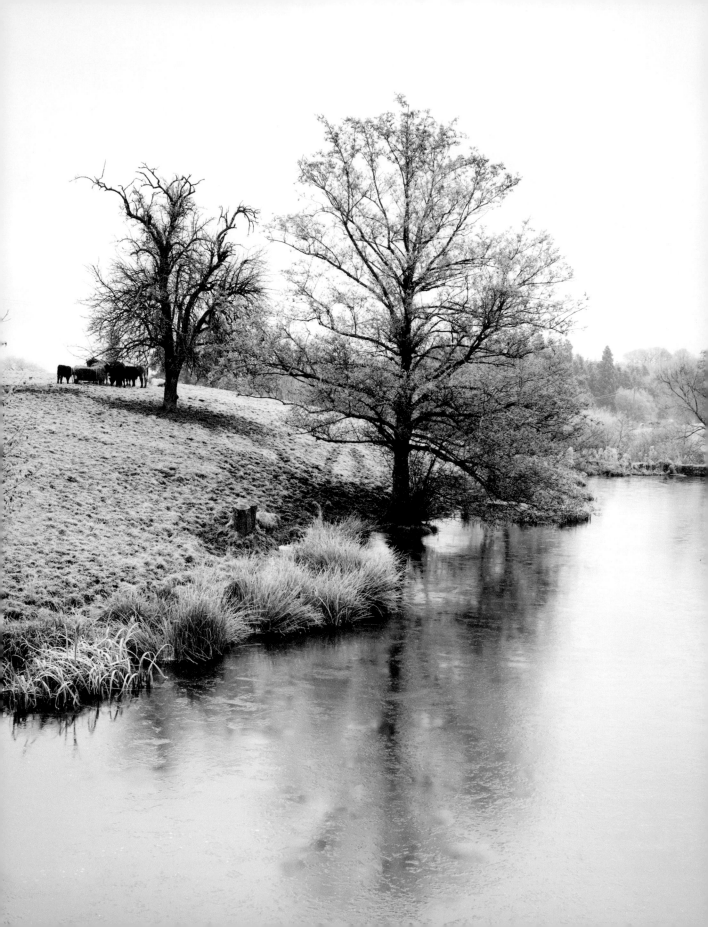

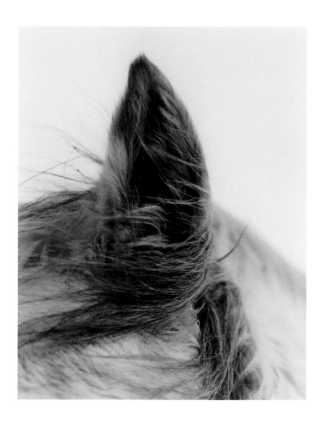

LEND AN EAR
photographed by Andrew Montgomery, 2007

The wild ponies of Carneddau in western Snowdonia are perfectly adapted to the rugged beauty of the landscape in winter, when blizzards swirl across the mountains and snow carpets the tussocky slopes. For most of the year, the ponies are 'cynefin' or 'hefted' like many upland sheep. This means they are free to wander over a huge area, but instinctively stick to familiar territory, and pass this knowledge on to their offspring.

WINTER LANDSCAPE photographed by Andrew Montgomery, 2013

The hoar-frosted pasture, apple orchards and streamsides sparkle in the low winter sun at Longlands Farm on the Herefordshire-Worcestershire border, creating a magical scene.

CAPTURING A COMMUNITY
photographed by Nato Welton, 2019

Dartmoor's boundless beauty – its vast moorland's weathered charm and ample opportunity for solitude – makes the area popular with creatives looking to escape the rat race. From bowl-turners to weavers, potters to shoe-makers, the National Park is home to a burgeoning community of crafters. To help put them on the map, photographer and journalist Suzy Bennett founded The Dartmoor Artisan Trail to connect visitors with local artisan producers.

NATURAL BEAUTY
photographed by Jason Ingram, 2020

Jason spent a year cataloguing the changing seasons at Woodhill Manor in the Surrey Hills. Head gardener Kate Halls and her team of experts ensure that whatever the season, there's always something of interest on display, such as this beautifully speckled double hellebore 'Double Ellen Picotee', a recently discovered favourite of Kate's.

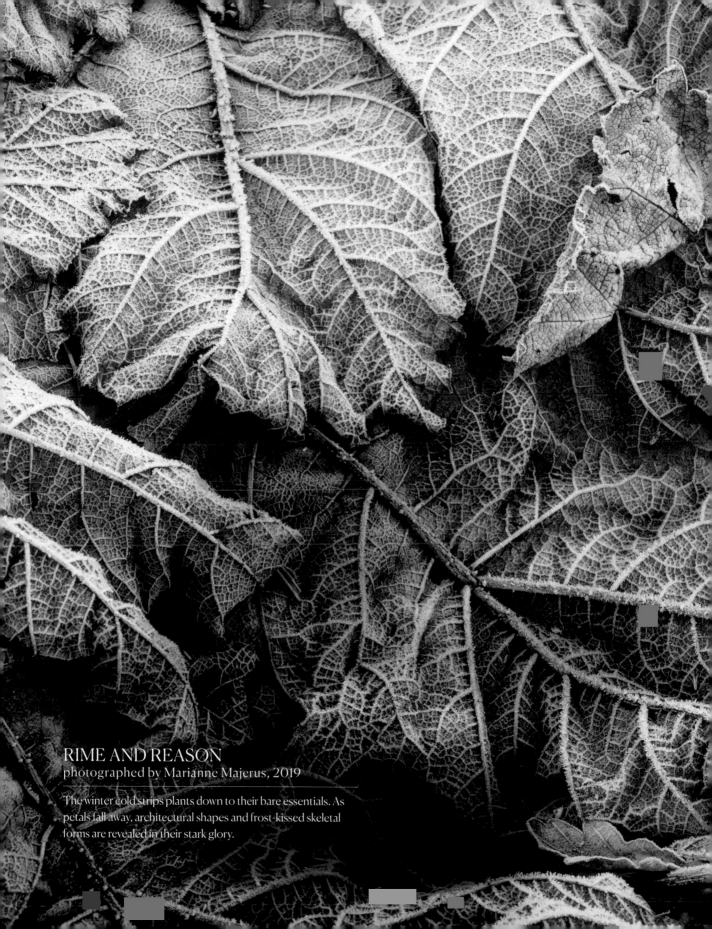

RIME AND REASON
photographed by Marianne Majerus, 2019

The winter cold strips plants down to their bare essentials. As petals fall away, architectural shapes and frost-kissed skeletal forms are revealed in their stark glory.

Spotters' guide...
SCOTTISH WILDCAT

Teetering on the edge of extinction, the Scottish wildcat survives only in remote areas of the Highlands, such as the Cairngorms National Park, where this photograph was taken. Twice the size of its domestic cousin and much more ferocious, this solitary super-predator embodies the mysterious, untamed spirit of its wild habitat. In winter, snowfall makes them easier to spot as, emboldened by hunger, they venture out more in daylight to hunt for food.

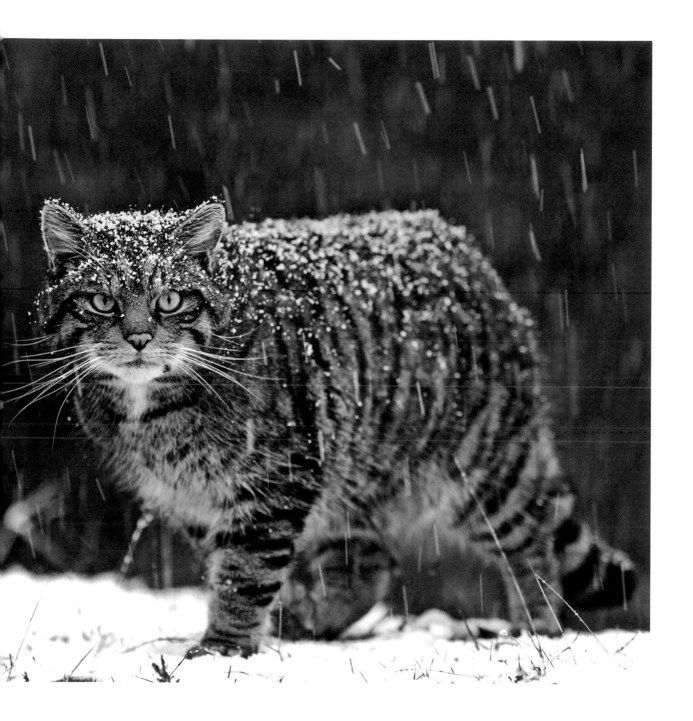

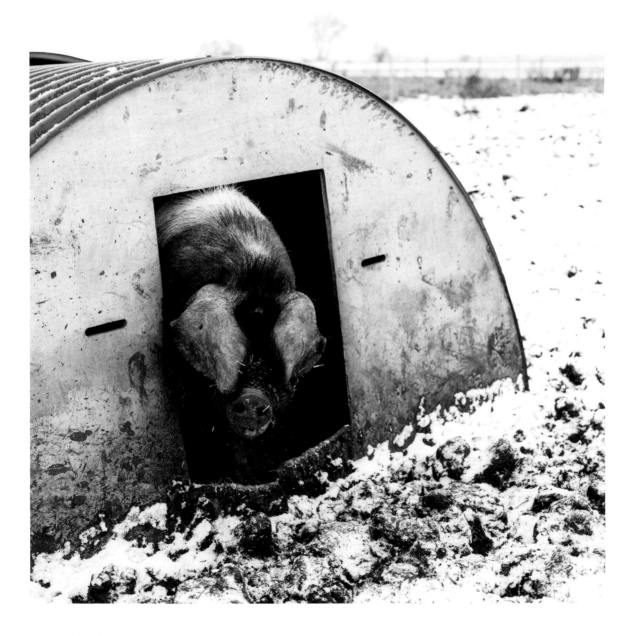

Priscilla was one of ten sows on a community SMALLHOLDING in Cambridgeshire. 'If I plan to photograph PIGS, I wear full waterproofs, as I'll likely be KNEELING down in the mud,' Cristian laughs.

SOW IN THE SNOW photographed by Cristian Barnett, 2013

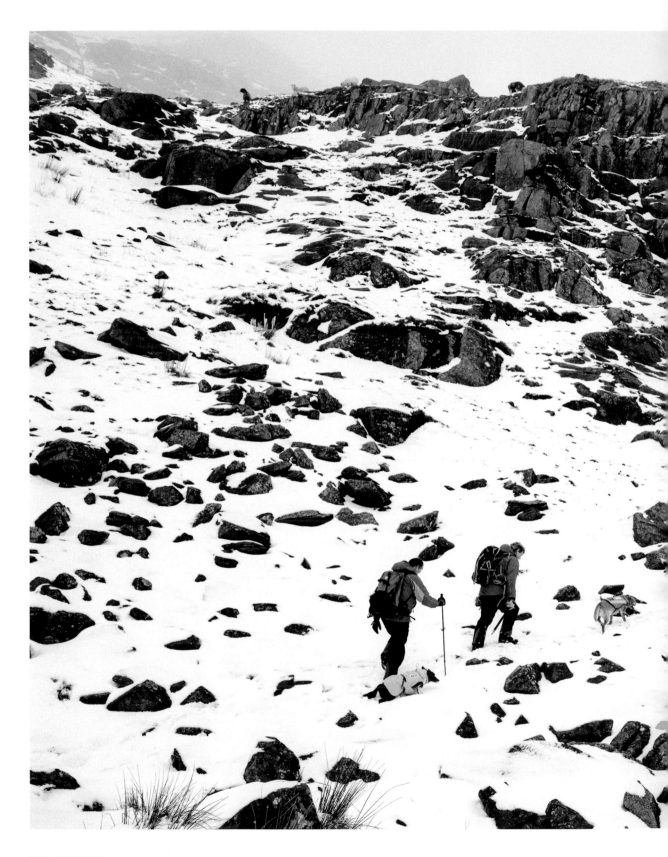

DOG STARS photographed by Andrew Montgomery, 2021

The Lake District may be beautiful, but it can also be hazardous. Each year, rescue teams receive hundreds of callouts to help injured and stranded hikers and climbers. In many of these incidents, search dogs, such as Labrador Rona and Border collie Brock, assist in locating them. These four-legged heroes belong to the Lake District Mountain Rescue Search Dogs Association, a voluntary group of handlers and their canine companions who are called out by local rescue teams.

SPRING IS ON ITS WAY photographed by Brent Darby, 2016

Heralding the end of the long winter months, pearly white snowdrops are like little promises of spring amid the gloom of January. Step out on a woodland walk and discover delightful drifts of this graceful flower. Although they are not native to the UK, snowdrops are thought to have been first grown as an ornamental garden plant in the 16th century and were only recorded in the wild in the late 18th century.

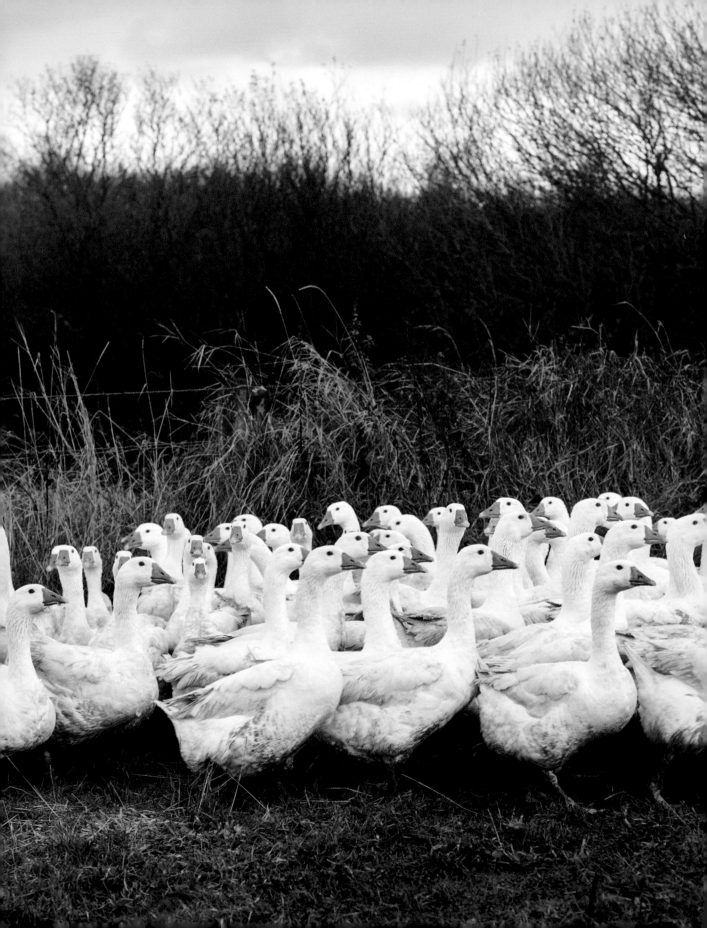

At Olive Elliott's poultry farm in Northern Ireland, the run-up to CHRISTMAS is especially busy as the last birds are delivered all over the country. Her free-range flock comprises about 1,000 turkeys, GEESE, chickens and ducks. 'The geese have their own four ACRES of GRASSLAND for roaming and prefer a routine and familiar faces,' she says.

THE HAPPY FLOCK photographed by Andrew Montgomery, 2020

UNDER THE MISTLETOE
photographed by Alun Callender, 2018

Come December, the apple orchards on Mark Adams's family farm
in Worcestershire provide the perfect conditions for mistletoe,
and the skeletal branches are covered with globes of glossy,
dark-green foliage with pearly white berries. Like generations
before him, Mark removes it each year, not just to sell but to help
the trees, as mistletoe takes nutrients from trees, making them
more likely to be blown down in winter winds or lose branches
under the weight of snow.

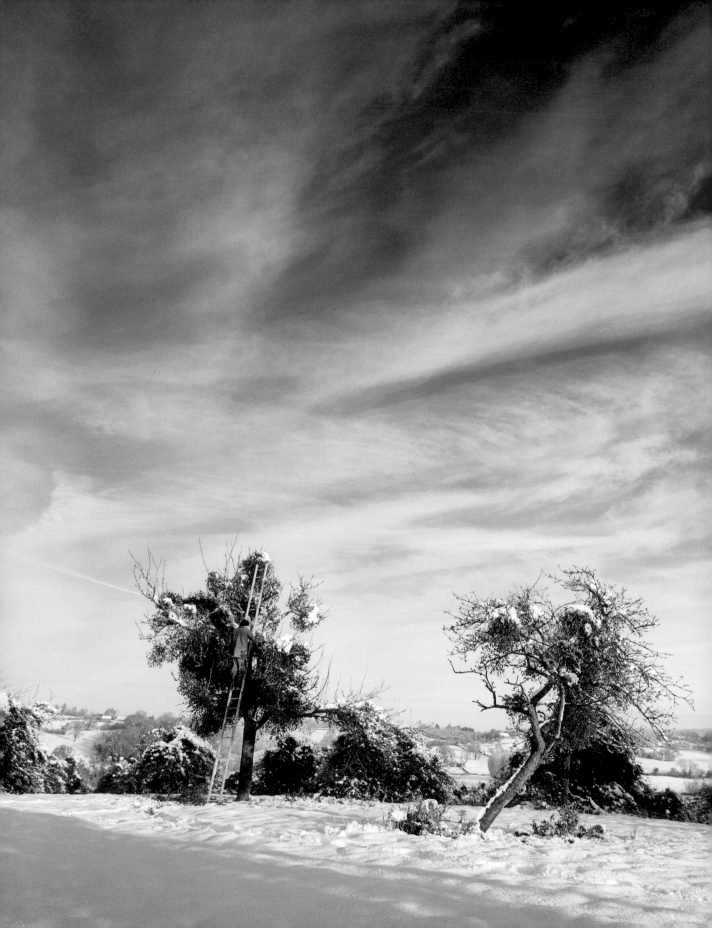

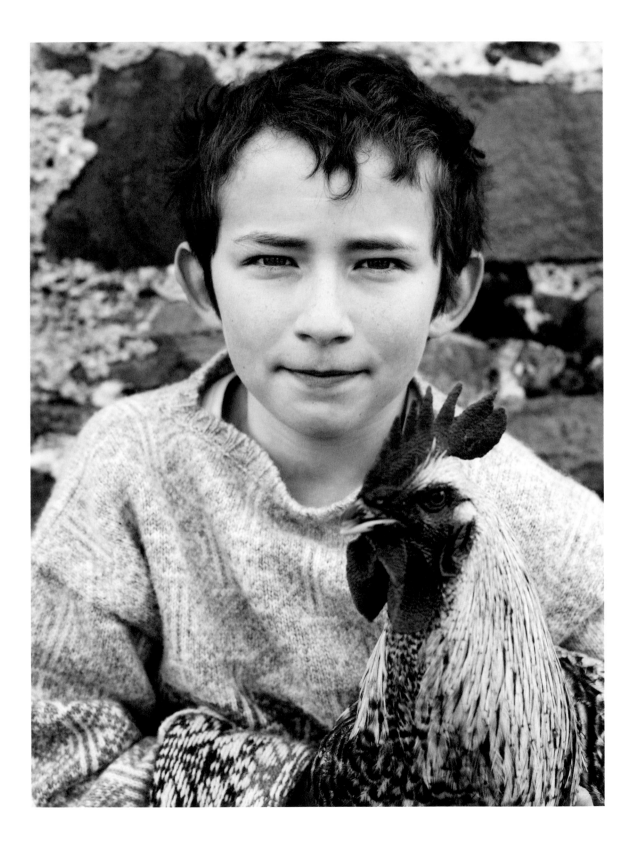

TIGHT-KNIT COMMUNITY photographed by Andrew Montgomery, 2015

Mati Ventrillon and her children have embraced traditional life at their croft on Fair Isle, and the fleeces from her flock of 20 Shetland sheep feature in her exquisite knitwear, for which she draws on the island's world-famous tradition, dating from the 1850s. 'Everyone here knits, and the patterns are so beautiful that I wanted to master the craft,' she says. Mati bases her designs on the early pieces that she discovered at Shetland's Museum and Archives. Sebastian (left) helps on the croft by gathering eggs from the family's hens.

Capturing Snowdonia's wild PONIES on camera wasn't easy. 'I had to commando-crawl through the SNOW so they didn't see me,' says our photographer Andrew.

BORN TO BE WILD photographed by Andrew Montgomery, 2007

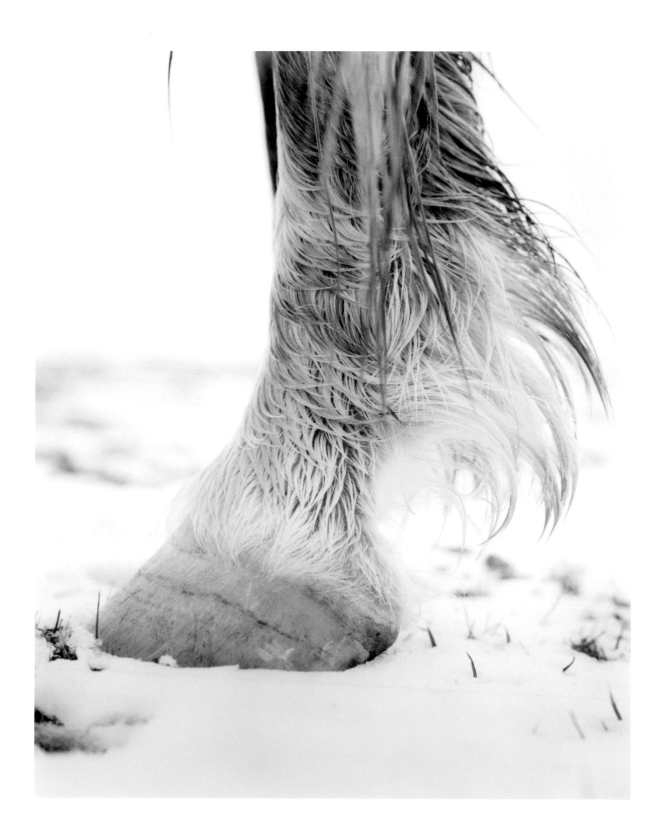

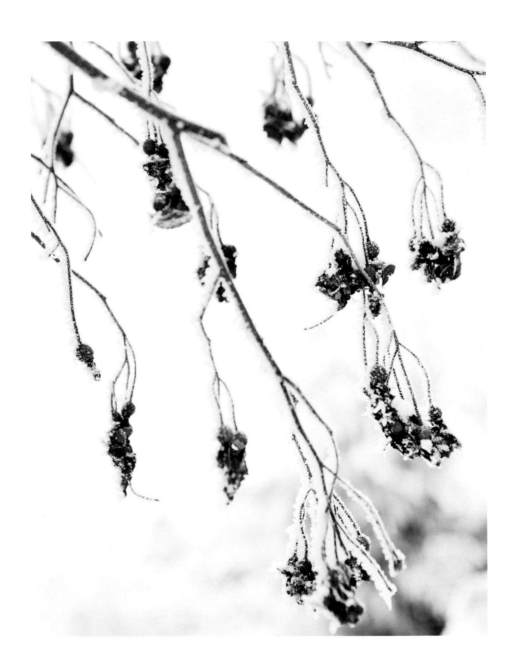

IN THE DEEP MIDWINTER photographed by Ester Sorri, 2020

A fresh blanket of snow transforms the garden into a magical wonderland of ethereal silhouettes and brings form to the fore, as familiar views take on a new appearance. Outlines soften or disappear entirely; evergreens carry a delicate frosting or bow snow-laden branches down towards the ground; trees stand in sharp silhouetted relief and traceries of twigs weave patterns in the air.

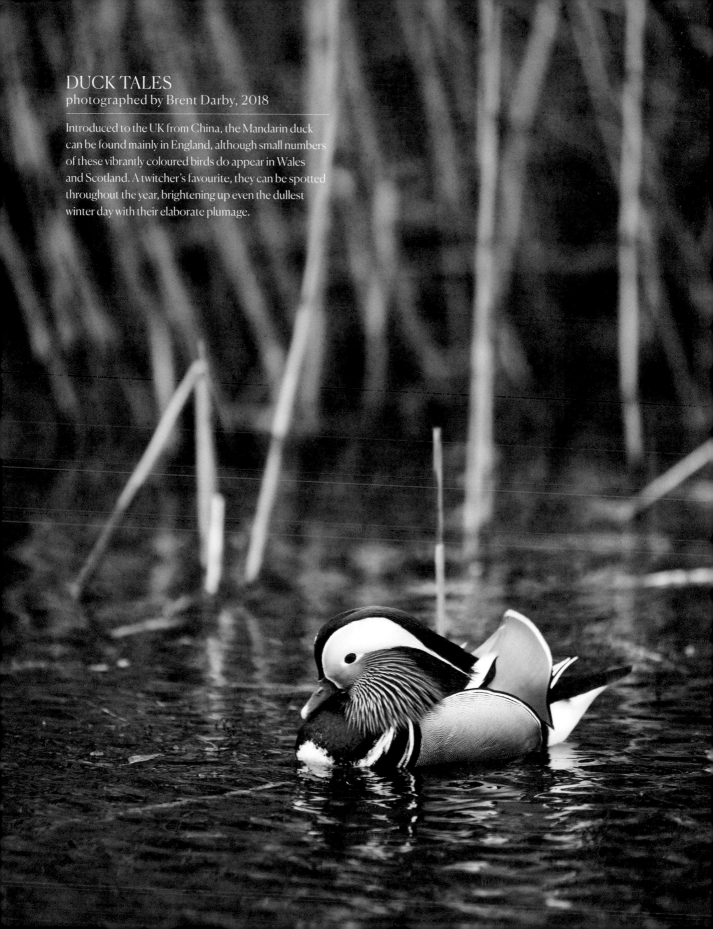

DUCK TALES
photographed by Brent Darby, 2018

Introduced to the UK from China, the Mandarin duck can be found mainly in England, although small numbers of these vibrantly coloured birds do appear in Wales and Scotland. A twitcher's favourite, they can be spotted throughout the year, brightening up even the dullest winter day with their elaborate plumage.

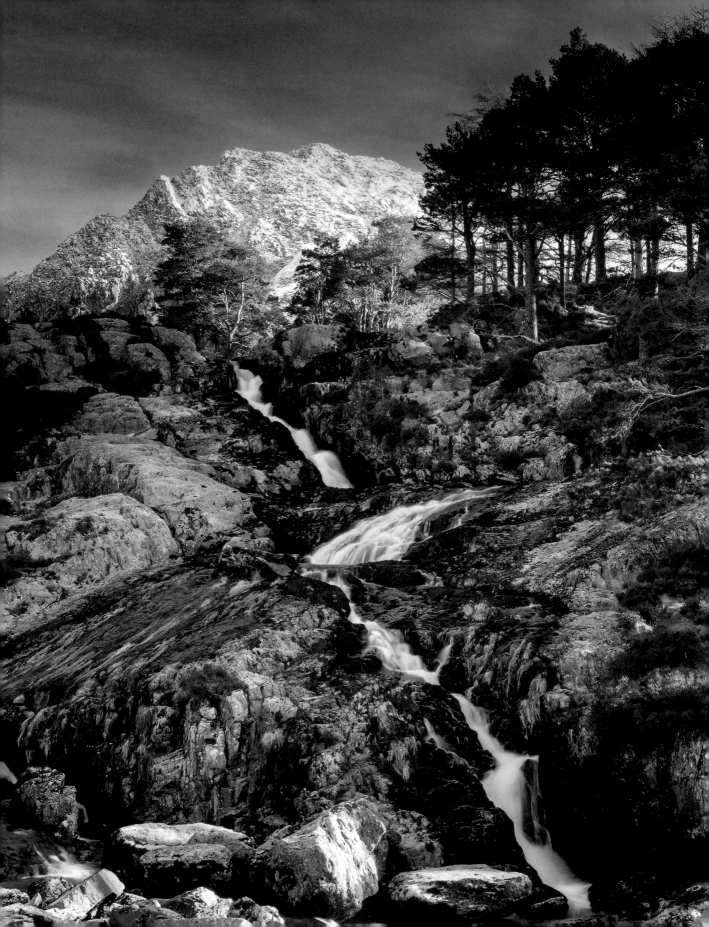

discover...

SNOWDONIA NATIONAL PARK

Snowdonia National Park, North Wales, is the location of the panoramic Rhaeadr Ogwen or Ogwen Falls. This marks the point where the Ogwen River starts its journey from Llyn Ogwen to the sea, through the rugged, steep-sided Nant Ffrancon valley, which was carved out by glaciers in the Ice Age. The Falls look particularly spectacular in winter, with the snow-capped crags of Tryfan mountain in the background.

OGWEN FALLS, SNOWDONIA NATIONAL PARK, NORTH WALES

Lake District DEER farmer Peter Stoeken patrols his FENCES together with lucky Weimaraner Charlie, whose diet consists largely of VENISON off-cuts.

LIVING OFF THE LAND photographed by Andrew Montgomery, 2014

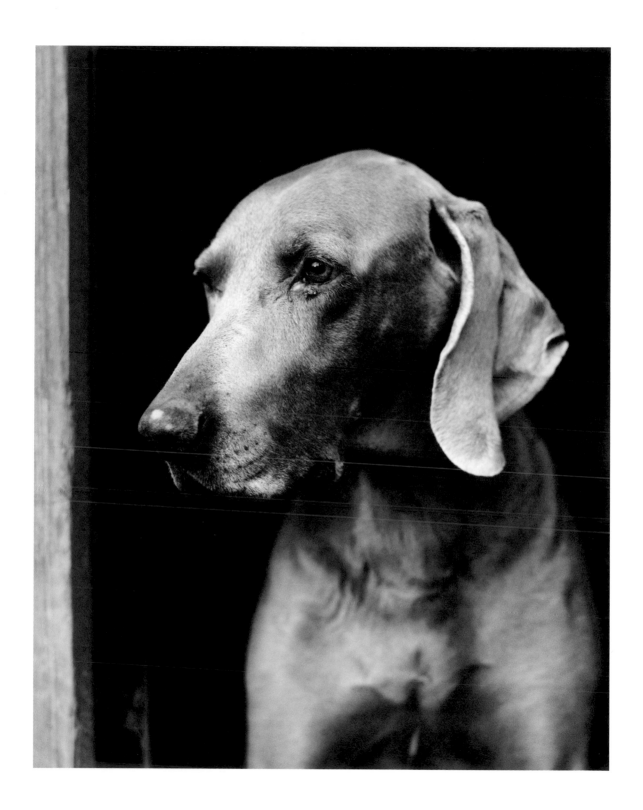

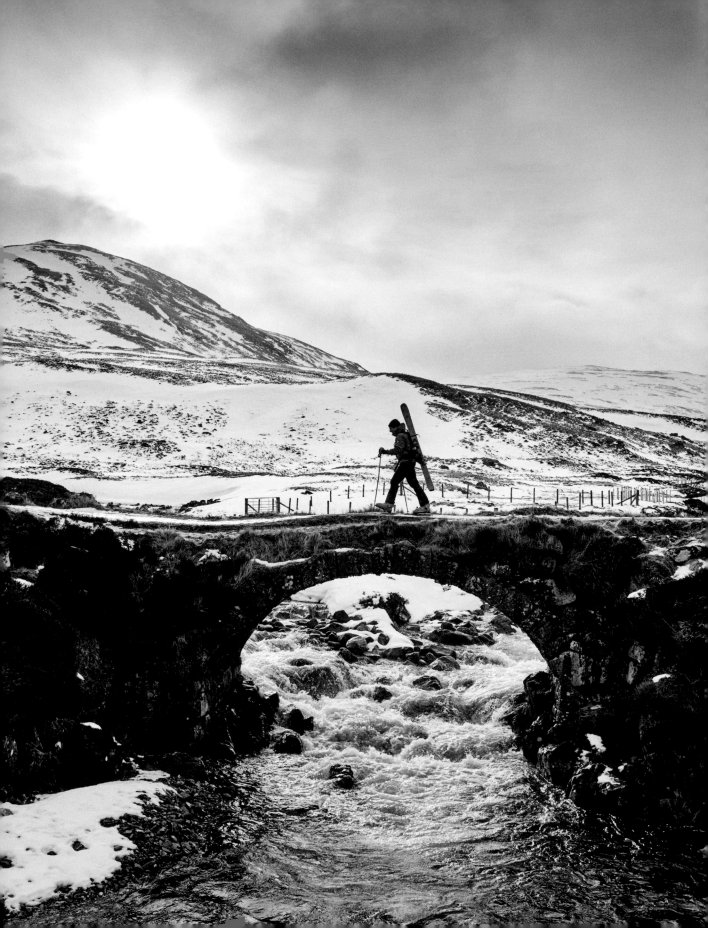

HIGH DRAMA photographed by Alun Callender, 2017

Perched precariously on a stack of rocks with ice-cold water gushing around him, Alun achieved this shot of ski-maker Jamie Kunka after the pair spent the day hiking through Perthshire's snow-topped Munros to capture Jamie's wooden skis in situ. After reaching the top of one such mountain at Glenshee Ski Resort, storm clouds and thunder began to roll in from the north. Jamie effortlessly skied down the slopes, leaving Alun to dart to the cable car station to catch the last one. 'It was a hair-raising and exciting journey!' he recalls.

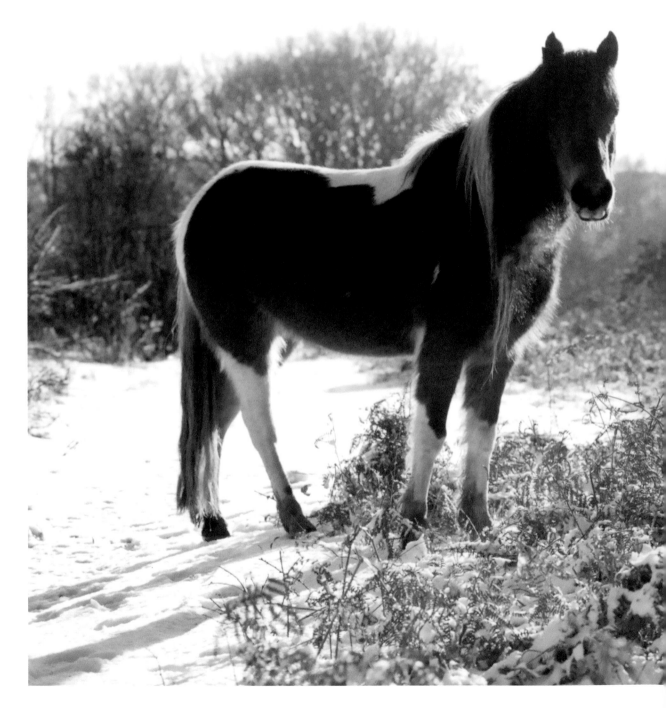

COMMON GROUND
photographed by Andrew Montgomery, 2004

A recognised British Isles breed, New Forest ponies may roam freely but are owned by New Forest Commoners who have had the right to graze their animals on 'common' land since William the Conqueror declared the area his private hunting ground. Each year, the ponies are rounded up in 'drifts' so their health, and that of their foals, can be checked.

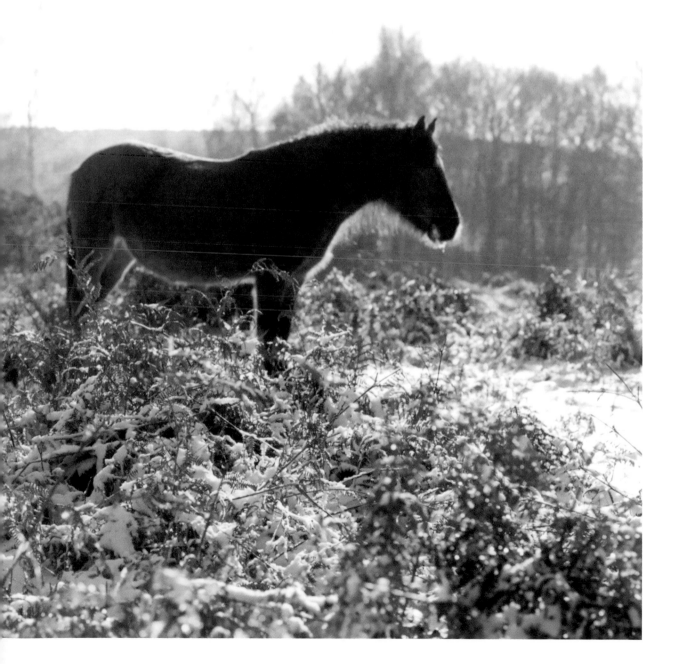

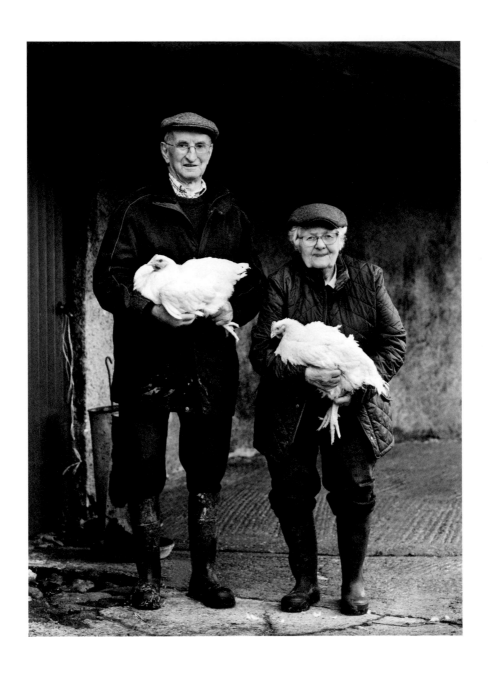

THE POULTRY PIONEER photographed by Andrew Montgomery, 2020

Olive Elliott and her husband Donald began farming poultry at Marlfield Farm overlooking Strangford Lough, in Northern Ireland, in the Seventies when Olive was offered the breeding stock of Bronze turkeys from her old college and learned how to hatch eggs using an incubator. 'I was the only woman doing it and people said that I wouldn't succeed,' she says.

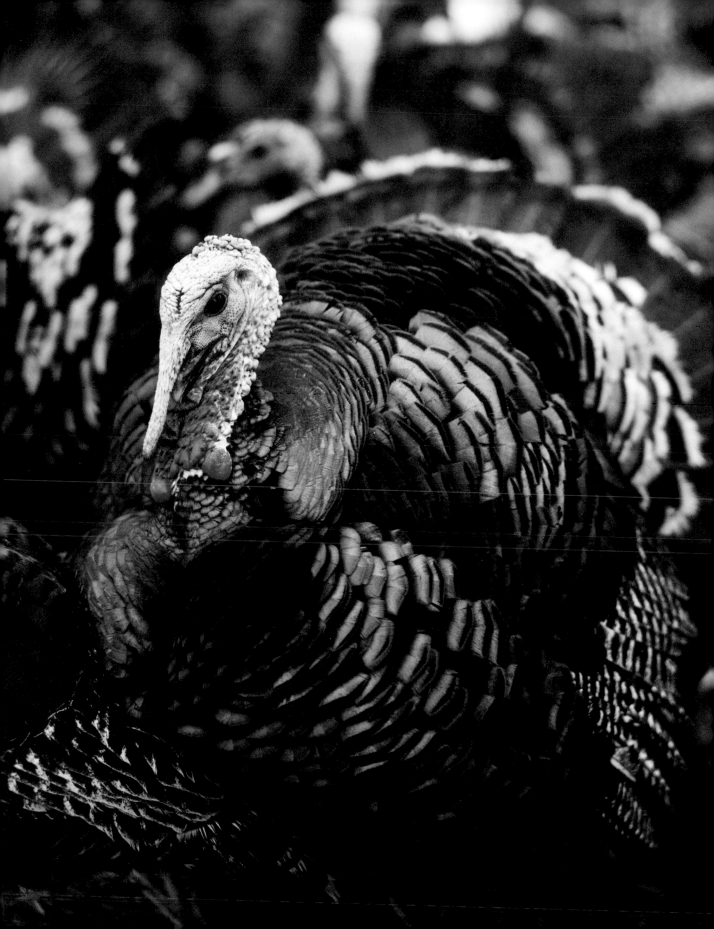

HOME TO ROOST photographed by Andrew Montgomery, 2017

Jo and Ed Cartwright raise free-ranging chickens and turkeys on their traditional mixed farm in West Yorkshire. Farming organically, supporting local wildlife and educating others about where their food comes from in the process, they organise regular farm tours so that customers can see for themselves the happy outdoor lives the animals lead. 'We actually encourage people to eat less meat,' Ed says, 'by explaining how it's better for the environment, the animals and you.' His mantra is 'eat less, eat better and eat it all', which is reflected in the farm's nose-to-tail, no-waste ethos.

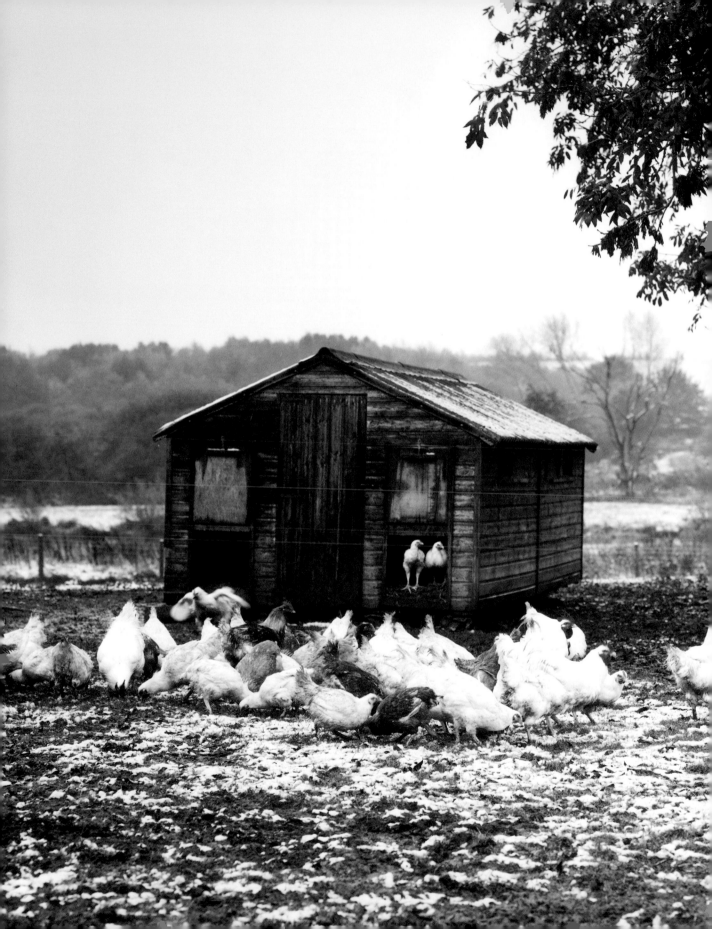

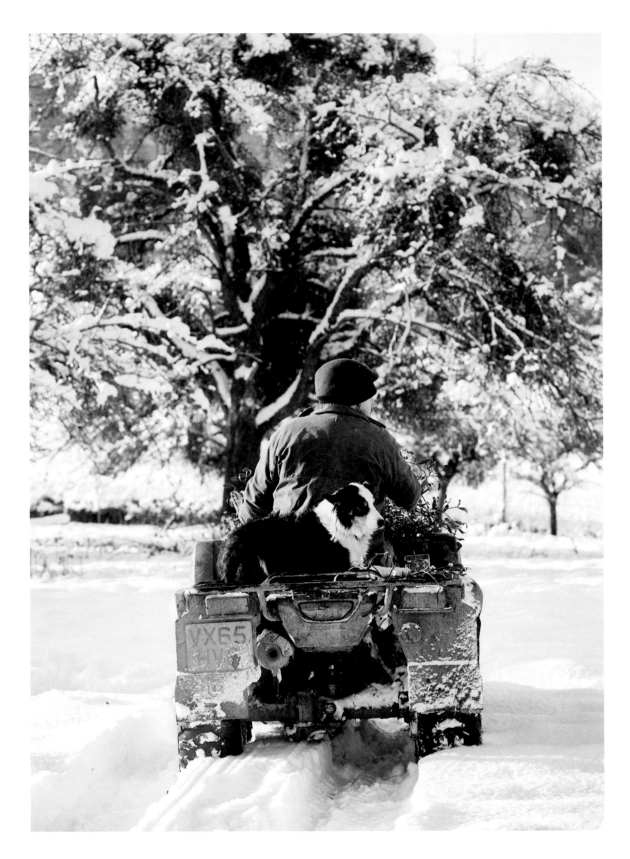

When MISTLETOE farmer Mark Adams harvests his festive foliage in Worcestershire, SHEEPDOG Meg comes along for the ride. Photographer Alun says: 'It was the best snow I'd had for a shoot, with BEAUTIFUL low light.'

FESTIVE HARVEST photographed by Alun Callender, 2018

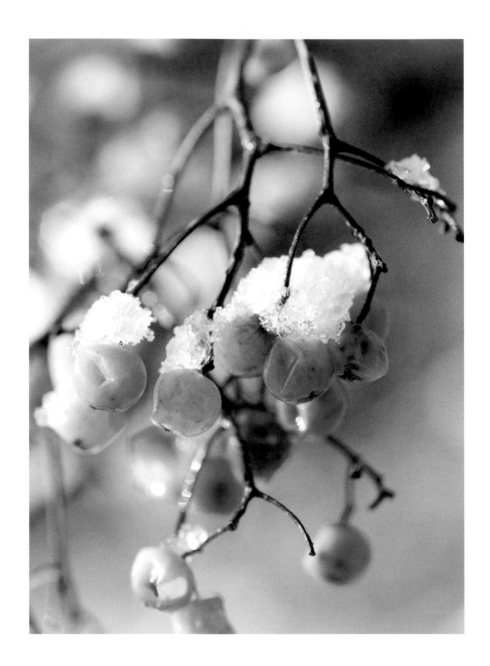

FEED THE BIRDS photographed by Andrea Jones, 2016

Planting to provide a bountiful supply of berries and seeds will add sculptural form to your winter garden and nurture wildlife in the leaner months. A good choice of tree is the rowan variety *Sorbus vilmorinii*, which has long-lasting pale-pink berries, providing late winter food after more obvious red and black berries – usually the first to go – have all been snatched by the early birds.

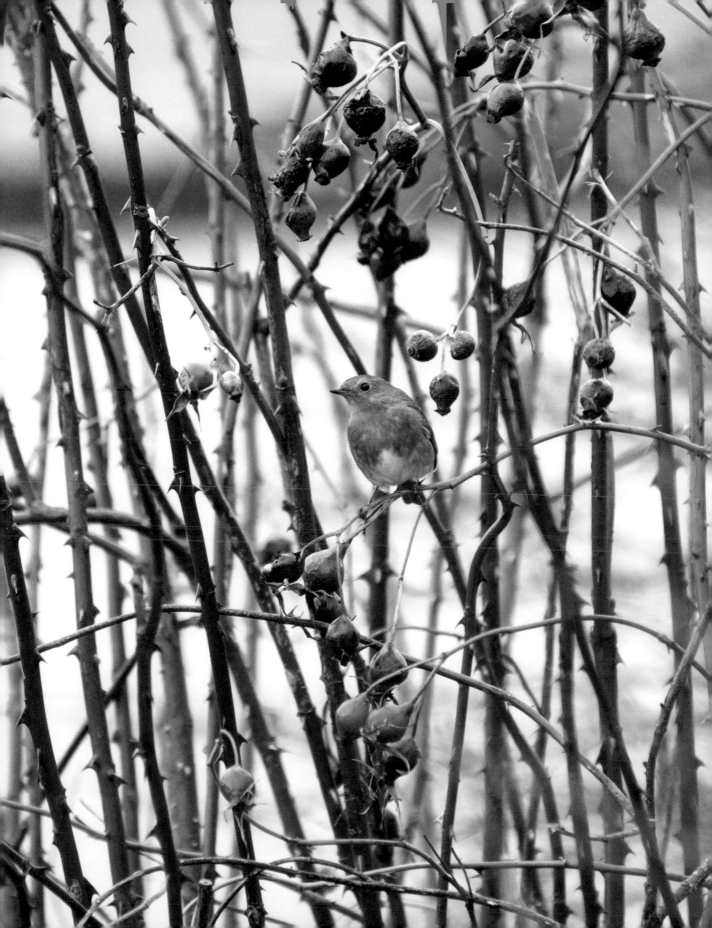

CHRISTMAS THIS WAY
photographed by Alun Callender, 2019

At Rental Claus rent-a-tree farm in Cheltenham, Craig Tennock has devised a sustainable scheme to ensure the seasonal centrepiece lives on long after the last bauble has been packed away. 'Instead of being discarded, the trees come back to us in the new year,' he says. 'We believe a tree is for life, not just for Christmas.'

THREE WISE MEN photographed by Alun Callender, 2019

An all-star community cast – including goats, sheep and a six-week-old baby – brings the story of the nativity to life on a historic farm near the riverside village of Aylesford in Kent. Surrounded by the meadows, barns and oast houses of this 28-acre working heritage farm, the volunteer actors – made up predominantly of the congregations of local churches – take starring roles. Pastor Kellie Edney set up the nativity ten years ago with her husband Steve, and she makes each of the costumes by hand. 'The nativity is often presented as a "nice story" that's told indoors in churches and schools, or like a fairy tale from a children's book,' says Kellie. 'I wanted to remind people that this is a real event that happened to real people. As we walk around the farm in the cold, mud and half-light, it gives a sense of that.'

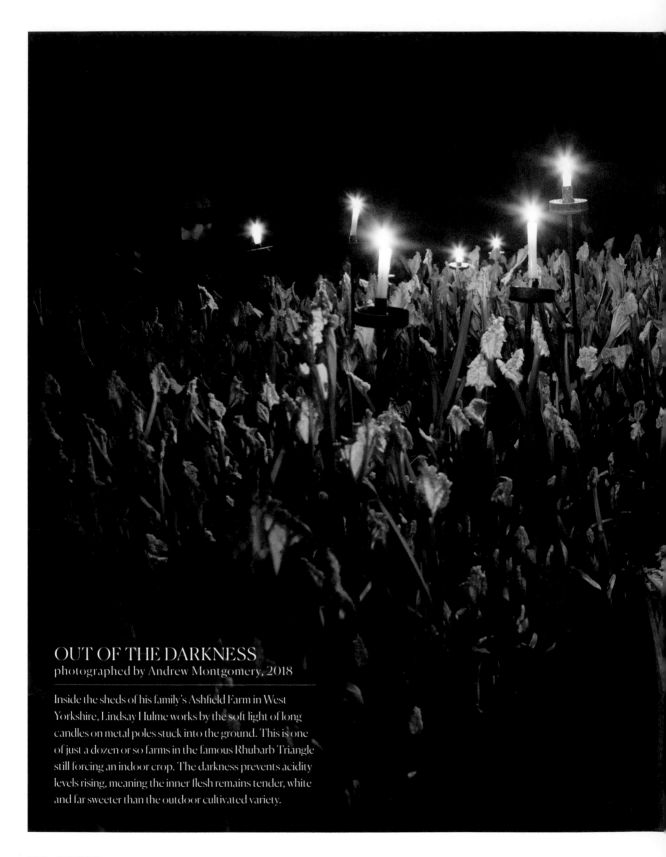

OUT OF THE DARKNESS
photographed by Andrew Montgomery, 2018

Inside the sheds of his family's Ashfield Farm in West
Yorkshire, Lindsay Hulme works by the soft light of long
candles on metal poles stuck into the ground. This is one
of just a dozen or so farms in the famous Rhubarb Triangle
still forcing an indoor crop. The darkness prevents acidity
levels rising, meaning the inner flesh remains tender, white
and far sweeter than the outdoor cultivated variety.

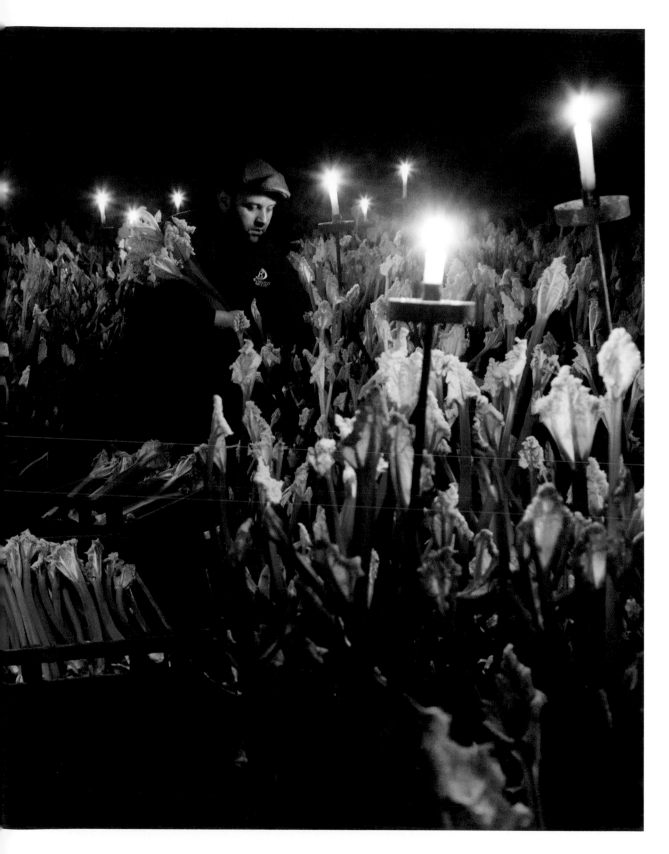

CRAFTED WITH KINDNESS photographed by Andrew Montgomery, 2018

On her farm in the Peak District, Deborah Griffin keeps rare-breed and pet sheep, over half of which she has saved from slaughter. Using their wool, she creates handcrafted rugs that, despite looking and feeling like real sheepskin, don't cost the life of the sheep. She achieves this by attaching the fleece to a felt backing rather than using the traditional suede one. To further their unique status (there are no others like these created in the UK), all Living Rug Company rugs are labelled with the name of the sheep that donated the wool, so you know which animal to thank for cosy feet on cold winter nights.

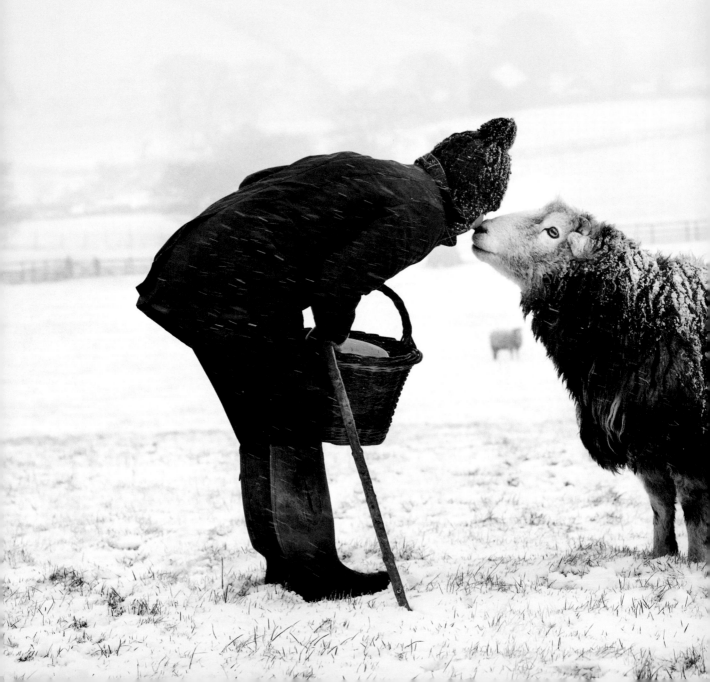

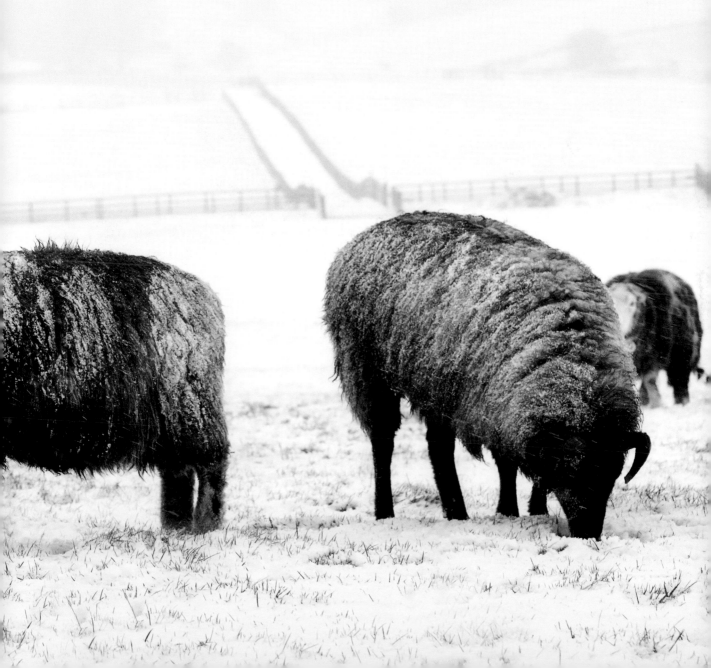

SHEEP ENCOUNTER
photographed by Andrew Montgomery, 2018

Deborah Griffin has a tight-knit relationship with her herd
of Herdwick, Gotland and Shetland sheep. 'They're like her
pets – she knows every single one by name,' says Andrew,
who captured this touching image of Deborah nuzzling
ten-year-old Herdwick Billy in the midst of a blizzard.

One icy DECEMBER day, Andrew headed to the CAMBRIAN Mountains to photograph a picturesque pig farm, but as the sun rose higher, SNOW was quickly becoming slush. He rushed to capture this fleeting moment. 'As the snow ebbs away, you get the tones, the CONTRAST and the undulations,' he says.

LANDSCAPE THROUGH A LENS photographed by Andrew Montgomery, 2018

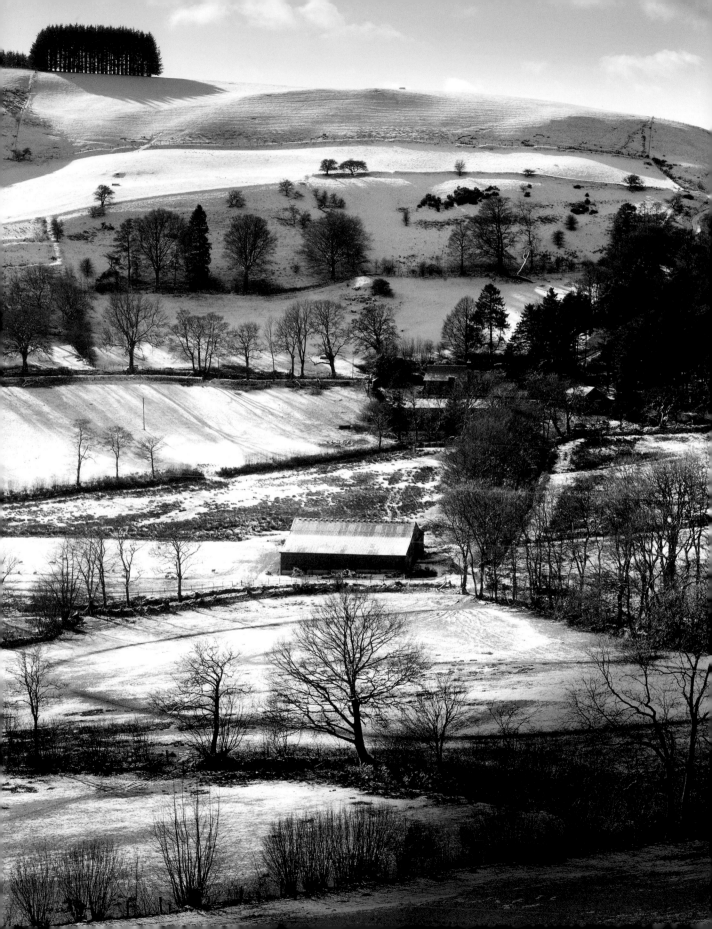

O COME ALL YE FAITHFUL photographed by Andrew Montgomery, 2019

At Pluscarden Abbey in Moray, white-robed monks still dedicate themselves to rites and rituals that have barely changed since it was founded in 1230. When photographer Andrew got the call from Brother Michael to say that snow was forecast, he knew he had to get to Scotland immediately. Unfortunately, he was in the south of France at the time. After driving all day and night, he arrived 24 hours later to find nothing more than a hard frost. 'I was gutted,' he says. Exhausted, he went to bed, but woke the next morning to a thick blanket of white – and with a new-found belief in the power of divine intervention.

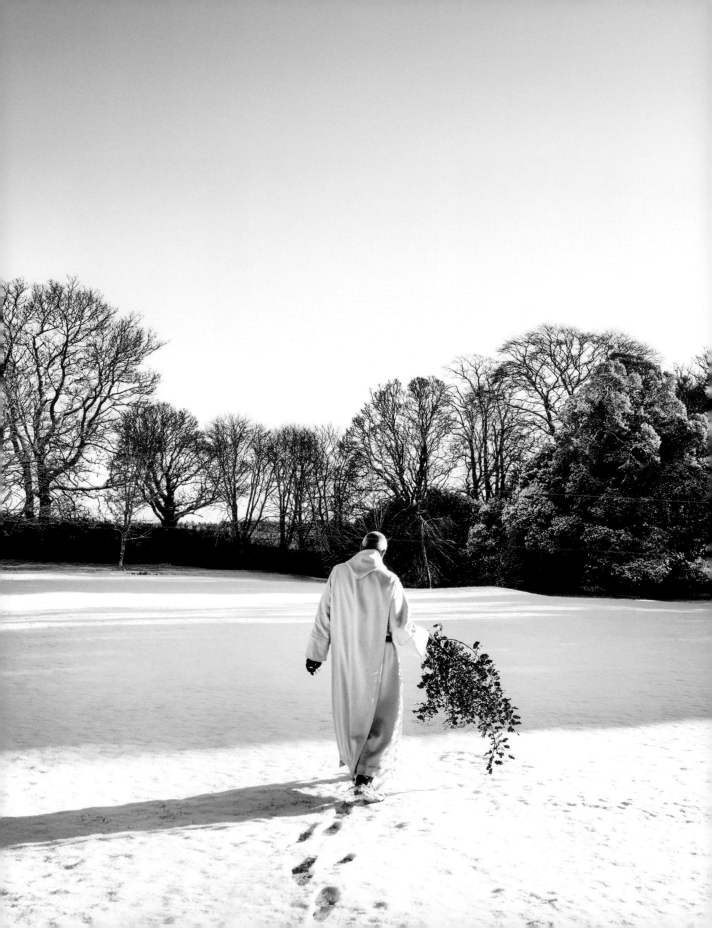

OUR COUNTRY LIVING PHOTOGRAPHERS

The Country Living team would like to thank these brilliant visual storytellers, without whom this beautiful book would not have been possible

Andrew Montgomery Alun Callender Nato Welton

Brent Darby Chris Terry Rachel Warne

Eva Nemeth Lisa Linder Jason Ingram

WITH SPECIAL THANKS TO Jan Baldwin, Cristian Barnett, Sussie Bell, Richard Bloom, Charlie Colmer, Britt Willoughby Dyer, Andrea Jones, Georgina Luck, Marianne Majerus, Nassima Rothacker, Ester Sorri, Alicia Taylor & Penny Wincer

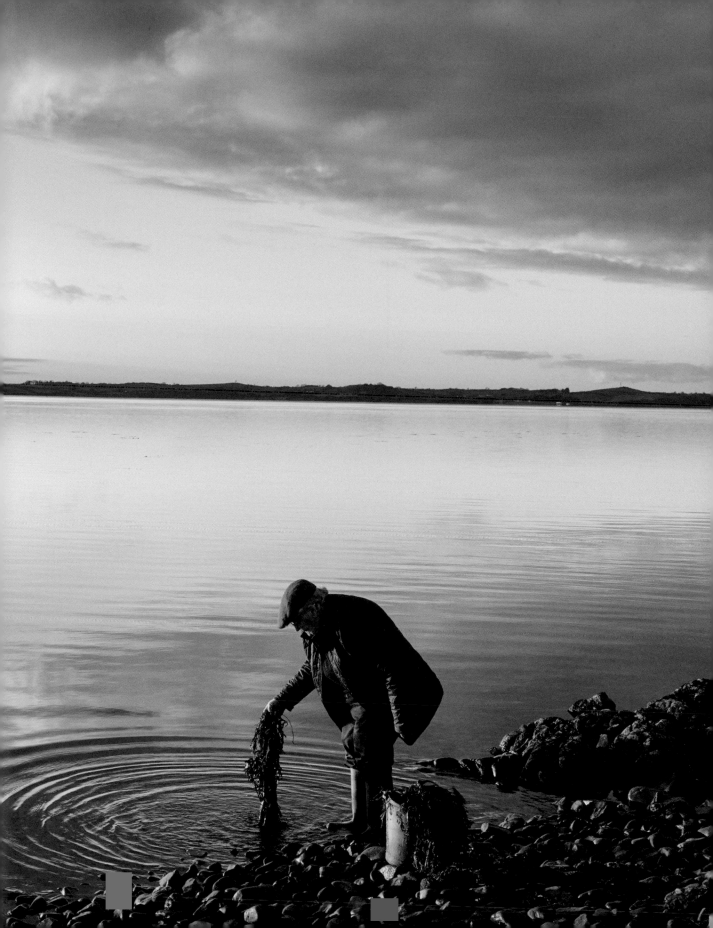

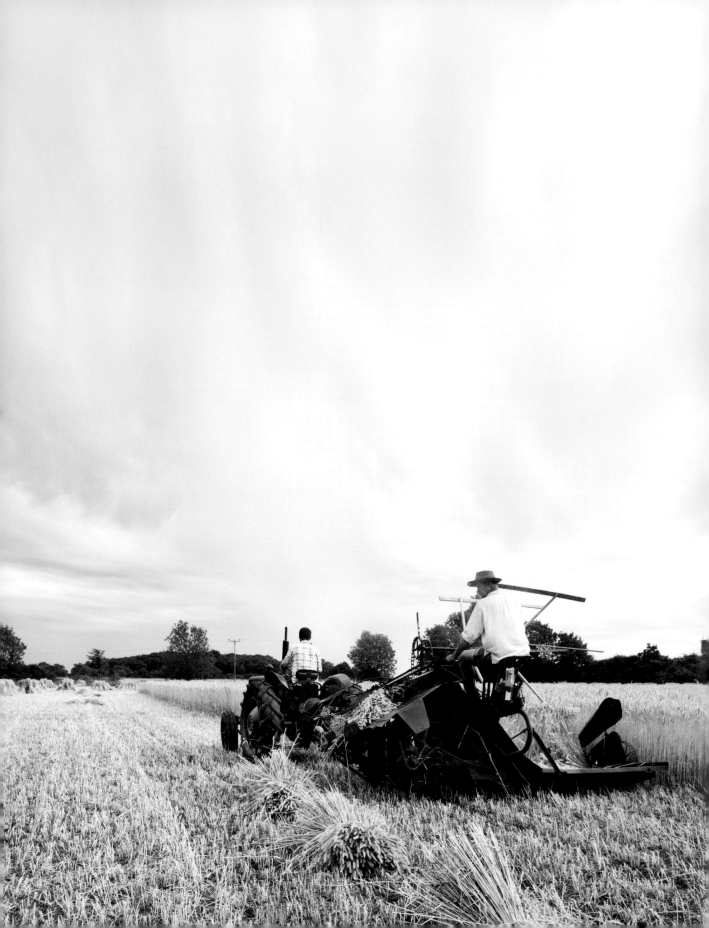

ACKNOWLEDGEMENTS

Louise Pearce – Editor in Chief
Amanda Morgan – Special Projects Editor
Vicky Carlisle – Executive Editor
Lindsey Jordan – Creative Director
Dina Koulla – Art Director
Susan Henderson – Chief Sub Editor
Sarah Openshaw – Chief Sub Editor
Patricia Taylor – Picture Director
Charlie Hedges – Picture Researcher

IMAGE CREDITS

Illustrations – Georgina Luck; pp.2–3 – Chris Terry; pp.4, 6, 237, 238 –
Andrew Montgomery; pp.8-9 – Nato Welton; p.13 montage – Getty Images
(top left, top right and bottom right), Alamy (bottom left); pp.14–15, 24–25,
58, 74–75, 163, 208 – Alamy; p.47 – Connor Mollison; p.69 montage –
Tim Gainey/Gap Photos (top left), Getty Images (top right), Andrew
Montgomery (bottom left), Chris Terry (bottom right); pp.92, 130–131 –
Getty Images; p.125 montage – Getty Images (top left and bottom right),
Andrew Montgomery (top right), Jason Ingram (bottom left); p.181 montage
– Getty Images (top left and bottom right), Brent Darby (top right),
Britt Willoughby Dyer (bottom left); pp.190–191 – Peter Cairns

HarperCollins*Publishers*
1 London Bridge Street
London SE1 9GF

www.harpercollins.co.uk

HarperCollins*Publishers*
1st Floor, Watermarque Building, Ringsend Road
Dublin 4, Ireland

First published by HarperCollins*Publishers* 2021

13 5 7 9 10 8 6 4 2

Published in association with Hearst Magazines UK. *Country Living* is a registered
trademark of Hearst Magazines UK

© 2021, Hearst Magazines UK

Country Living asserts the moral right to be identified as the author of this work

A catalogue record of this book is available from the British Library

ISBN 978-0-00-851699-4

Printed and bound at GPS

MIX
Paper from
responsible sources
FSC™ C007454